Speke to Me

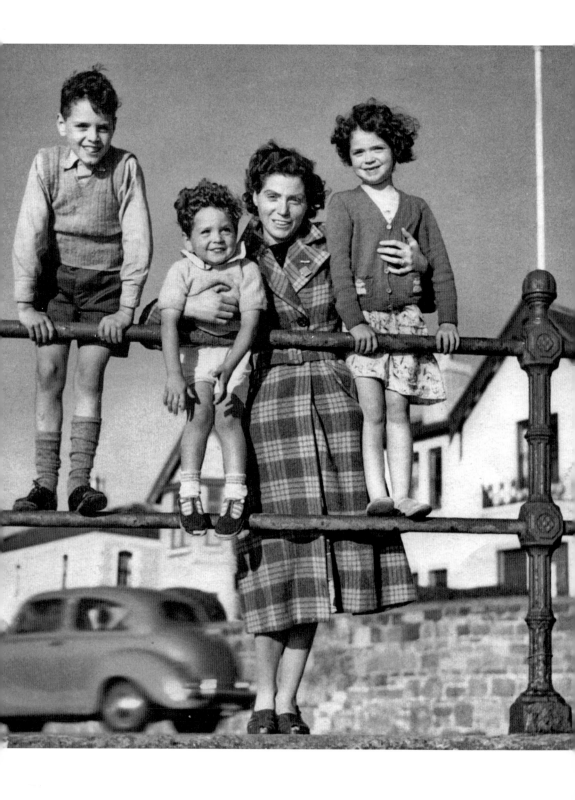

Speke to Me

DAVID PAUL

AMBERLEY

For my family, both then and now,

but especially for my Mum and Dad.

Frontispiece: On holiday in Hoylake.

First published 2011

Amberley Publishing Plc
Cirencester Road, Chalford,
Stroud, Gloucestershire, GL6 8PE

www.amberleybooks.com

British Library Cataloguing in Publication Data.
A catalogue record for this book is available from the British Library.

ISBN 978-1-4456-0210-3

Typesetting and Origination by Amberley Publishing.
Printed in Great Britain.

Contents

Introduction

'Well Paul, I'll say one thing for you lads from Speke – you certainly appear to be very well balanced, carrying, as you do, a chip on both shoulders.'

Teacher, St Margaret's school

There was a magic about Speke, which many people now would perhaps question. Speke has never been, and never will be, an affluent area, but that doesn't suggest, in any way, that it doesn't possess a unique charm.

Growing up in Speke was exciting, different and fulfilling. Life was raw, but as a youngster, it never appeared that way, quite the reverse in fact. In writing *Speke to Me*, I have endeavoured to sketch a true picture of events that happened in and around and to me. Some of them weren't that good, but the vast majority of them were. One thing is certain, I learnt many, many values in Speke; values that were embedded during my upbringing, and which have stayed with me ever since. The influence of my parents and family was profound, but there was a hidden influence exerted by the environment of Speke and also the people who lived there.

David Paul
La Croix Tasset, July 2010.

I

First Steps in Speke

The first vivid memory that I can lay claim to was sometime before Christmas in 1946, just before my sister Jean was born in March of the following year. Mum and Dad had started married life living with Mum's parents in Dingle, and it was to there that I was first 'brought home', on VE Day – 8 May 1945.

It was often the way then, as in fact it is now, that many newly-weds started married life living with one set of their in-laws, or 'outlaws' as my father was wont to call them in later years. I don't know how long this arrangement lasted, but four people and a newly born baby living virtually on top of one another in a small terraced house cannot be the best way to start married life; so, needless to say, Dad was anxious to find his own little castle as soon as it was feasible.

The three of us moved to a 'two up, two down' terraced house in Cambridge Street, Liverpool. I'm told that the move was just before the Christmas festivities were about to start. That year was a very special year for many families, in that returning servicemen, and most of them were men, were coming home and finding a new life after the vicissitudes and depravations suffered during the Second World War. Dad was certainly no exception to this rule. In addition to living in a house which he could call his own, even though it was rented, it had two other main advantages; firstly it was very near to Picton Road swimming baths, where Dad did a lot of his swimming and playing of water polo; and secondly, the Lamb public house was not that far away, where his own father had the occasional pint on a Sunday lunchtime. So, Cambridge Street had a lot to commend it.

But getting back to Christmas, Mum had placed a small artificial Christmas tree on top of the Singer sewing machine in the back room – the living room. She'd also managed to acquire from somewhere a set of brightly coloured electric lights which she'd arranged around the tree, together with some home-made baubles. The light catching on the decorations had the effect of making the whole room sparkle with tiny beads of twinkling light.

A few days before Christmas, one of Dad's nephews, Arthur, called to see us with his new wife. They stayed for some time, exchanging family news and talking about the upcoming festivities, but when they left, I happened to notice a small parcel wrapped in blue tissue which had been conveniently left under the tree on

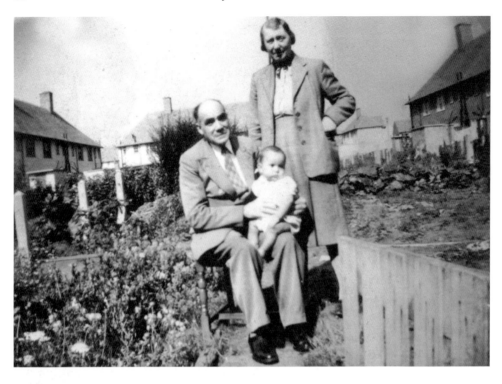

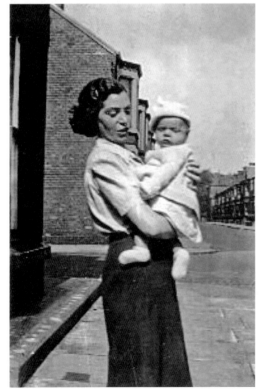

Above: Gran and Granddad in Speke with their new-born grandson.

Left: A proud mum with her new-born son, outside Blythswood Street.

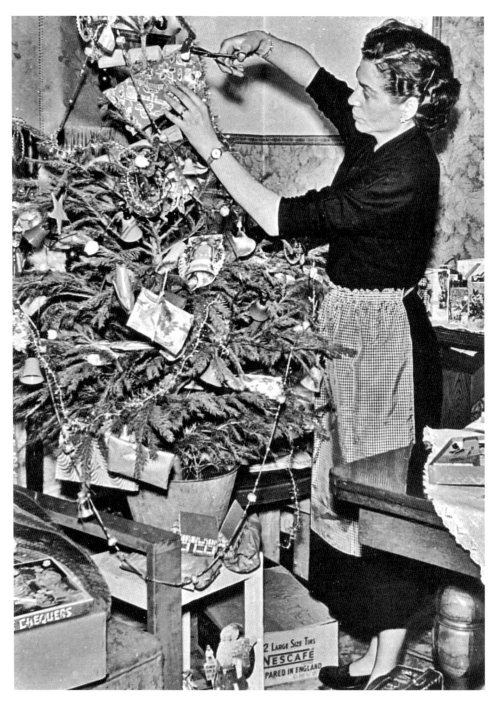

Mum decorating the Christmas tree.

A very special Christmas present.

the sewing machine. Even at that age, the excitement and anticipation of Christmas were very real. The present on top of the sewing machine was the first to be opened on Christmas morning. Inside the cardboard box was a scale model of a fire engine. The fire engine was exact in every detail. The red paint was the same colour as real fire engines, and the model also had rubber tyres on the wheels. I played with it throughout Christmas, much to the chagrin of my doting parents, as the tricycle for which they'd saved up was left to one side.

Cambridge Street was in the Picton Road area of the city; it was where Dad's side of the family had lived for years and years, although recently his eldest sister, Rose, had moved up to Barrow-in-Furness where her husband had found work in the shipyard. Jobs were certainly hard to come by, and Dad didn't have any formal qualifications at that time, but he proved that he was a willing worker and also a quick learner. By pulling whatever few strings various members of the family could get hold of, he eventually managed to secure a job as a junior clerk at the Transport and General Workers Union offices in Garston, just a few miles down the road. It was too expensive travelling by bus six days a week, so there was no option but to cycle to and from work, leaving home just after seven every morning, and sometimes not returning until well after six in the evening. But things were looking up, and soon the family was to have another addition. For this reason, it became even more important to find more suitable accommodation, but, as yet, the post-war house-building programme hadn't swung into action, and what houses were being built were soon allocated to more deserving families. Mum and Dad had been on the council's housing list for ages, almost since the time that they had been married on New Year's Day in 1941, but the lists were very long, especially in a place such as Liverpool, and they didn't meet all of the necessary criteria to be given a 'corpy' house. But then as if out of the blue, and just a week or two after Christmas, a plain buff envelope with the city council frank on the front dropped through the letterbox at Cambridge Street. The letter, written in very formal 'council speak' said, when translated, that Mum and Dad had been given an option on a new house which was being built on the council's overspill estate at Speke. It wasn't called an overspill estate, but that's, in effect, what it was. They had two weeks to reply to the offer. The reply was posted the following day, and preparations were started for the move to Speke!

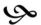

The village of Speke, on the southern most edge of the City of Liverpool and running roughly parallel to the northern banks of the River Mersey, had been in existence for hundreds of years, but the concept of a new Speke was only brought to the drawing board sometime just before the outbreak of the Second World War. The original idea for the new Speke was a bold move in social engineering – a landmark decision taken by the aldermen and councillors of the city to create a model satellite town, with its own cinemas, golf courses, riverside promenade, swimming baths, parks, shopping and sports facilities, and a range of other social amenities which

would herald the re-generation of the City of Liverpool. One of the key features in the social engineering aspect of the new Speke was the design intent to build houses for managers and workers cheek by jowl. Three-storey houses were planned in part of the town, so that managers could return to their homes and still have space to continue their office work. Also, with the advent of more widely available motorised transport, many of the houses were to be built with private garages attached – truly a far-sighted concept. But, as was replicated throughout the length and breadth of the country, the war put paid to that! Instead of a new concept in town planning being turned into reality, the land allocated to the new Speke was instead used to build factories which would help the war effort.

Then, with the return of troops from the front, it was soon realised that there was now a desperate need for housing, so working from much modified plans, the building of the new Speke was started. But because of extreme austerity after the war, and also re-ordered building priorities, the previously grandiose scheme for a revolutionary satellite town was completely changed; gone were the swimming baths, public parks, golf courses and riverside promenade. Indeed, little or no thought appeared to be

Dunlop Road, Speke.

given to social planning or social engineering. Some houses were still built with three stories, but these later became known as family houses, and were used to house larger families. Apart from that, most of the other houses that were built in Speke adhered to a starkly rigid pattern: three bedrooms upstairs together with a separate bathroom and toilet, and downstairs, a hall, living room, kitchen and parlour. The parlour was a throwback to the late nineteenth century, but was still considered 'proper' in many northern towns and cities, so most houses in Speke were built with a parlour. Also, nodding acknowledgement was given to the *Dig for Victory* campaign, in that every house built in Speke had both a front and rear garden – the back garden as it was known. To maximise every available acre of the land designated for house-building, the majority of houses were terraced and constructed in neat straight lines, with roads, walks, avenues and ways all set at ninety degrees to one another – a grid system similar to many American towns and cities. Passengers flying into Liverpool Airport – Speke Airport as it was known colloquially – or John Lennon Airport as it is now more grandly called, can still see the estate's clearly delineated boundaries, the layout plan looking like a huge sheet of graph paper.

Building work did go on at quite a pace, but when families first moved into the estate, major planning failures soon became apparent – apparent at least to the families who lived on the estate. The city's architects had either overlooked or failed to realise that even returning troops and their families needed groceries, meat, and other provisions for everyday living. People also needed social facilities and space in order to enjoy their leisure time and activities. But in Speke there were no pubs, no cinemas, no theatres, in fact, no opportunities for entertainment of any kind whatsoever. When the estate was developed, even the most basic of facilities weren't planned. There were no schools, no public conveniences, no shops and no churches. Speke was a dormitory estate, an estate needing a focus and a belief.

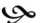

Loaded up on a Morris van that Dad had borrowed for the day from one of his friends at the Transport and General Workers Union offices, all of our family's worldly goods were taken from Cambridge Street to Lovel Way in Speke. I, together with my baby sister Jean, had been farmed out to our grandparents in Blythswood Street, in the Dingle area of Liverpool. It was a few days later when our grandparents took us on the 82 bus all the way to Speke. At that time, it certainly was the journey of a lifetime. We waited at the bus stop on the opposite side to the Mayfair cinema in Aigburth. It was a long walk there from Blythswood Street, and, in my childhood innocence, I couldn't understand why we didn't just wait at the nearer bus stop in Errol Street, just two streets away from Blythswood Street. Apart from anything else, it would have been much easier for Gran who was carrying Jean in her arms. It was many years later, when boarding the bus to Speke at the Mayfair became a regular practice, that I was to learn that the Mayfair was a 'fare stage', which meant that it was cheaper to board here than it was just a few hundred yards back.

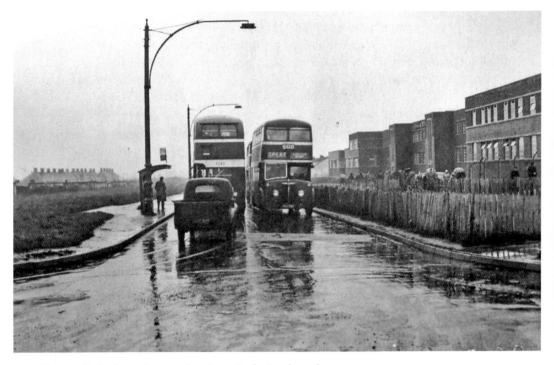

The 500 limited stop bus coming down Speke Boulevard.

We seemed to wait ages for the 82, but then time is always elastic for young children; but eventually the green double-decker rolled up. The conductor at the back of the bus helped Gran on, and we went inside. I don't think that this pleased Granddad, as, unless he went upstairs, he couldn't smoke! The Kensitas tipped would just have to wait another thirty minutes or so. The first place that we came to was Aigburth Vale, where Gran pointed out Jericho Lane, Otterspool Park and, as we went sailing past, one of the main entrances to Sefton Park and the famous boating lake where I was to enjoy many exploits in future times. By this time Jean was fast asleep in Gran's arms, and Granddad was quietly humming *What a Friend we have in Jesus*, one of his favourite hymn tunes. The bus trundled on, picking up and dropping off passengers along Aigburth Road, until it made its way through to Grassendale and the telephone exchange. It was here that three young women boarded the bus; Gran said that they must be telephone operators at the Grassendale telephone exchange. I hardly knew what a telephone was, let alone a telephone exchange, but Gran, filled with inexhaustible patience, tried to explain to me. A few minutes later we went down a very busy road, St Mary's Road, which was the main shopping street in Garston, and a street I was to become very familiar with in the not too distant future. The bus drew to a halt shortly after passing the swimming baths. We pulled up outside Garston bus sheds, where the driver switched off the engine and climbed out of his cab. He then walked around the bus, and together with the conductor, walked off somewhere. I hadn't got a

clue where they were walking, and I did feel a little threatened – who would take us on to Speke? After an interminable wait of maybe upwards of five minutes, all of my questions were answered; another driver climbed into the cab, sparked the bus's engine into life, and when he heard the two rings on the bell from the new conductor, he pulled out on the final stage of our momentous journey. After going over the railway bridge out of Garston and passing Bryant & May's match works, we went out into the countryside. There were very few houses and the landscape looked barren, uncared for and completely different. Also, by this time, there weren't that many people left on the bus. I really was beginning to wonder just what was happening and where exactly we were heading! Gran pointed out the funny lights as we went past the airport field, and mumbled something about them being special because of the war – just something else which I didn't understand on that journey. We got to the top of Speke Boulevard as it was known, and then went round the roundabout and turned right into Western Avenue. Granddad told me that we were now in Speke, and this was the place where we were going to live. The prospect didn't fill me with joy! We got off at the next to last stop: Central Avenue. It was then a long walk for tired legs past Linner Road, finally turning left at Lovel Road and then meeting Mum and Dad as they were making their way out of Lovel Way to meet the bus. We'd beaten them to it.

We walked the short distance back to 31 Lovel Way and when we got there, some three or four minutes later, there was another surprise in store for us. Grandma Paul was ensconced in one of the armchairs in the living room. I hadn't seen that much of Grandma Paul while we lived in Cambridge Street, but now it seemed she was to become a permanent fixture in our lives. Dad's father had died earlier in the year and Dad had promised his father, on his deathbed, that he would look after his mother. In those days that meant having her to live with us.

Everything settled down to a regular routine before long, not that I knew too much about it, but in new surroundings there was lots to explore. Funny, we always called Grandma Payne 'Gran', but Grandma Paul was always called Grandma Paul. There just wasn't the warmth there; they were two completely different people, and it was noticeable even to us children. It certainly was different from living in Cambridge Street now that we had Grandma Paul living with us. But I never bothered too much, as there was always something new to discover. Lovel Way was a rectangular block of terraced houses, and even around the block, I found everything exciting.

Speke had a well-defined character of its own, with blocks of new houses standing clean and honest, perhaps reflecting some of the traits of the people who lived in them, or was it the other way around? In fact, the character of Speke had developed and grown during the war.

On the outer side of the rectangle which formed Lovel Way, families had been settled into 'half houses'. These had been built in the early 1940s and, due to

wartime economies, had only reached the first level of their construction. Building then came to an abrupt halt. When construction ceased, the rabbit-hutch-like dwellings were then given a 9-inch layer of concrete icing over the top. This served to render the houses fit for human habitation. If nothing else, they did afford accommodation for families who were on their 'uppers' towards the end of the war.

When the grand plan for Speke was unveiled at the town hall and building work started once again, the houses which formed the inside of the block to be known as Lovel Way actually reached their design height of two storeys. Houses were built in long terraces of six or seven dwellings in one block. Our house, on one of the shorter sides of the rectangle, was one of only four dwellings in that block. At the far end lived Mrs Marsden and Elva. Also living with them was Mrs Marsden's ageing mother. This family unit was a long way from the given norm. In fact, at the time, they were the only lone parent family in Lovel Way, bearing in mind that the big block housed perhaps upwards of seventy families. The term 'lone parent family' was not then a common concept or expression. Sandwiched in between us and the Marsden's were the Bretts. Mr and Mrs Brett had one child, their beloved daughter, Thelma. The Bretts kept themselves very much to themselves. This tendency appeared to become even more marked as Thelma began to grow up! On our other side, and completing this side of the block, were the Brews – mum, dad and four sons, each very conveniently spaced at intervals of eighteen months.

During the time that we lived in Lovel Way all of the families grew, changed, developed, interacted, and, in many cases, moved on. It was an environment rich in change, challenge and character.

Tuesdays were always good. Mum went to Garston on her weekly pilgrimage. Garston, about 3 miles down the road, was more civilised than Speke. It had shops, schools, banks, churches, cinemas and a large and very busy bus shed. For some reason, this always fired my imagination. It thrilled me to watch the constant comings, goings and intricate manoeuvring of the large double-decker buses in the confined space of the garage. Garston could also boast Irwins, the general grocers. There was also a very special toyshop in Garston, halfway up St Mary's Road. But, when I went to Garston with Mum, it was a while before we got that far. The 80 took us to the cenotaph at the top of Horrocks Avenue, and just across the road was Garston market. The market had been on that site as long as anyone could remember, and was held twice weekly on Tuesdays and Fridays. The visit here was strictly limited to half an hour, and was very ritualistic in form. Mum carefully assessed the prices on all of the fruit and veg stalls, before ending back at the same one every week. Sometimes, she didn't buy any veg at all, and relied solely on the mobile shop which came round Lovel Way every Tuesday evening. She did, however, always buy a dozen fresh eggs from the egg man, believing these to be the best eggs in town. The rest of the time was used to get a 'fix' on prices, so that she

had some comparative base to work from when she ventured into the main high street. Our allotted half hour was soon up, and we made our way past the cottage hospital and the Empire cinema, to come out just above George Reed's barber's shop in St Mary's Road. Although we never visited this particular establishment, the window display fascinated me, with a flamboyant array of various sized jars of Brylcreem, interspersed with packets of Durex. At my tender age, I couldn't understand why barbers sold such strange commodities!

Our first port of call along St Mary's Road was to the toyshop. Before we got anywhere near I started the warm-up routine, the objective being to convince Mum that by giving me three pence for the lucky dip she was really making a sound investment. Fortunately, she could always be persuaded to part with her hard-earned cash, and allowed me to exchange the money for a dip into the bran tub. While Mum was engaged in paying her Christmas Club money, I duly gave my three pence to the assistant, and was rewarded by being allowed to put my arm deep into the sand-filled barrel. The lucky dip, which must have been a good source of revenue for the shop, was prominent in the centre of the open floor area. Logic dictated that if I pushed my arm as far as it would go into the sand, I was sure to get a really good present. I was never disappointed. On most trips to the toyshop I managed to win a lead soldier, which always pleased me. On leaving here, we walked a bit further down the road to the newsagents. Mum went here for her little treat of the week, her copy of *Woman's Weekly*. Her strict code of personal discipline dictated that she never read the magazine on the bus going home, but saved it for a quiet evening's reading later on. The newsagent's shop, which also sold sweets, several different types of pipe tobacco and cigarettes, was filled with a mixture of aromas, ranging from the pungent smell of Uncle Joe's Mint Balls, right through to the intoxicating scent of Golden Virginia tobacco. Cigarettes and pipe tobacco were displayed on the lower shelves, as they were no doubt easier to reach. State Express, Passing Clouds, Craven 'A', Senior Service, Capstan Full Strength, Players, and, most popular of all, Woodbines, were all neatly stacked in their respective slots. The shelves above the tobacco, which interested me far more, were filled with a series of large glass jars full of many different varieties of sweets and toffees. A choice from one of these was a rare treat. Sometimes I was allowed a 2-ounce twist. Sherbet lemons were my favourites, purely for the reason that they were very large, and when the outer casing melted away, there was always the surprise of the sherbet inside. Sometimes, if it came really unexpectedly, this resulted in uncontrollable coughing, spluttering and sneezing.

The culmination of our expedition to Garston was the visit to Irwins. This was just by the traffic lights at the bottom of St Mary's Road, next to the Trustee Savings Bank, which in turn was next to the Municipal and General Workers Union Office, which is where Dad worked when we first moved to Speke. Going into Irwins was like entering a different world, with the fresh distinctive smell of the grocer's shop assailing our nostrils. It was a clean healthy smell, a combination of different aromas, but predominant among these was the rich smell of the smoked hams. These were hanging from the chromium-plated rail which was located over the

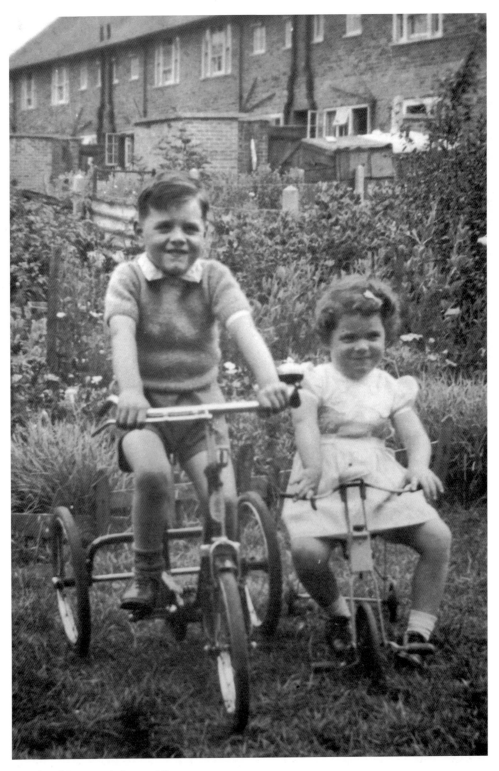

David and Jean on their new bikes.

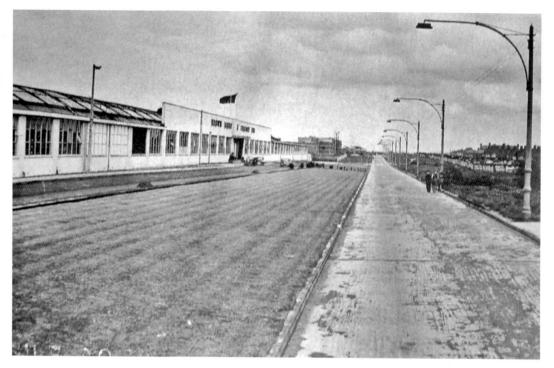

Brown, Bibby & Gregory, Speke Boulevard.

main counter running along the side of the shop. The hams hung down to just above grown-ups' head height. The black and white chequered stone-tiled floor of Irwins always had over it a light dusting of sweet-smelling sawdust. The shop assistants, of whom there were many, were very neatly dressed in white aprons and black shoes. The men had black smartly creased trousers with white shirts, and the women wore black skirts, white blouses and had white net hats covering their hair. But the person who was dressed most smartly was Bill. He was the manager and wore a full-length white starched apron, which was always spotlessly clean. He was a large jovial character, and smiled whenever customers walked into his shop. He had a large gap between his front teeth, which were almost as white as his apron. There were also gaps on his left hand; he only had three and a half fingers. Local legend asserted that he'd lost the other bits on the bacon slicer; this may or may not have been true. It didn't stop me from being apprehensive whenever he placed a side of bacon in the hand-operated slicer. If the truth was known, I was looking for a repeat performance!

In addition to being shop manager, Bill was also a keen amateur child psychologist. Because of the queues at Irwins, Mum would often have to wait as long as fifteen minutes. As time elapsed, I became more fractious. It was at this stage that Bill produced his three-legged stool, sat me down, and gave me a slice of ham. This had the combined effect of keeping me quiet, bestowing a calming influence on Bill's other customers, and maybe boosting the sales of boiled ham.

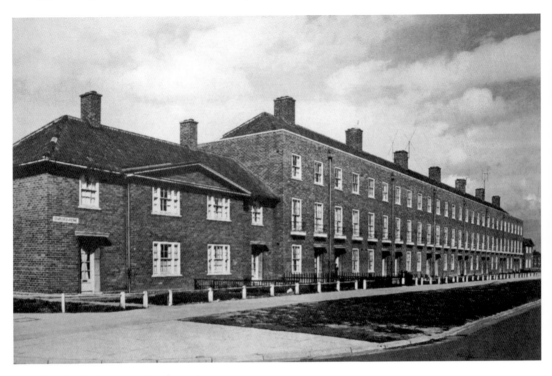

The family houses in Stapleton Avenue.

By the time we left Irwins the bags were bulging. Invariably, before we had time to cross the road and walk to the bus stop, a bus went whizzing past on its way to Speke. But, as the service was every ten minutes, it didn't really matter that much. I was given the two heaviest bags to carry, and Mum carried the other two. She always insisted on carrying the string bag which contained the eggs. This was because on the one occasion when I'd been trusted with the care of the eggs, only nine got back home in tact. If we were lucky, we caught the 500. The fare was the same as on other buses, but the 500 was a limited stop service which made the journey home a lot quicker. Most of the passengers going to the frontier at Speke had full bags. By the time we passed Bryant and Mays, the match factory just over the bridge out of Garston, the crowded bus was filled with laughter and chatter. It was only ten minutes back to Speke. The bus dropped us off in Western Avenue at the stop next to the terminus. Then it was a short walk along Central Avenue before turning into Lovel Road and home. Gran greeted us with a cup of hot watery tea which was just the way Mum liked it. The eager anticipation in Gran's face signalled her unspoken question as to whether she'd be allowed to unpack the bags. This was her way of being able to check exactly what Mum had been buying, and what goodies she could look forward to during the coming week.

Although Mum preferred weak tea, there were occasions when Gran would volunteer to read the leaves for her. These readings would take place perhaps once or twice a month but always when Mrs Larch, Gran's friend from across the road, was present. The mystical process involved first making a large pot of very strong tea, with maybe four or five spoonfuls of tea being placed into the brown earthenware teapot. After being left to brew for a few minutes, the tea was then poured without the tea strainer being placed over the top of the cup. Then, rather than stirring the tea after the milk had been added, the leaves were allowed to settle. The tea was then sipped very slowly. At the end of the process, the leaves were carefully emptied out onto their respective saucers, leaving a random pattern of leaves for Gran to interpret using her mystical powers. Whether or not she actually had any powers was certainly open to debate, but nobody ever seemed willing to challenge her. She would then take a few deep breaths while staring intently at the dark brown moist pattern. Invariably, her interpretation always included a tall dark stranger arriving at the house, but nine times out of ten, this could mean either the post man knocking on the door in the next few days, or Uncle Ted showing up

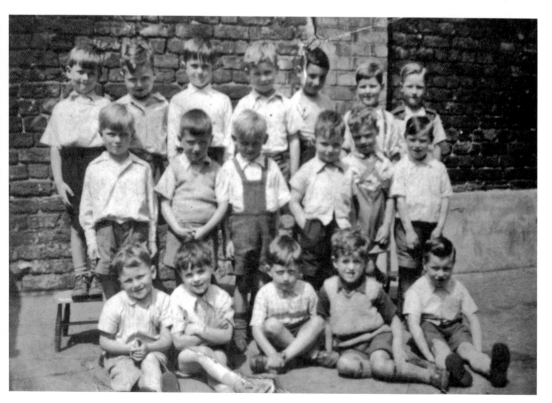

St Peter's Infants School. Boy's in middle class, 1951.

unexpectedly; she never failed to give an answer on this one. Her predictions also tended to include a visit somewhere, and the other favourite was either finding or losing money. In between such occasions, Gran, a diminutive, rotund figure and always dressed in black full-length dresses, would often make reference to the last reading when something out of the ordinary had occurred. Her vivid imagination could turn anything to suit her earlier predictions, even the nightly headlines in the *Liverpool Echo* could be shown to justify her claims. Mrs Larch always left with a prevailing sense of awe, clearly wondering where Gran had acquired her gift. It was at that point that Gran would flash a knowing look, a malevolent glint in her eyes which somehow signalled the sham of the readings.

2

Early Days

In addition to having no social facilities, Speke was not blessed with many educational establishments. It did, however, spawn a preponderance of different faith churches in those early frontier days. As schools in Speke became full very quickly, Mum and Dad soon realised that their eldest son and heir wouldn't be able to take advantage of the state system of education until he was almost six. They decided to explore some other possibilities, and were told of a village school, 4 miles away, which still had places available. Dad made a series of protracted 'phone calls and had time off work to make personal visits to the school. Eventually, after experiencing some considerable difficulty in trying to explain to officials at the education offices why a minor was having to travel so far to school, my name was entered on to the new enrolments list for St Peter's Infant School, Woolton. This was a Church of England foundation, and had been established primarily for the sons and daughters of the worthy parishioners of Much Woolton.

Mum and Dad viewed this early start as a distinct advantage in my educational development. As far as I was concerned, it was very much the opposite, as I was now able to start school at the tender age of four and a half. In retrospect, this initial advantage, so called, didn't achieve the desired effect. But on a cold September morning in 1949, I was taken on the 81 bus down the road to Woolton and started on a very different phase of life. I was crying before we'd travelled as far as Speke Boulevard. We still had to go over the hill by Mothaks, past the Co-op dairy, round the roundabout, and along Hillfoot Avenue to Hunts Cross. After stopping here, the bus negotiated its way down the road that cuts right through the centre of Woolton Golf Club. I was greeted at the gates by one of the teachers and coaxed into school. As soon as I started the long walk across the playground, Mum beat a hasty retreat. Looking around just before I entered the building, I couldn't see anybody outside of school at all.

One positive benefit of my early start at school was that, since the third child was due in October, it helped everyone else if I was out of the way during the day. I'm sure that this wasn't the motive for packing me off so early, but the timing was fortuitous to say the least!

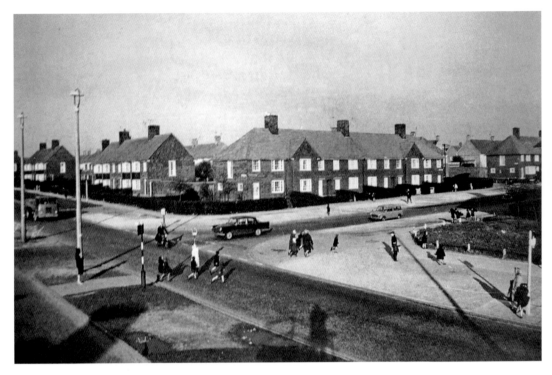

Children on their way to school, crossing Western Avenue.

School was rather a daunting prospect. My earliest memory was being given a wooden framed slate and some chalk, and shown how to form the letters of the alphabet. Like so many other events which were to occur in school, I couldn't understand the logic behind this, and why there was the need to take me away from an environment which I both understood and enjoyed. Fortunately, it was only in this first class that we were made to write on slate. By the time that the end of each day came we were all covered in chalk dust and felt very grimy indeed. Even then there were fights and scrambles to see who could get the best and newest slate. Squabbles also took place when the chalk box was produced. Everybody always wanted to have the longest piece of chalk. In Class 1, my arch-rival and adversary was David Jennings. One day, while the teacher was out of class, our scramble for chalk erupted into a full-scale fight. Panic set in when Jennings's nose started to bleed. Blood went all over my hands and clothes. Our teacher heard the commotion, and hurriedly returned to her class to sort out the miscreants. David was told to lie flat on the floor at the front of the class, and I was suitably admonished. When school finished and his mum came to pick him up, she was informed of his unfortunate accident. I don't think she was too pleased to hear of the rough treatment which was being meted out to her son by the 'Terror from Speke'. Unbeknown to me, this was a nickname I'd been given by some of the teachers.

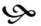

I soon adapted to school life, and enjoyed my time at St Peters. The school had no canteen facilities, so at lunchtime we walked down the road, in crocodile formation, to the dinner centre in Out Lane. The meals were brought here in a 'corpy' van. The spuds, veg and meat were kept warm in large aluminium canisters. But, nine times out of ten, the mashed potato was cold, the gravy was congealed, and the tapioca pudding stiff. The happy chatter on our way down to the centre made up for the inadequacy of the meal which the local education authority provided. It was what they called a 'square meal', or, in today's parlance, 'nutritionally balanced'.

We didn't last long in Out Lane, as the building was condemned as being unfit for human habitation – the inference being that we formed part of this group. The school had to seek alternative accommodation. This was soon found in a redundant church hall on the other side of Woolton, not far from the public swimming baths. The walk from school was past the plantation by the side of Woolton woods, and only took about five minutes. In autumn, when leaves were heavy on the ground, we walked along kicking them as high as we could, laughing and embracing the sheer joy of living. School dinners didn't improve much at the new dinner centre however!

Assembly was held in the school hall every morning from nine 'til quarter past. The different classes all marched in to the accompaniment of Miss Wallace playing the piano. We started with a hymn, and then there was a short time while Mrs Sterling, the head teacher, said a few prayers. Once a week, Mr Pryce-Jones, the Rector of Woolton, came to the school and told us a story from the Bible. The end of assembly was marked with the teachers leading us out, class by class, to start the day's work. After assembly on Tuesdays and Thursdays, a few children were allowed to stay behind to practice in the school band. Although I didn't realise it at the time, my musical career was about to blossom. My undoubted skills on the triangle had been recognised, and were being sought by Miss Wallace. The school band had a limited range of instruments, three side drums, three triangles, two tambourines and Miss Wallace on piano. After much practice, I was told that I was now a full member of the band, and allowed to play a triangle. When Revd Pryce-Jones arrived some weeks later, the whole band was to accompany the singing, rather than just Miss Wallace on her piano. The performance was an absolute disaster, and was never repeated again. Our timing was completely awry, with the rector starting two or three beats before us, and the rest of the classes finishing a few beats behind. The instruments were discretely put away in the stock room. Evelyn Glennie's career was safe!

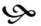

The top class in the school was rewarded with the biggest classroom. They also had a frieze which 2 two feet in depth, and painted right around three walls. Depicted on it were colourful scenes from along the banks of the Mersey, starting

from Speke at one end with its developing airport, right through to the Pier Head, docks, and Bootle at the other end. Liverpool boasted over 12 miles of docks which ran along the Mersey's edge, from the timber docks at Garston to the deep basin docks moving towards Waterloo, near to where Canadian Pacific, Cunard and other ocean liners tied up. The frieze showed many different types of ships coming and going as they did throughout the day and night. Also, painted on by one of the teachers, was the Liverpool Pilot cutter, weaving its way in and out, dropping pilots onto some ships, and then picking them up from others. The pilots were very important, bringing the ships – and the trade – to the port. Everyone who passed through that classroom shared the impact of the frieze. Most of us assumed for a long time that there was only activity along the seafront in Liverpool, and that nothing occurred away from the river. Indeed, that may well have been true!

School was developing into a really enjoyable way to pass my time – well, that is, during the week. It didn't bother me getting up early every morning, and jumping on the twenty past eight 81 bus for the penny journey through to Woolton. When the days grew warmer after Easter, Mum walked from Speke, pushing Colin in his pram to meet Jean and me from school. The walk back took an hour. In honesty, I preferred it when Mum just met us at the bus stop in Speke, rather than having to endure that long walk behind the pram, through Hunts Cross, down Woodend Avenue and home.

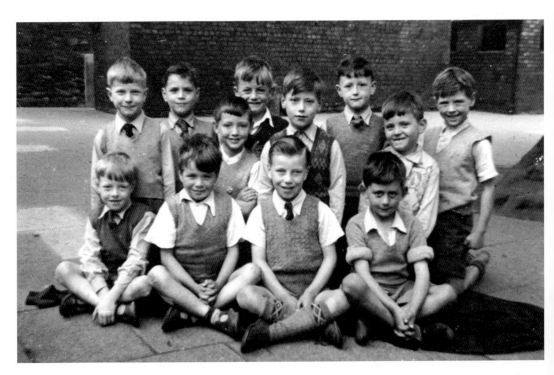

St Peter's – boys in top class, 1952.

There were no such things as parents' evenings, but occasionally, teachers did need to say something to parents, normally when their child had strayed from the straight and narrow. Mum was asked to visit the school a couple of times for this reason, once when I'd persisted in playing with the ribbon in a girl's hair, and the second, and more serious occasion, when I was caught peeing through the windows in the outside lavatories. The school had been built in the middle of the nineteenth century and sanitary facilities were not as sophisticated as in some other schools. We had to go out into the playground to use the outside loos at various times during the day. The lavatory was a solid brick building with no windows, just large square openings which allowed light in. They also allowed other elements to escape! Boys being boys always had something to prove, and we were no exception to this rule. It was seen as being a great achievement to successfully pee through the windows, the bottom ledge of which was at head height. On the occasions when we were successful, there were disastrous consequences for anybody who might happen to be playing outside at the time. It was just such an occasion which prompted the head teacher to ask to see both Mum and Dad. Following a severe reprimand from both my parents and the teachers, I promised never to aim for the window again – a promise I was forced to keep, since I'd been threatened with expulsion from the school if I didn't comply.

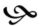

Every Tuesday evening, regular as clockwork, George's charabanc pulled up near the lamp post opposite our house shortly after five o'clock. All the women from the block queued up, turbans around their heads, shopping bags in hands, ready to enter George's bus, via the three steps. The bus had been converted into a mobile greengrocers, and sold a wide range of fruit and vegetables, lemonade, sweets and eggs. In fact, most of the commodities which should have been on offer at local shops. In their absence, however, George's entrepreneurial spirit had prevailed, and he journeyed down from Garston most days in the week, taking particular routes around the estate on different days. Tuesday just happened to be our day. As the charabanc normally stopped for over half an hour, I was allowed to perch in the driver's seat and pretend that I was a bus driver. Looking across at the mixed fruit and veg, I saw two boxes of apples set on either side of the alleyway. Although the boxes looked to be identical, the apples in one were priced at nine pence per pound, while the sign over the other box indicated that the apples here were one and three pence per pound. I couldn't see any difference in the apples, only a difference in the price.

'Why are those apples priced differently, George?'

'That's simple. It's because housewives think that the more expensive apples are the better ones. Also, I always get rid of that box first!'

At the age of seven, I learnt one of the first principles of psychology, a subject which was destined to become a lifetime's study.

ॐ

Fridays also had a distinctive character. Whenever I managed to feign illness and absent myself from school I was able to observe, at first hand, the several different and distinct rituals associated with that day. To start with, Gran was asked to stay in her room for the morning. Reluctantly she agreed to this request, but then spent the remainder of the time clattering around and making as much noise as possible in her temporary confinement. After successfully negotiating this arrangement every Friday, Mum's first job was to pull all of the moveable furniture out from the living room and into the back kitchen. It was then back to polish the linoleum on the floor, dust the bookshelves which stood either side of the chimney-breast, and finally clean the sideboard. Halfway through the morning, just before the mantelpiece clock was wound up for the week, there was a sharp knock at the front door. Mum, with a knotted turban planted on her head, which somehow looked quite incongruous, went down the hall to greet the *Betterware* man. The opening of the door was his cue to reveal the contents of his *Betterware* suitcase. With a well-rehearsed flourish, the case was flung wide open revealing his extensive range of natural hair brushes, furniture polish, small kitchen utensils, and other assorted household cleaning aids. The trademark of the *Betterware* man was that,

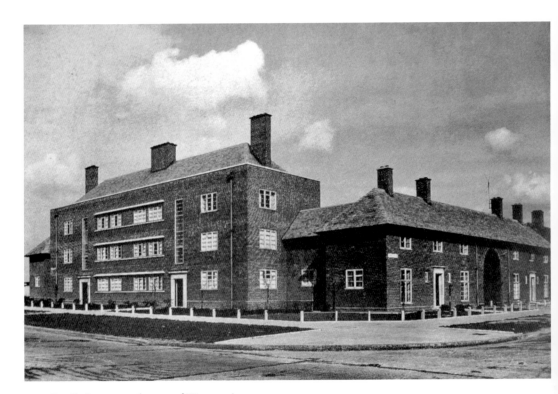

Family houses at the top of Western Avenue.

irrespective of how much was actually spent, he always presented to the lady of the house a small free gift. What a sales pitch! Every Friday Mum fell for the sucker-punch, and always bought something, whether she wanted it or not. Although the quality of *Betterware* products was never in doubt, the brushes seemed to be very expensive!

Before the work of the morning had been completed, and everything was back in its place ready for Dad coming in at lunchtime, the distinctive cry of the rag and bone man could be heard in the distance. Dressed, as always, in his dark brown, tattered and threadbare tweed jacket of dubious provenance, the rag and bone man was a familiar sight around the streets of Speke. His trousers, just like Steptoe's, were always held up with a cord of rough twine tied around his waist. Joe's son Nick, a third-generation rag and bone man, could often be seen sat on the back of the cart, or sometimes, when Joe felt tired, which was often the case, Nick would pull the cart and collect the offered rags. It was a long apprenticeship, but a profitable one; some years later, Joe and Nick were seen climbing into a new Morris Minor after they'd finished their traipsing around Speke!

As soon as their cry was heard Mum, wanting to be helpful, delved into the recesses of the walk-in pantry, looked in the cupboard under the stairs, and then in all of the back kitchen cupboards. This was to try to find enough old rags to pile onto the waiting handcart. By the time everything had been collected together, the

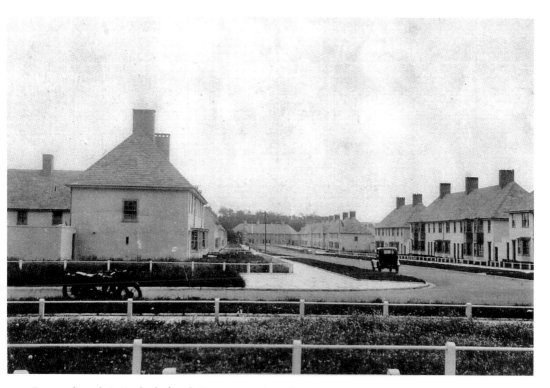

Deserted roads in Speke before being over-run by private cars.

cart was halfway up Lovel Road. I had to go legging after it with armfuls of rags and old newspapers, eagerly anticipating my reward. The exchange was never good and Joe always won. Only two gifts were ever on offer, either a balloon or a manky goldfish. The balloon, which had droplets of spit on the inside from where he'd blown it up, would always burst shortly after arriving home. If there were enough rags to barter for a goldfish, the chances were that, by the following morning, it would be dead! But every week we tried again, either for a balloon that would stay up longer than half an hour, or a goldfish that would live for longer than a day.

The brick dividing wall between our back garden and the Brews' played a significant part in my early life. The Brews had an Alsatian which was allowed to roam in the backyard during the day, acting as a guard dog. Sitting astride the wall, which afforded a degree of safety, it was easy to taunt the baying hound below. This wasn't always such a sensible idea as when Nicky became particularly agitated, he could jump rather high. When making a determined lunge for one of my legs, I had to take evasive action rather smartly. Unfortunately, instead of landing safely on our path, I fell rather badly from the wall, catching my head on a rusty nail which was protruding from the garden fence. Blood spurted out over the backyard and all over my clothes. I stumbled into the back kitchen, and Dad came running out as he heard my cries for help. As soon as he caught sight of my injuries, he promptly flaked out onto the kitchen floor. My blood-covered face was just too much for him to stomach. It was left to Mum, as usual, to make the best she could of bathing my wounds.

Some ten minutes later I was being ushered into a cream-coloured Daimler ambulance by two very sombre-looking ambulance men. I'd never travelled in this form of conveyance before, and it was with some degree of trepidation that I stepped into the back of the vehicle in full view of the gathering crowds. It wasn't every day of the week that we had an ambulance in Lovel Way. Neighbours were doubtless wondering just what had happened at 31. Gran, who was on her way home from the over 60's club, saw everything from a distance and no doubt wondered what the commotion was all about. By now the ambulance had gathered speed, and its bell was ringing with a certain degree of urgency as we sped along the airport perimeter road towards Garston. I asked Dad why the bell kept on ringing, as it was beginning to annoy me. He suggested that this would help the ambulance get to the hospital a bit quicker. He didn't explain just how a bell could possibly help the ambulance to travel faster. There were no such things as blue flashing lights or those horrible American-type wailing sirens. Perhaps it was a bit more civilised, and I'm sure that it can't have been very much slower than it is now. We arrived at the emergency wing of Garston cottage hospital, to be greeted by two nurses dressed in dark blue uniforms with lace-edged small starched caps, sitting atop of their bouffant-style hair. I was stretchered out of the ambulance and wheeled to the theatre area. It smelt very clinical here, with walls clad in crazed,

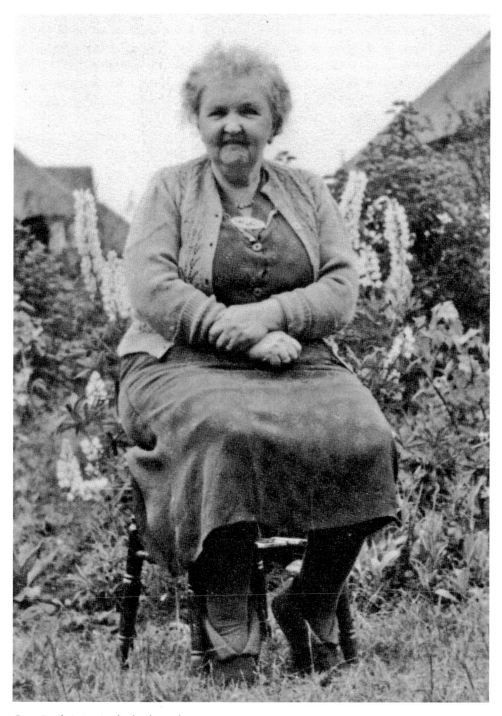

Gran Paul sitting in the back garden.

pale green rectangular ceramic tiles. My head was examined by a doctor with a mask over his face. Dad was also standing by the side of the examination table. By now he'd regained some of his colour and composure, but his gaunt and worried expression informed me that he still wasn't sure as to the severity of my injuries. Added to this, when another doctor came in, there was much shaking of their medical heads. It was revealed to me much later that if the injury had been half an inch further over, then the vision in my right eye would have been lost forever. As it was, I had four stitches which caused me quite some pain as they were being put in, but that was certainly preferable to having major eye surgery. All's well that ends well. But, from then on, the dividing wall was off limits – well, at least for the next few weeks!

Later on that year, the backyard path featured in another epic. Being keen to develop my somewhat fundamental interest in engineering, I decided to experiment with a mild steel bar. At the time I was observing was that the higher up I dropped the half-inch diameter bar, the higher it bounced after hitting the concrete flagstones in the yard. I made a slight miscalculation during one of the tests, which resulted in a particularly high bounce, and the bar, which was now assuming the proportions of an RSJ girder, jumping straight towards my mouth. My front teeth were cracked and I looked even more like Dennis the Menace than I'd done earlier in the morning.

Once again, Dad was there to come to my rescue. As it happens, one of his 'oppos' at work, Mr Curry, had a son who was studying at the Liverpool Dental Hospital. On Saturday morning, I was carted off to Pembroke Place. This was right at the centre of the university area in Liverpool, and was the home of the Dental Hospital. That visit was to herald the start of a very long and happy association. During the next eight years, I spent many hours in various dental chairs being treated by many different students of all shapes and sizes. My first series of appointments, which was to last well over six months, was intended, primarily, to repair the damage caused by that stupid steel bar. They started by cutting my tooth away, until it looked just like a little stump, and when I went every week they insisted on putting what they called a temporary crown on it. During the next few weeks, various impressions were made of my teeth, and assessments carried out as to their exact colour. The great day arrived, and the off-white porcelain crown was fitted during a 3-hour stint. A final-year student, who'd spent many afternoons working to achieve a perfectly matched denture, obtained particularly good grades in his examination. I too was well satisfied with the result, as indeed were his professors who congratulated themselves on their excellent tutelage. As a hidden benefit, the hospital, without too much effort, had gained a willing guinea pig with a horrible set of teeth. It could rightly be claimed to be a mouth just ready for students to transform during the final and practical stages of their degrees. I was moved around several different departments at the

hospital, from the bog-standard practice rooms, through to X-ray, to extraction, and finally to the orthodontic department, which was by far the most interesting. I gained a tremendous insight into the life of a student at the hospital. I also had all of my teeth systematically worked on. After lots of different impressions, as they call them, some teeth were taken out: upper left four, lower left four, upper right four, lower right four. Others were left in, but the enthusiastic students and staff wanted to straighten out everything in sight. This they did by means of a brace. I soon discovered that the spring-loaded brace for my teeth was very different indeed from the braces which supported my trousers. In all, I had five different braces, which were fitted over a period of some three years. My perambulations continued. I was pushed around to other departments, so that I could be fitted with gold inlays, have various other extractions, innumerable fillings, and one or two other operations which I could never fathom. Somehow, it was always more pleasurable when a female student was drilling my teeth. In fact, I became quite relaxed when they bent over me and started prodding inside my mouth with their stainless steel instruments. As a young boy, I thoroughly enjoyed that part of the proceedings.

The other benefit, at least as I saw it at the time, was that visits to the Dental Hospital gave me a legitimate excuse to take official leave from school for one afternoon every week. After sitting in a dentist's chair for a few hours, I was then able to spend lots of time in the centre of Liverpool. The centre was very different from Speke, being crammed full of character and activity.

My association with the Dental Hospital came to an end when they moved from Pembroke Place. Although they only moved down the road, the new building seemed to be stark, bland and impersonal. I decided that I'd had enough attention to my teeth to last me for a few years to come. In all of those visits, I'd only sat through torture on two occasions, which, considering my long association with the hospital, wasn't a bad record. When they did catch the proverbial raw nerve however, the roof seemed only a short distance away!

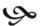

While St Christopher's was being built, a huge monolithic rectangular brick structure on the corner of Stapleton Avenue and Lovel Road, the priests from the presbytery, with a remarkable degree of foresight, had engaged in some of their own fundraising activities well before the church had been built. As far as we kids were concerned it was the Friday night film show, which was held in the make-shift church hall-cum-church, and nothing to do with fundraising. I believe that as another fundraising activity there was also a club for grown-ups where alcoholic drinks were served, but I never gained access through the hallowed portals.

Every Friday evening when we walked up the road to see whatever film was showing an enterprising chap from somewhere outside of Speke, parked his old Ford van and parked it on the driveway to the church. The back of the van was kitted out with shelves on both side walls and there was an array of cardboard trays

on the floor area. On the shelves and trays there was a rich assortment of sweets and associated confectionary, starting at the penny dips, which were nearest to the rear of the van, and hence gave easier access for little thieving hands. Towards the rear of the floor area were the more exotic sixpenny bars of Cadbury's chocolate and the yellow boxes of Rowntree's fruit gums and fruit pastilles, although very few of these were ever sold. I think that one of our gang, Michael James, might have bought a box at some time when he suddenly found himself in possession of the odd half crown or two.

It was after we'd made our purchases that we joined the queue to go into the film. The projector was generally operated by one of the worthies from the church, although sometimes that dubious pleasure was delegated to one of the more junior priests. Sometimes, and invariably at the most critical time of the film, the two-reel 8-mm projector failed, causing pandemonium in the auditorium; very often the disgruntled kids resorted to pushing over the rows of co-joined wooden chairs, adding to the mayhem. As soon as the lights went up so that the miscreants could be identified, we ran out and legged it back to the safer confines of Lovel Way to carry on with other games, our parents not expecting us back until sometime after nine o'clock.

As the Friday evening films were gaining in popularity with the local waifs and strays, the priests, sensing a loss of potential income, decided to build a lean-to on the side of the club, which not only sold sweets and chocolate, but also had an off-licence so grown-ups could go along to purchase their Friday bottles of Guinness, Mackeson and IPA. This, in turn, prompted the sweet-man to hawk his van around the immediate vicinity and, no doubt, considerably improved his takings. It was only a matter of months later that we observed that he was driving a much newer van, and now had his name proudly painted along both sides, thus proving the adage that 'when one door closes another opens'.

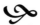

During the summer holidays that year, the Brabazon came flying over our house. Dad had told me that the biggest aircraft in the world was due to fly over Liverpool; he wasn't sure if it would be landing or not, but somebody at work had said that it would be coming over at sometime during the day. Fortunately, the weather was very sunny that day and we were all out in the garden. Gran and Granddad Payne had come over from Dingle, so Mum had brought their cup of tea out into the garden. All of a sudden, all eyes turned upwards as the deep droning sound of the powerful aero engines could be heard, heralding the arrival over Speke of this giant 150-ton airliner. It was unlike any sound that I'd ever heard before, and then, as if from nowhere, this huge aeroplane came roaring over the top of our house. By now all of the neighbours were out in their gardens, and a spontaneous and resounding cheer went up as the giant flying craft swooped low over our heads. It was as though this huge plane was going to clip its massive wings on the chimneys – but, it didn't!

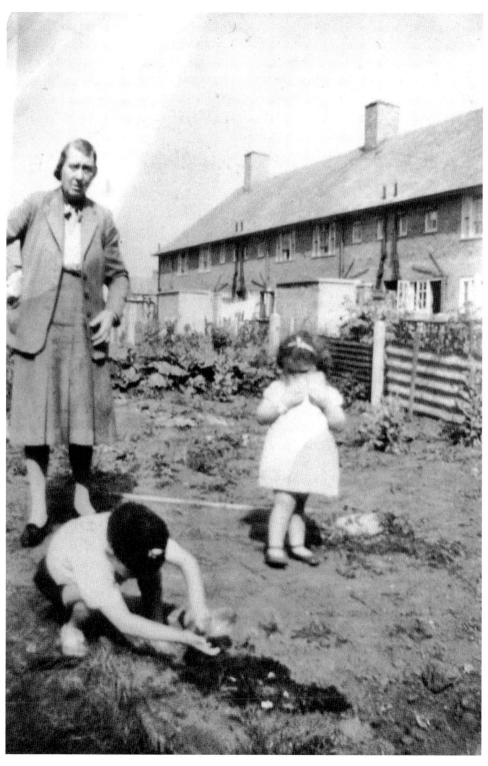

Gran Payne with David and Jean in the back garden.

Later that night, when all of the excitement had died down and Gran and Granddad had gone home, Dad told me a bit more about this incredible feat of engineering: not only was it the biggest passenger aircraft in the whole world, it was also the most expensive to build. The cost was over £6 million, a figure that I couldn't even begin to comprehend. Dad said that in post-war Britain, passengers would not spend twelve hours in a Brabazon flying across the Atlantic when they could reach their destination in a smaller, faster aircraft in seven hours.

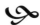

I started to attend my first Sunday school down Oglet Lane well before leaving the infants school in the early part of the '50s. The after effects and ravages of war were still very evident, both in the landscape around the outskirts of Speke, and also in some of the older buildings which still survived from the old village. Sunday school was held in the 'hut', as it was affectionately called. This was an old, now redundant, Nissen hut, holding at the most sixty to seventy people on a good day. The building was of wooden construction and, either due to lack of maintenance or poor initial design, was prone to dampness and leaks. Gus Edwards, an immigrant of Lithuanian extraction, was the Sunday school superintendent. Although the building was in such a poor state of repair, he, together with the other elders of the Baptist Church, seemed to be totally oblivious of this fact. Their main aim in life was to propagate the gospel of Christ to the people of Speke.

Gus, not that we ever called him that, had a team of seven Sunday school teachers, each of whom took charge of a class of anything up to ten children. My teacher during most of my time there was Miss Graham. She was the deputy superintendent, and was a frail stereotypic spinster of middle years, with a hooked nose and a slightly stooped stature – looking for all the world like an under-nourished house sparrow. Her Sunday-best outfit was a trim tweed twinset, which she wore throughout the Sunday school year, which started when the schools went back after summer and lasted until when they broke up again for the next summer holiday. She was somehow set apart from many of the other people who lived in Speke; most of the mums who sent children to Sunday school didn't wear smart twinsets. Nonetheless, she was kind and radiated goodness, and seemed to be acutely aware of the many differing needs of the youngsters in her charge. Every Sunday, without fail, Miss Graham made her rounds, calling at many homes and then leading her little flock along to the 'hut'.

Sunday school started at three o'clock with the singing of some well-known and well-loved choruses like; *If you want a pilot*; *Wide, wide as the ocean* or *Two little eyes to look to God*, but my all-time favourite was *Marching beneath the banner*. Maybe this was because Cliff Hall, who played the harmonium, really let rip during this rousing chorus. All of us used to sing at the tops of our voices:

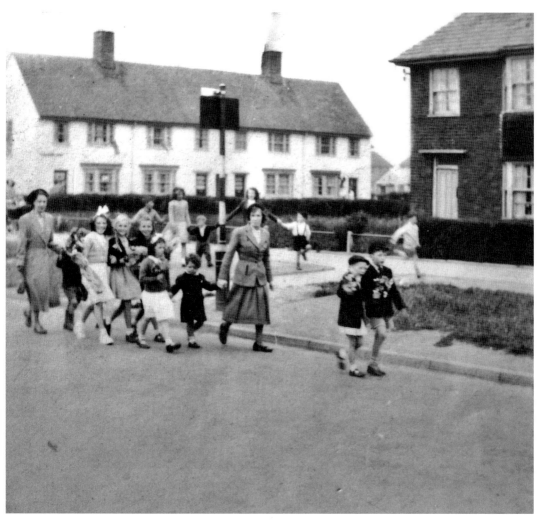

Miss Graham leading her Sunday school class in a Procession of Witness.

Marching beneath the banner
Fighting beneath the cross
Trusting in Him to save us
Ne'er shall we suffer loss
Singing the songs of homeland
Loudly the chorus rings
We'll march to the fight
In our armour bright
At the call of the King of Kings

After the choruses, which took about a quarter of an hour, we'd have some prayers which were led by the teachers, and then we'd split into our class groups. Here we

were told different stories and parables from the Bible. At the end of Sunday school, when we all came together again, we had closing prayers and one last *request* chorus, and then we were given a text card before going home. This was a small rectangle of cardboard, about the size of a cigarette card, with a coloured picture on it – usually flowers or birds, or sometimes a biblical scene – and a relevant verse from scripture underneath. Text cards were very collectable. Sunday school attendances were very high during those years.

The Sunday school anniversary came round with monotonous regularity. We practised new choruses for weeks beforehand. The service on that day took a completely different form. Parents were invited along, and looked proud when their children took part in the many tableaux. Along with the choruses and the tableaux, which formed the centrepiece of the afternoon's activities, some children also read short pieces from the Bible. Children chosen to read were invariably the teachers' favourites. Needless to say, I never read at any of the anniversary services.

Many years later the time came when we were due to leave Oglet Lane and move to a new hall. The word 'hut' was discreetly dropped from the teachers' vocabulary. On the anniversary immediately before leaving, the main tableau depicted the building of the new church. A model church was to be assembled in ten different stages, starting with the foundations and ending with a ceremonial placing on of the roof. When the whole lot was completed, it looked just like a giant dolls house. We practised for ages. Each pupil chosen to add a piece to the model made a short statement about the significance of that part in the construction. In the case of the foundations, analogies were easily made. Later on, when the walls were positioned in place and a cross was put inside, things became a little more difficult. I had been given the final spot. My task was to put the roof in place, and thus complete the building. On the day of the anniversary itself, I walked out to the front of the hall with the model roof tucked under my arm. It was only when I got to the front, with all those parents watching me, that nerves took the upper hand. I said my few words very quietly and very hurriedly, and then set about securing the roof. This action was effected with perhaps rather more gusto than was strictly necessary, whereupon the whole model collapsed. In the resulting mayhem, teachers and parents rushed forward to help try to salvage the wreckage, but all to no avail. With all the analogies that had been flying around during the afternoon, people no doubt began to wonder what this collapse said about the extension of Christ's Kingdom in Speke. Suffice it to say that very few people in Speke go to church.

Finally, the great day arrived for us to make the move to our new church. Miss Graham called early that day and, together with our parents, we made our way for the very last time, down to Oglet Lane where we were all lined up outside of the 'hut'; children and teachers were near the front, and behind us we had parents and other members from the congregation. In front of us, and right at the very front of the procession, we had the Warrington Silver Band. They had been engaged to lead our march of triumph. It took almost an hour to parade to our new hall, following

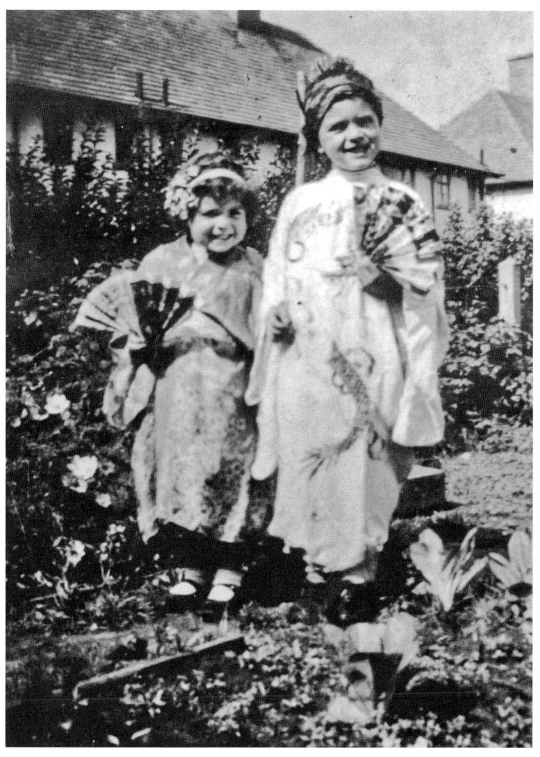

David and Jean dressed up for a street procession.

the band down Western Avenue, along Central Avenue, right past the newly built library, past the shops which were still in the course of construction, past the new police station, and eventually on to our new hall which was in the centre of a still-to-be-cleared building site. Clambering over the rubble and mud, we made our way into the new hall for a service of thanksgiving. Many important people attended the service. Elders of the Baptist church from as far afield as Manchester, St Helens and Preston made encouraging statements about the work that was beginning today, here in Speke. They proclaimed that this church would be at the heart of a new and vibrant community. There were so many people at the church that day, that some of the members of the band had to remain outside during the service. Afterwards there was tea, sandwiches and scones, which had all been prepared by members of the ladies committee.

Shortly after moving into the new church, the first service of baptism was held. Converts to the faith were ceremoniously immersed in the pool which had been built in the basement of the church. This ceremony was similar in form to the way in which early believers were baptised in the river of Jordan. Because today's converts were scantily clad during the service, young people were not allowed to bear witness here.

I continued to attend Sunday school here for quite some time, until I learnt about the Unitarian Church that had set up in opposition just down the road. They offered a much better Sunday school treat than the Baptists, so my allegiances changed. As it happens, I only went on one treat with them. This was because the reality of the event in no way matched my expectation. In fact, we were only taken 5 miles down the road to a farmer's field in Gateacre. All we did was play games during the afternoon, before eating sandwiches and crisps. After this we ran a few races, with the winners being rewarded with slim volumes of Bible stories. The Unitarian experience was short-lived!

After a suitable break, I started to attend the Church of England. This was a completely different proposition; they certainly gave the appearance of being far more organised than both the Baptists and the Unitarians, and they clearly had a lot more cash in their 'sweetener' funds. To start with, their annual Sunday school treat was free. This was very different from the others, who insisted on a cash payment for the trip. On my first Sunday school outing with the Church of England, they hired twelve double-decker buses from Liverpool 'corpy'. Six started from All Saints', and the other six buses left from St Aidan's. We linked up just outside Hale, and snaked our way in a green convoy towards the small Cheshire village of Helsby. It was unusual boarding a 'corpy' bus which didn't stop for over an hour, as everyone was used to buses stopping every two minutes on the way to school. Before reaching Widnes, some 5 miles down the road from Speke, teachers were already coming round and handing out with largesse packets of crisps, drinks of lemonade, and toffee bars. All of these treats were free. It really was too good

to be true! Everyone was excited, wondering what Helsby held in store for us. When we got there, we found a small fun fair right at the top of Helsby Hill. But the best treat was the tuck shop, where we discovered chocolates, sweets and other souvenirs on sale. There were two old women in charge of the shop who clearly were more at ease dealing with the gentile children from the village. The odds were stacked against them from the minute the buses drew to a halt. We descended like a veritable swarm of locusts, and the effect when we left was similar to the havoc which they wrought in Biblical times. The shop was completely denuded. Most of the items which were now missing from the previously well-stocked shelves hadn't been paid for. The trick, which was painfully easy to effect, was to ask for something which wasn't on the shelves. One of the ladies then went into the back of the shop to find that particular item, while the other one was kept busy serving. This gave free rein to the rest of us to lift whatever we wanted. There was no way they could cope with light-fingered streetwise kids from Speke. After a twenty-minute rampage, the Sunday school teachers were alerted to the wheeze. Even with their methods of interrogation, they had no chance of ascertaining just who had or hadn't paid, for the goodies in their possession.

Mums and Dads were eagerly waiting for us when we returned home later that evening. Gifts were bestowed upon them which had been brought back all the way from Cheshire. It was abundantly clear that Sunday school was having a beneficial effect on their children. Mum received her pound box of Cadbury's Milk Tray with immense, but unwarranted, parental pride.

Not long after that Sunday school trip, I took the plunge and joined the church choir. This was another move which was motivated by cash. Every three months each choirboy received five shillings, and, as I was already attending church on a regular basis, it struck me as being good sense to get paid for the effort. Admittedly, the three months did take a long time to pass, but the prospect of receiving five shillings in one dollop proved too much to resist. The normal pocket money in our house at that time was a penny a week for each year of our age. Five shillings was a very different proposition. But when I'd been in the choir for eighteen months, I realised that it was better to be a choir leader. The two choir leaders, who had slightly different roles from the rest of us, received ten shillings for their efforts, exactly double our remuneration. I decided that it made much more sense to be a leader rather than just another choirboy. A year later I started to receive my ten shilling note every quarter.

Even though he watched our development with interest, Dad tended not to talk about his own childhood very often. He had three sisters, all of whom were older than himself. The youngest, Rene, demonstrated a fiery temper and, as far as we were concerned, found children difficult to accommodate and tolerate. She had very sharp edges, and was a woman not to be crossed. Like many of our other relatives on Dad's side, she paid her dutiful visit once a week, primarily to see

Gran. She seemed to be very bitter about everything and, maybe because of this or for other reasons, there was a very real and easily defined tension between her and my mother. Mum was far more gentle and rounded in her approach to life, nevertheless, she knew in which direction she was going. Rene too knew what she wanted, it's just that the two women had very different methods of approach. Also, it's got to be said, Gran living in our house on a permanent basis caused some of the tension between them. I'm sure that Mum would have preferred for her to have been shared around the rest of the family. Living with a crotchety mother-in-law and trying to bring up a family of three children in a small 'corpy' house in Speke was far from most people's idea of Utopia.

Uncle Sam, Aunty Rene's husband, was very different from her. He was very gentle in character, slow to anger, and a man of very few words, but it was always worthwhile listening when he did speak. He spoke in deep, rich, sonorous tones, which were inviting, beguiling and intriguing. A gentle orator who, together with the rest of Dad's side of the family, was a deeply committed socialist. His fund of knowledge and profound beliefs had been inculcated from lessons at the Workers Educational Association. He was very widely read, and could articulate his views with eloquence and conviction. Mum's brothers hated him, as they were all 'true-blue' Tories. Sam was a post office worker, and took a leading role in the union at the central Post Office in Liverpool. His views were deep and well founded, and his manner of expression was very different from that of his wife.

When I was five Mum was taken ill, and I was sent to stay with Aunty Rene and Uncle Sam for a few days. It must have been in the middle of the holidays, as I can't remember having to get up early every day to make the journey to school. They lived not far from Childwall, in the pre-war equivalent of Speke. It was a small corporation housing estate in a well-established area, having been built between the two World Wars. Pushing on the white-painted wicket gate opened the way into a small cottage garden. There was no path as such, just trodden earth leading to four large steps in front of the door, around which were masses of sweet-smelling flowers. The garden too had an abundance of gaily coloured flowers, with foxglove, marigolds and cornflowers in profusion. Directly leading from the front door was the entrance to the main living room, and also access to the staircase. On entering the living room, the predominant smell was of mothballs mingled with beeswax polish which was frequently applied to all of the chairs. The room was quiet and tranquil, reflecting Uncle Sam's character somewhat more than Aunty Rene's. It also felt very different from the hustle and bustle which was the norm at our house in Speke. The only sound that could be heard was the well-regulated ticking of the clock on the mantelpiece. This too was indicative of Uncle Sam's measured approach to living. The room was generously proportioned, being almost 16 feet long and 12 feet wide – a big room for a 'corpy' house. It was gentle and uncluttered, and homely in its being. The only other room downstairs was the kitchen. This was a small room, and had wooden shelves spaced at 18 inch intervals covering the whole of one wall, and stacked with jars of home-made jam, chutney and bottles of preserved fruits. It was here at breakfast the following morning that I was introduced to the dubious delights

of sterilised milk on my Kellogg's corn flakes. I'd never heard of sterilised milk and, having had the process of sterilisation explained to me, couldn't understand why normal fresh milk wasn't being used. Everybody at Nook Rise seemed to love this milk, but I took an instant dislike to it.

My cousins in Nook Rise, Pauline and Brenda, were both older than me, and Pauline was soon beginning to pay regular visits to our house to see Gran, and also to introduce us to her fiancé, Don. He dressed very casually, and wore trendy brown suede shoes with thick crêpe soles. A smooth character, even down to the quiff in his hair, which Brylcreem helped to define. He was a good role model for the time, but Pauline on the other hand was so slim that Gran always said that she was like 'a drink of water'. She tended to wear ribbed knitted dresses, with a loose belt around the waist; they were very much in vogue. She didn't drink tea like most other people, but preferred milk instead, and always had to have some at supper. This didn't please me, as it meant that one of us went without at breakfast the next day, and it was usually me!

I was beginning to grow up when Pauline got married. The service, at Saint David's in Childwall, was not without its moments of drama and tension. Don was a Roman Catholic, as were all of his relatives, but all of our side of the family were Protestants, and Saint David's was well and truly in the tradition of the Church of England. It was embarrassing when only one side of the church joined in with the hymns and responses. After the service we went back to the Labour club in Childwall, which, being in quite a good area of Liverpool, was not a very well patronised establishment at the time. After the reception a three-piece band set up, but the tension didn't ease, with Don's family sitting on one side of the hall, and ours arrayed, stony-faced and resolute, on the other. Dad couldn't stand it, so we caught an early bus home.

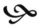

Dad's other two sisters were Rose and Gladys. In total, Gran had had thirteen children, including three sets of twins, but only four had survived to adulthood. Aunty Gladys lived in Bromborough, which was on the Wirral peninsular. Her husband, Uncle Sid, was employed at Lever Brothers. None of us got to know him very well, as he was a very quiet man who appeared to eschew any warmth or friendship from the family. On the other hand, Aunty Gladys was a bubbly kind of woman and full of life, but that vivacity had been stifled and suppressed during her many long years of marriage. But, although Uncle Sid wasn't our favourite uncle, he was certainly very generous. One year, when he and Aunty Gladys came to visit us in Hoylake, we were walking along the promenade when we spotted an ice cream man. Without any hesitation, he asked everybody what they wanted and came back five minutes later with four wafer ice creams, costing sixpence each, and three 99ers, costing nine pence each. We'd never had ice creams either as big or as costly as this before. When Mum or Dad bought us ice cream, we had a penny lolly or a two-penny cone.

We only went over to Bromborough twice a year, once during our summer holiday in Hoylake, and again sometime over the Christmas break. Things were very formal when we got to their home in New Chester Road. In fact, the best part of the afternoon was getting the 38 bus which took us back to Birkenhead bus station. Dropping down the hill to the ferry terminus we passed the distinctive green of the Crosville buses, which were parked at the top. Further down the hill, nearer to the ferry's ticket office, and just across the road from the railway station, there was line upon line of pale blue and cream Birkenhead buses. Dotted in between were the pale yellow buses from Wallasey.

Dad's other and favourite sister was Rose, whom I first met when I was six. We met her and Uncle Bob at Exchange station after they'd travelled down from Barrow-in-Furness. On our way to the station, Mum explained that Aunty Rose was Dad's eldest sister, and that he didn't see her very often. Just when we were all beginning to think that the train might have been cancelled, it was announced on the crackling loud speaker system that it would be arriving on platform three. We made our way over, and got there as the huge grime-covered steamer was easing to a halt a few feet from the buffers. Seconds later, doors were flung open along the length of the train, and an amazing assortment of people started to leap out and rush towards the ticket collector's barrier. First off came some soberly dressed men, obviously bound for the Cotton Exchange, as Dad pointed out. Next, we saw a few school children, all very well dressed in striped brown blazers and cream-coloured straw hats, and all carrying dark, real leather, satchels. Mum didn't know which school they were attending, but we did know that it wasn't ours! Last to get off were the shoppers and pensioners, most of whom were taking life at a much easier pace than the people in the earlier groups. The chances were that Aunty Rose and Uncle Bob were somewhere in this throng. Jean and I strained our eyes looking for them, but I don't know why, as we'd never seen them before. Then, at some unseen signal, Mum and Dad frantically started waving. Their waves were acknowledged by an older couple some way down the platform, who were both carrying large suitcases. The person whom I took to be Aunty Rose was a diminutive figure, but looked quite formidable in her full-length grey overcoat with an Astrakhan collar. She also wore a black bowler-type hat which was held in with hatpins on either side of her head. Uncle Bob was a little taller, and had a clipped military-style moustache. He carried himself very erect as he came striding determinedly down the platform in his grey flannels and black Barathea jacket. He sported some sort of military badge which was sewn onto the breast pocket. Introductions were made and greetings exchanged, and then I was delegated to carry Aunty Rose's massive case.

As we made our way out onto Exchange Street, Uncle Bob suggested that it might easier if we caught the bus from the Pier Head. How did he know that this was the bus terminus? This was our city, he came from Barrow-in-Furness! It took me many years to realise that he'd done much of his courting in Liverpool before getting married and moving to his job at Barrow shipyard.

Over the years, Aunty Rose and Uncle Bob made many visits to our home in Speke, ostensibly to see Gran, but I think that they really preferred coming to see

Mum and Dad. Whenever they came down there was the obligatory pilgrimage to the big shops in town, no trip to Liverpool being complete without first visiting Owen Owen's, T. J. Hughes, and Lewis's, where Jimmy Lewis's statue stood outside of the shop, proudly proclaiming his manhood for all to see. On the way home, they were loaded down with pairs of new shoes, raincoats, something for each of my cousins in Barrow, and more often than not, another new overcoat for Aunt Rose. It was always the same; Gran's old case was pressed into service so that they could pack everything in. Somehow, I always got the impression that there weren't any shops in Barrow!

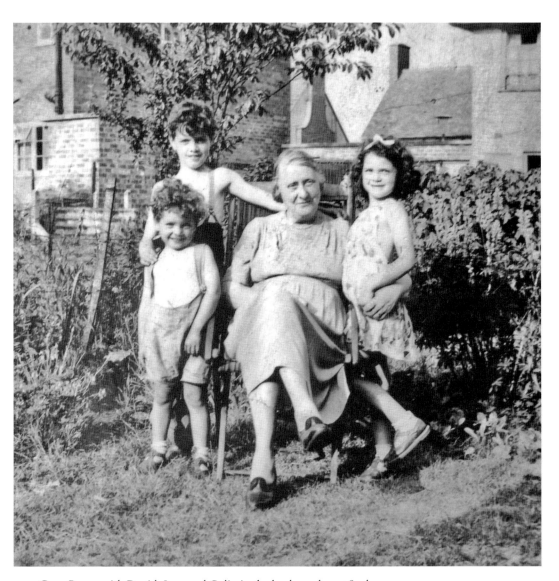

Gran Payne with David, Jean and Colin in the back garden at Speke.

Just as Dad had three elder sisters, Mum had three elder brothers, George, Joe and Albert. George, the eldest, lived in Dingle, right at the edge of the Mersey, in an area colloquially known as Shorefields. Most of the houses here didn't have bathrooms, so every Thursday Uncle George got the bus to Blythswood Street straight from work. Before having his evening meal, he'd chat with Granddad and read the *Liverpool Echo*. After that, it was upstairs for a hot bath. He revelled in this weekly ritual, and came down twenty minutes later looking like a very red lobster, his colour being more exaggerated when set against the starched white collar of his uniform shirt. Uncle George worked in the Merchant Navy Establishment at Mann Island. This was one of the busiest offices in Liverpool. Their responsibility was crewing the hundreds of ships which passed through the port every month, a very exacting business. He seemed to enjoy his work, which was just as well, as his home life wasn't too bright. Aunty Evelyn, whom I only met on a few occasions, normally at Christmas, was bed-ridden, and George's hours at home were spent in caring for her. He did, however, manage to escape to his 'local' every evening just before ten o'clock. This was a Higson's house, and as the brewery was only a mile or so away, it reputedly had one of the best pints of bitter in Liverpool. Uncle George spent a lot of cash and many hours in checking the validity of this claim.

Mum's other brother who lived in Liverpool was Uncle Joe. He'd been great friends with Dad when they were youngsters. They went through school together at Wellington Road, were in the Sea Scouts together, and also went to the Florence Institute together. Uncle Joe was a seafarer, so we didn't see very much of him. When we did see him, he told us about his great friend, *Johnny Barleycorn*, and added that we must never make his acquaintance! Until his life's end, *Johnny Barleycorn* remained Joe's staunch ally and greatest enemy.

Mum's third brother, Albert, lived in London. We only saw him when there was a family wedding or funeral. It was probably just as well, as Dad didn't think much of him.

But, as well as family, Mum had many friends, most of whom she'd known since school days at St Edmunds, although some were friends she'd made during her time in the Girls Friendly Society, or at the Liverpool City Mission, or at the Gas Company where she'd worked during the war. One of her closest friends was Aunty Margaret, whom Mum had known from schooldays. Aunty Margaret lived in Dombey Street, not far from the city centre, and every Friday evening straight after work, she came to visit us. Of all the friends and relatives in our wider family, Aunty Margaret was the only woman that we knew who actually went out to work for a living. Mum said that she was a spinster, which no doubt justified the activity.

After the three of us had eaten our evening meal, the table was sided and reset again before Aunty Margaret arrived on the ten past six bus. She and Mum always had lots to talk about, but Dad seemed ill at ease in her company, and confined himself to generalities or the odd interjection when Gran tried to muscle-in on the conversation. The four of them had their meal together, which was normally a little different from the fish fingers and chips which was our dinner on Friday's.

After their meal, Mum and Aunty Margaret discussed issues of common interest, while Dad and Gran caught up with local news. At the end of the evening, Mum and Dad walked to the bus stop with Aunty Margaret.

As children, we thought that she had a magic about her. I'm not sure whether Mum was too pleased about this, as she obviously sensed the awe in which we held Aunty Margaret. What we couldn't understand was why such a lovely woman wasn't married. Every adult that we knew was either married or was about to become married. Because Aunty Margaret had no children of her own, she lavished

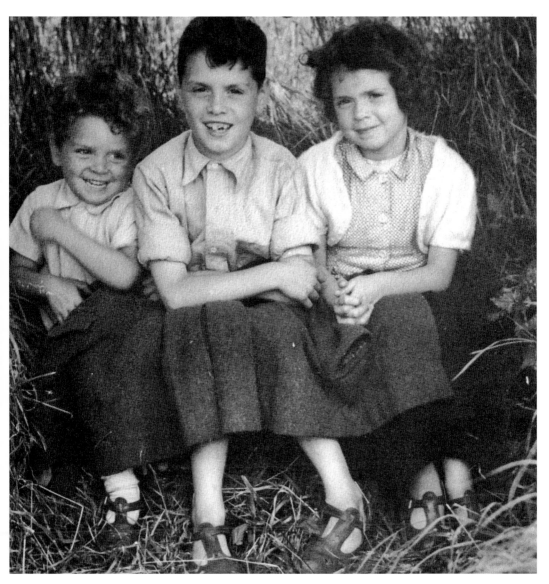

David, Jean and Colin in their 'den'.

affection and presents on the three of us. Every Friday evening after her meal she gave us some fresh fruit, usually oranges or apples, but sometimes the fruit was quite different and exotic. One Friday we were stumped, having struggled for ages to peel the skin from a very tough orange. When we managed this, we found that the contents were quite different from a normal orange, with lots and lots of juicy pink pips. We felt cheated, until we were told that the fruit was called a pomegranate, and the pink pips were edible.

Friday night also meant that the 'Good Fairy' would be visiting. When we came down to the living room on Saturday morning, we found on the sideboard, just in front of the seven-day clock, three little presents. Usually, these were Bounty bars, Toblerone chocolate or tubes of Smarties. Jean always had the present on the left, Colin's was in the centre, and my present was on the right. Aunty Margaret was our Friday 'Good Fairy'. On the rare occasions when Mum had money left over from her housekeeping, the 'Good Fairy' would come again during the week. This time she only left Penny Arrow bars. It wasn't difficult to detect which 'Good Fairy' had visited that night!

3

Coronation Year

We'd only just gone back to school after the Christmas holidays when news broke that the *Empress of Canada* had caught fire in Gladstone dock. In fact I'd read in the *Liverpool Echo* that the boat had actually caught fire shortly after it had finished a complete refit. On 25 January the boat had been moved from the dry dock, ready to bring people to England for the queen's coronation later in the year. The boat had been taken to Gladstone dock and the final touches were being made before she sailed from Liverpool, but late in the afternoon a fire was discovered and, as the fire took hold, more and more emergency pumps were called to the scene. Shortly before six o'clock in the evening, there were over thirty pumps attending the blaze, which by now had completely taken hold of the ship. According to the *Echo*, it was round about this time that the boat started to list to port. By quarter to eight the list had increased to ten and a half degrees and there were by now forty pumps in attendance, spraying some 1,400 tons of water an hour into the fire. Attempts were made to stabilise the ship, but all to no avail. After high level talks between the owners, the Mersey Docks and Harbour Board, and various experts on ships and shipping, the decision was taken to cease fighting the fire in the hope that the boat might revert to an upright and stable position. This decision did not please the local fire brigade, as they considered that the fire was now being brought under control. As the fire swept through the boat unchecked, the list steadily increased until, early the next morning, the boat keeled over into the basin, leaving her starboard side uppermost.

A few weeks later, Granddad offered to take me along to see the helpless beached whale as he called it. We walked from Blythswood Street the few hundred yards to Dingle station, just past the tram sheds. This was the southern terminal of the Overhead Railway, the 'dockers' umbrella'. From here the line then ran right along the dockside until it reached the Pier Head at the heart of the city. It then carried on through the northern dock complex to Seaforth, the other end of the line. Granddad bought our tickets from the solid wooden edifice of the dust-ridden ticket office, before we ventured down the musty tunnel which led to the trains. The smell inside of the tunnel was pungent, and evoked thoughts of journeys of exploration into the unknown. The tunnel was only dimly lit, but by contrast, the platform itself was

bathed in bright electric lighting. The overhead railway system was one of the first transport networks in the country to have electricity throughout its operational length, a feature of which the city council was, with some justification, very proud. When the dark brown carriages came trundling into the station, we had our choice of any of the wooden-slatted seats in our third class compartment. Apart from journeys in rush hours, when the trains were jam-packed full of dockers, most of the time the trains ran half-empty. As we got ourselves seated, the electric doors closed, and we went clattering down the line towards the Pier Head. It was only seven stops away, and one of the busiest of the Overhead's seventeen stations. We then continued along to the northern docks, where the *Empress* was. As the train slowed down before the station, we could see a sad and terrible vision in front of us. Seeing one of the mighty ocean liners lying on her side in the dock like this, she really did look just like a huge, helpless, beached whale. There was actually some work being carried out by the Mersey Dock's and Harbour Board Salvage Team, at least, that's what Granddad told me, but the boat was still, very definitely, lying on her side, and it took many more months to right her. Hopes of her going back into regular service were not to be.

On our return journey we got off at the Pier Head. We crossed over the tramlines and made our way to Liverpool's world-famous floating landing stage. There was a mild breeze blowing, which caused the stage to pivot gently on its bearings. We walked down the tunnel which led from Mann Island onto the stage, which was painted in the green and cream livery of Liverpool Corporation. It had a cast-iron

Overhead railway near to the Pier Head.

framework that, after many years of weathering, was filled with rust and housed a resident population of barnacles on its underside. The floor of the stage was constructed from 6 inch wide oak timbers, sealed with tar, no doubt reminiscent of the decks of the sailing ships that had graced Liverpool's seafront in earlier days. I saw Granddad looking down and then wistfully staring out over the river. He went on to tell me about the first time that he'd sailed back into Liverpool, and that was on a power-assisted sailing ship after a three-year-long trip to sea.

As we stood looking across to Birkenhead, all we could see was a mixed fleet of many different kinds of ships and the ferry weaving its way between them, back and forth across the Mersey. Some of the ships were large ocean-going passenger or cargo vessels, and others were trawlers or other types of coastal craft. We saw ships from many famous shipping lines, including Blue Funnel, Cunard, White Star Line, T & J Harrison and Bibby Line. Sadly, most of them no longer sail from the port.

The remainder of the spring term passed without incident, and soon we were looking forward to Easter. Easter meant school holidays, extra services at church and a boxed Easter egg from Clooks. Clooks was a very special cake shop along Allerton Road in Woolton. Normally, they didn't sell chocolate confectionary of any sort, but at Easter, their chocolate eggs were the best around. Clooks was certainly the kind of shop that Mum couldn't afford to patronise, but we never had 'bought cakes' anyway. Apart from at Christmas, the only cakes that we had, generally, were Mum's cup cakes which she called fairy cakes. Sometimes we had scones which she made on the flat hot plate on the top of the cooker. But once a year she joined the Easter Club at Clooks, so that when the day came, Jean, Colin and myself would all receive one of the celebrated and very special boxes which contained the eggs. The boxes were about 5 inches by 8, and, say, about 6 inches deep. They were always patterned with Easter bunnies and daffodils, but although there was a mild 'cardboardy' smell, this was soon overwhelmed by the aroma of delicate milk chocolate; it was what was inside that was of more interest to us children. Sat squarely on top of the cardboard insert was a large, light brown Easter egg with a crazy paving-type pattern all over. And nestling on the top of the egg was a light marzipan oval shield which served as a nameplate. Inscribed on top of the marzipan in fine chocolate piping was the name of the intended recipient. So, on Easter morning, as soon as we were allowed, we raced down to the living room, where, on top of the sideboard, we found the three boxes. In the middle, as always, was Colin's box. On the left-hand side was a box marked for Jean, and on the right-hand side was my Easter egg. We weren't allowed to consume all of it on Easter Day, and in fact, Jean could make her egg last anything up to a week; she was always very disciplined. Normally we received perhaps two or three Easter eggs: one from Gran and Granddad Payne, and sometimes we had another egg, or at least a bar of Cadbury's chocolate, courtesy of Aunty Margaret. Generally

speaking, there was traditionally another gift that we all received at Easter, and this was a new pair of leather sandals for the summer. Mum always tried to get Clarks' sandals, but sometimes we received a cheaper imitation with slightly thinner white crêpe soles, and the brass finish on the buckles soon wore off, unlike the real brass buckles on Clarks'.

When we went back to school after Easter, everyone was talking about the Coronation which was to take place later in the year. As the time grew nearer to the Coronation, and the frieze around the classroom wall was changed from showing scenes of Liverpool to showing scenes along the Coronation route, it dawned on us that this event was probably a little more important than our imminent move from the infants to the juniors. The Coronation service itself was to be held on 2 June, and we were to be given the day off. Towards the end of March the schools patron and main benefactor, Miss Tod, arrived to present us with earthenware mugs. Now we knew that it must be important! Miss Wallace, our teacher, had one of the mugs on display on her desk at the front of the class. On the side of the white mug was a transfer of somebody's head. We were told that this person was to be our new queen, and live in London, which was a long way away. Miss Tod was very old.

As soon as we'd been presented with our mugs we were told that we could finish early for the day. We all raced down the schoolyard to the gates to show our mums the presents. Hughie Green, one of the other pupils from Speke, took an early lead. His mum was standing chatting, when, quite accidentally, I bumped into him and tripped him over. Unfortunately, his mug fell to the ground first, so it was not only his pride that was shattered. As the allocation only allowed for one mug for each pupil, he couldn't have it replaced.

But it wasn't just at school that things were happening. Our little community in Lovel Way decided to hold a street party. So, every week during the early part of 1953, Mum doled out six pence to Rose Bowden. She was the daughter of a neighbour who lived just round the corner. The grown-ups had delegated to her the role of collecting the money for the Coronation party. This was to be held after the street procession, which, in turn, was going to take place directly after the Coronation itself. Every Friday, whatever the weather was like, Rose made her trip around the block, collecting money from just about every house, and managing to keep one or two doors ahead of the man from the 'Pru', who was charged with the same mission. The grown-ups seemed to have lots of meetings to discuss exactly what would be happening when the great day arrived. By any stretch of the imagination, Dad could not be described as being gregarious in his demeanour, but he certainly seemed to enjoy attending these meetings.

A few weeks before the Coronation, Mum and Dad invested in a television set. All of the programmes were in black and white, with several shades of grey in between. During most days, all that could be seen was the test card, as transmission

didn't normally start until Children's Hour, which was from five until six. There was then a short break before transmissions recommenced later in the evening, so that grown-ups could watch. The television station normally closed down for the night shortly after ten o'clock. We weren't the first family in the block to get a television set, the Wilson's, just round the corner, had rented one a few months earlier from Radio Rentals. We'd bought ours, as Dad was very much set against rental agreements. He was always very dubious when it came to borrowing money for any reason, especially when it was from somebody outside of the family. The very fact that a family owned a television set automatically conferred some standing in the community. The status level was ranked in direct proportion to the size of the screen. Our television had a 12 inch tube, which was just about the smallest that could be bought. Dad took some remedial action, and went out and invested in a magnifying lens. This was placed directly over the screen, and held in position by securing straps which were bolted on at the back the set. The lens made all of the pictures look a little distorted, but at least they were also a little bigger.

News quickly spread that the Paul's had invested in a television set, and many of our neighbours soon became very close friends. In fact, on the day of the Coronation itself, our living room was packed to overflowing. This was so that as many of our neighbours as possible could watch the six hours' live coverage of the event. Apart from the settee and two armchairs, we only had four other upright chairs, so, the day before the Coronation, the neighbours who had been invited in brought their own chairs in order to enjoy the spectacle in comfort. Everything that wasn't a seat was cleared out of the living room, even the sideboard, which was very heavy and difficult to manoeuvre. That was left in the hall, and the table was put into the parlour. Only the television set, which was sat on top of its table in the corner of the room was left. Even the bookshelves, which lived either side of the chimney breast, had been moved out for the day. We were allowed a glimpse into the transformed room before we were packed off to bed. There were two rows of small chairs at the front, immediately in front of the telly. This is where most of the children would be sitting. There were then rows of other chairs just behind. These were for the grown-ups. Finally, there was one armchair which had been allowed to stay in as a concession to Gran. Even Mrs Larch had to make do with an upright chair on that particular day. Next morning people started to arrive very early, and soon the room was packed to overflowing. Apart from any Health and Safety considerations, anybody wanting to go to the loo, especially anyone at the front, was going to have a very difficult and tortuous journey. We then sat for the next six hours in complete darkness. Reception in those early pioneering days was always better in a darkened room. As the occasion was to be the biggest outside broadcast in the BBCs history, and relayed to many different countries in the British Empire, they were breaking lots of new ground in television technology. The reception wasn't particularly good during the transmission, and became even more hazy as the weather conditions deteriorated into torrential rain. A huge cheer went up as the open coach carrying the queen of Tonga passed by, with its

effervescent occupant apparently not noticing the rain. In the room, apart from the luminous glow coming from the television set, and the glowing extremities of the cigarettes which some of the adults were smoking, it was totally dark and, for the most part, totally quiet. After six hours of being glued to the television set, the room had become smoke-filled, hot, and had that smell of stale body odour, which tends to collect when people congregate in such close proximity. Even the Lifebuoy soap had been stretched to its limits on that day.

Emerging into the daylight and fresh air, it was time for our local events to begin, starting with the Coronation procession around the block. As Jean had had measles and had been confined to bed for the last week, Mum had other ideas for us. She was convinced that both Colin and I were also due to contract it, so we were packed off to bed. The only concession that we were given was that we could all go into Mum and Dad's bedroom and watch the street procession from out of their window. When we got to their room, there were three bottles of lemonade. There was a bottle of Full Swing cream soda. This was very much the 'in' drink at the time, being bright green in colour. Next there was a bottle of Dandelion and Burdock, which most of us kids thought was a good drink to have as it looked like beer. The third bottle of pop was Tizer, an all-time favourite.

All of the children in the procession were dressed up for the occasion, and many of the grown-ups were also sporting patriotic outfits. The street's Coronation committee had done a really good job, there was even bunting stretching across the road – this went right around the entire block. As the procession passed by our open window, everybody looked up and waved to us. It was almost like taking our own Coronation salute! Afterwards, when it came to the street party, different neighbours brought up plates of sandwiches, cakes, jellies, ice cream and more pop. One enterprising company had developed blue jelly, so multi-coloured jellies of red, white and blue were the centrepieces at just about every street party up and down the land. Walls, the ice-cream makers, had also introduced another new three-coloured block which they'd been selling from their vans for the past few weeks. We had loads of this!

The day ended, for the children at least, with a huge firework display in Robinson's back garden. We weren't allowed to go to this, but instead ended our day in the usual way by singing our prayers in bed. Mum said that we had extra prayers to sing as from now, as we had to thank God for the Coronation of our queen.

After the excitement of the Coronation had died down, there were still lots of community activities taking place around the block. Also, Rose continued to call at our house. She'd become a firm favourite, especially while we were all ill. On most weekends, she would take Colin down to Oglet Lane in his pushchair. Sometimes she'd walk on as far as the shore, with Jean and me trailing somewhere behind. Although we were only out for an hour, at least it gave Mum some time to herself, if only to catch up on the jobs which she couldn't do while we were running around the house under her feet.

Every Thursday, regular as clockwork, Mum caught the bus to Aigburth. She got off at Errol Street, the stop after the Mayfair, and cut through to Bryanston Road. It was then only a short walk to Gran's house in Blythswood Street. After she'd taken off her coat and said hello to Gran and Granddad she drifted, automatically, into her ritualistic routine. First, there was a cup of hot, very weak tea. While the tea was being made Mum had a chat with Gran in the kitchen. When she was drinking the tea, she sat in the living room and talked to Granddad, while he drew heavily on his Kensitas-tipped cigarette. Next, it was into the parlour to play Chopin on the piano for ten minutes. Finally, it was back on with the coat before setting off to make the long trek to Tunnel Road. Aigburth is miles away from Tunnel Road! Every year, on my Blythswood Street summer holiday, I was dragged along to help carry the bags. Gran and Granddad were great walkers. Living in rented accommodation on a state pension didn't really leave them with too many options. So, come hail, rain or shine, we'd set off in the early afternoon and walk the length of Blythswood Street onto Aigburth Road. The first milestone, so to speak, was the tram sheds at the top of Aigburth Road. The sheds were very busy, competing with both the overhead railway and the normal bus service, but ultimately, the buses won-out over the 'green goddess' trams. After the tram sheds we walked on up Belvidere Road and into Devonshire Road, and then along to Saint Edmund's College. It was here that Mum had been a scholarship pupil in her younger days. By now we'd been walking for upwards of an hour, but we still had to cut through Bentley Road onto Lodge Lane, and Tunnel Road was still quite a long way off. Sometimes, by way of variation, we'd walk into Sefton Park and then along the bridleway through to Princes Park, but we didn't often take this route as the other way was well tried and tested. It certainly wasn't the shortest way to Tunnel Road, but as pensioners, Gran and Granddad had all the time in the world! During the walk they chatted to Mum about what was happening in Speke, and she caught up with all of their news about the family and other events in their neck of the woods. Ultimately, the conversation turned to the way Liverpool used to be when Mum was a girl. Gran and Granddad loved living in the city, and blamed the Labour council for everything that was going wrong. After all, it was the Labour council that had designs on pulling down the Overhead Railway, one of the main arteries of the city. There were now fewer ships in the river than there used to be, and everything about the city was beginning to look worn and shabby. Yes, according to Granddad, the Labour council was slowly, but surely, bringing the city to its knees.

While we walked down Lodge Lane, buses passed us every ten minutes on their circular route. It never entered into Gran's head to jump on one, and I didn't dare to suggest it. As we went past the Pavilion, Granddad somehow managed to avert his gaze from the explicit posters which were advertising that week's strip show. As a sidesman at Saint Michael's church, he couldn't be seen to be enjoying these lewd

posters. Maybe, as we were passing, he might just have caught a glimpse out of the corner of his eye! We crossed the busy Smithdown Road at the traffic lights. Lodge Lane ends here, and Tunnel Road begins. This was where Jack had his butcher's shop. Originally, he'd been the leading hand at a butcher's down Aigburth Road, but had now branched out on his own account. He took Gran and Granddad's trade with him, and also gained a new customer in Mum. Granddad insisted that nobody could beat Jack's lamb, and Mum was obviously convinced as to the truth of this statement, as she never bought anything else other than lamb! Pleasantries exchanged and purchases made, the leg of lamb was securely placed into the string bag, and carried with us on to Wavertree Road. This was the home of Morris', the best and cheapest greengrocers in town. There wasn't really much dispute or argument about this statement, as everybody for miles around seemed to shop there. By the time we arrived in mid-afternoon, there were queues outside of the shop, and customers coming out laden with fresh cauliflower, cabbage, carrots, apples, oranges, lettuces, end-of-season potatoes, and all manner of other fruits and vegetables. After queuing for what seemed like hours, we too came out with our bags laden, and were now ready to start the long march back to Blythswood Street. By now the day was beginning to get a little cooler, and the bags were a lot heavier than they were when we'd started out. Needless to say, I was always delegated to carry them home. Mum's little joke was that, if she carried the bags to the shops, then I could carry them home. It took me a long time to work out the logic and cunning of this particular ploy. So be it! In making her weekly pilgrimage to Wavertree Road, she saved a few bob on the housekeeping bills, and, when all was said and done, it was this good domestic management that enabled Mum and Dad to pay for such enjoyable holidays year after year.

It was our holidays that we looked forward to with eager anticipation. It's got to be said that maybe Mum and Dad cherished this time on their own even more than Jean, Colin and me. As children we were, to a large extent, shielded from the reality and rigours of living in a small terraced house with an ageing grandparent. But, even at that age, we could sense that this situation caused tensions in the home. Fortunately, Gran wouldn't be with us for the next two weeks.

We knew that the holiday preparation sequence had started when Dad got home from work and pulled the bathroom chair onto the landing; it was then that he precariously eased himself up into the loft. Meanwhile Mum waited patiently below while he fumbled around in the darkness, looking for the dusty old suitcases. These were only brought down once a year. On the Friday of that week, which was normally the last one in July, Dad could forget for a while the trials and traumas of Dunlop's. His US Army surplus bike was put away for a few weeks, after a good cleaning and greasing.

The scene was then set for us to head off to Hoylake. This quiet little town, which doubled as a seaside resort for many working-class families from Liverpool,

is over the Mersey on the Wirral peninsula. It only takes about thirty minutes driving on the mid-Cheshire motorway now, but in those days, the journey from Speke took a goodly part of a day.

So, on that particular Friday, it was early to bed and Aunty Margaret didn't pay her usual visit. Next morning we were all up bright and early, and by the time that we'd arrived downstairs, Dad had all the cases labelled and neatly arranged in the hall. Meanwhile, Mum had prepared a cooked breakfast for the five of us – just something else which was a long way from the norm. During our holidays, Gran was packed off for an enforced holiday, either at Aunty Rene's or at Aunty Gladys' over the water. After breakfast we were each given either a rucksack or a case, all of them bulging with assorted items of holiday clothing – some of which had been bought new from the Freeman's catalogue. But it was Dad's case that was always the heaviest, being filled with some of the other trappings which characterised our holidays in Hoylake. Essentials such as a large tin of pale pink John West salmon, two packets of Crawford's cream crackers, a full bottle of HP sauce, and a couple of blocks of Anchor butter. During holidays we moved away from our normal Summer County margarine, and were introduced to the taste of real New Zealand butter.

Loaded up, we set off on the short walk to the bus stop in Western Avenue. Boarding the bus was an event in itself. Before we could take our seats, we had to load the cases under the stairs, in the space that was reserved for parcels too large to go inside the bus. The area was soon full, much to the chagrin of the bus conductor. We sat downstairs to keep an eye on our precious cargo, so Dad couldn't smoke his pipe for that part of the journey. The 82 took us through the south of Liverpool, and then all the way to the Pier Head, some 10 miles away. We got off at James Street, the stop immediately before the terminus. With so much luggage, it was difficult crossing the road to get to the underground railway station. Also, after buying our train tickets, it was a bit of a crush getting into the lift with so many other passengers. The lift took us down into the bowels of the earth, and onto the crowded, smoky, fetid platform. Even the advertisements pasted up on the arch-shaped tunnel walls looked grimy. Then, every year without fail, we were told that we mustn't stand too close to the edge. Just to reinforce the point, we were told the story of the man who had fallen in front of the train, seconds before it arrived at the station. On falling onto the lines he'd been electrocuted, and then run over by the train, just to finish off the job! Grizzly stuff for us kids, but enough to deter us from straying too near to the lines. A distant, deep, resonating drone heralded the imminent arrival of the train for West Kirby. The trains were amazing in themselves, and very different from the ones that we were more familiar with – the trains that took us to Barrow. These trains looked like massive cigar tubes, with hundreds of wheels, and windows which were cut in the sides. All of the doors were electric, and all of them, two to each coach, closed together automatically before the train was due to leave. Quite a novel feature at the time. The seats too were far more comfortable than second class on other British Railways trains. The carriage lights stayed on for the first fifteen minutes of the journey as we travelled

under the Mersey. There was total darkness outside. It was difficult to understand just how we travelled across the Mersey without the coaches letting in any water whatsoever. However, they never did leak, and we managed to get across every year. Soon we were travelling overland once again. The train had maybe four or five station stops before reaching Meols. The only significance which Meols had, apart from it being quite a posh area having a particularly good swing park, was that it was the station immediately before Manor Road. When the doors closed and the train was ready to leave Meols, we were handed our respective cases and rucksacks. By getting prepared, we'd be first off the train, and ready for the short walk around the corner to Mrs Shipman's. She lived at 41 Newton Road, and

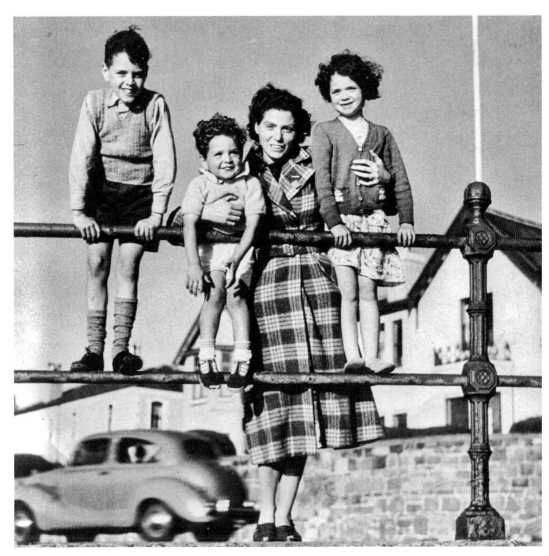

Mum with David, Jean and Colin in Hoylake.

together with her husband Jim, owned the boarding house which was to be our home for the next two weeks.

We were greeted and welcomed by Mrs Shipman as though we were some close relatives returning from exile in Australia or some other equally distant dominion. Mrs Shipman was a warm, friendly, working-class Irish woman, who sported a delicately etched Pedro moustache over her upper lip, had a dark mole with hairs growing out of it on her left cheek, and always wore large drooping imitation pearl earrings. Having no children of her own, she seemed particularly pleased to see the three of us, and treated us as though we were her favourite niece and nephews. She did, however, find some difficulty in trying to understand our strong scouse accents. We had a similar problem in that Mrs Shipman was very quietly spoken, and it was often difficult for us to understand her broad, lilting Southern Irish brogue. During the day she spent long periods out of the house. This didn't please her other half too much. Her time was taken in either shopping around for our everyday groceries, or attending Mass at her local church. She was a devout Roman Catholic.

On the rare occasions when she was at home, Mrs Shipman spent most of her time in the kitchen, which was in marked contrast to her enigmatic husband, who confined himself to the back room during the entirety of our stay, save for the hallowed hours that he spent at his allotment. The back room, his living room, was cramped but cosy, and had the atmosphere of a war museum. Hanging from the ceiling there was a clothes maiden just in front of the cast-iron fire grate. When Mum washed our holiday clothes during the week, they were all dried over here, and judging from Mr Shipman's gruesome physiognomy on these occasions, he didn't appear to enjoy viewing countless pairs of dripping wet undies and knickers, but there just wasn't enough room on the backyard clothesline.

Hanging on the chimney breast wall was a finely tooled model of an old sailing clipper. The high mantelpiece didn't escape either. On display here was another schooner, but this time mounted inside a discarded Johnny Walker whisky bottle. During his war service in the Navy, Mr Shipman had been taught this skill, and it had been a consuming hobby ever since. Model making and his beloved allotment were all he seemed to live for. He was very quiet, not to say dour, and always stayed in the background. When he wasn't sitting by the fireplace, making pieces for his models, he was out across the railway line, tending to his allotment. And, as there was far more veg coming from the allotment than Mrs Shipman could cope with, we also benefited from the harvest. We were able to eat as much as we wanted, and also sample vegetables which we'd never seen or heard of before. Leeks were one of Dad's favourites, while Jean went for shallots, but I think that it was the name that fascinated her as much as the vegetable itself. We were never privileged to see the allotment, but as long as the veg kept arriving, it didn't bother us too much.

The days in Hoylake were always packed full of fun. Most mornings were spent walking down Market Street, and then along to the swing park. As the swings, roundabout and the witch's hat were invariably empty, we were allowed to spend as long as we wanted just enjoying ourselves. Dad filled his pipe with St Bruno,

while Mum read one of the serials in her *Woman's Weekly*. After the swings, we made our way down the tree-lined roads to the promenade and the shore-side shop, where we bought paper flags to adorn and crown our sandcastles, which were built in the afternoon if the tide was out. The promenade ran right along the front at Hoylake, had a little gap to take in the Royal Liverpool Golf Club, and then started again and went all the way to West Kirby. The prom' had lots of hidden treasures to yield and reveal to inquisitive children. At the start there were tennis courts and a bowling green. Further along there was a special toyshop, swimming baths, and a busy lifeboat station, and ice cream stalls were dotted at frequent but discrete intervals. Most important of all, right next to the swimming baths, was the boating lake. On this concrete-lined pool we imagined ourselves to be North American Indians or warriors from Africa, and even dressed the part on occasions. The steel canoes, all gaily painted in primary colours kept us amused for hours, or as long as Mum and Dad could afford the hire charges. They always sat and watched, Dad contentedly continuing to enjoy his St. Bruno, and Mum now turning to read one of her holiday Mills and Boon novels.

Weekends were a little bit different on the sands. Instead of making our way there after lunch, we headed off in the morning. Alongside of the Punch and Judy tent, there was now another one which had been erected specially for the children's Sunday school. The Sunday school attracted a regular following of over fifty

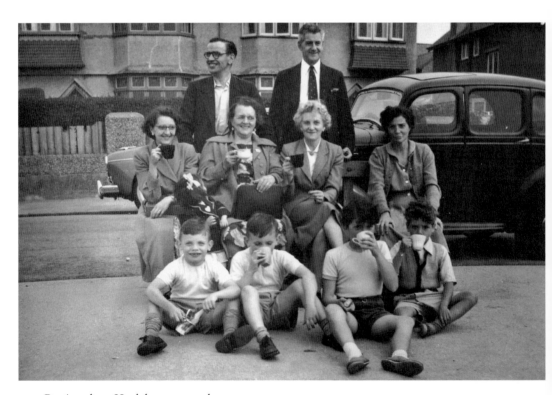

Resting along Hoylake promenade.

Jean, Colin, Richard and Ken at Hoylake baths.

David, Jean and Colin enjoying the sands at Hoylake.

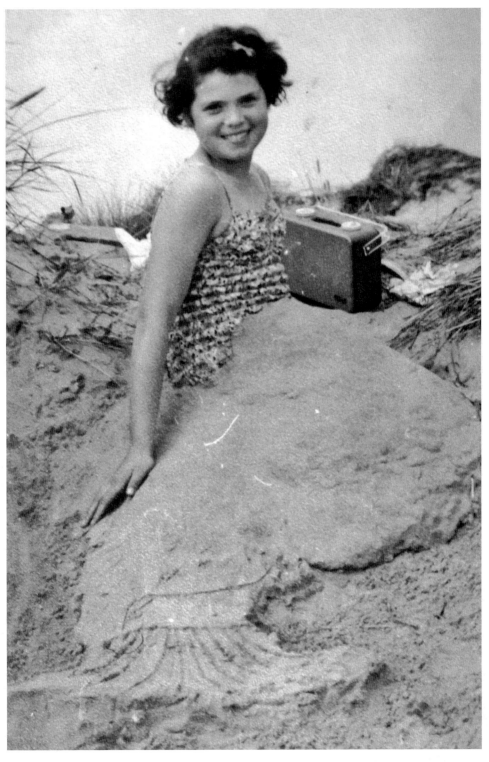

The little mermaid.

youngsters. We sang well-known choruses, and then had a little talk about God's goodness. The theme often centred on God giving us such good summer holidays and kind parents. A collection was taken during the last chorus.

When it rained, as it sometimes did, it was time for window shopping. F. W. Woolworth was a safe bet, as it afforded some protection from the elements. We'd stand there for ages, gazing at the passing traffic. Dad knew all the different makes of cars, so we spent our time 'car spotting'. The walk through Kings Gap to West Kirby also provided more car spotting opportunities. Many of our afternoons ended up in West Kirby, as they had some seaside donkeys here. Also, from West Kirby it was possible to walk out over to Hilbre Island. This was a great adventure as it meant striding out over the sands to the bird sanctuary. The walk back was a little bit more testing, and more often than not, as a special holiday treat, we were allowed to get the electric train from West Kirby back to our digs in Newton Road.

Our holiday in Hoylake also meant that relatives and friends could spend a day with us. Aunty Flo and Uncle Dick usually came over from Dingle every year. On that day, Dad and Uncle Dick had a few pints at lunchtime, and then we all played games on the sands. Mum, who always seemed to have lots of ideas, explained the rules of French cricket. This soon became a firm favourite. One day, when Aunty Gladys and Uncle Sid had made the trek across from Bromborough, I was told off for not joining in with the spirit of the game. Rather than wait around

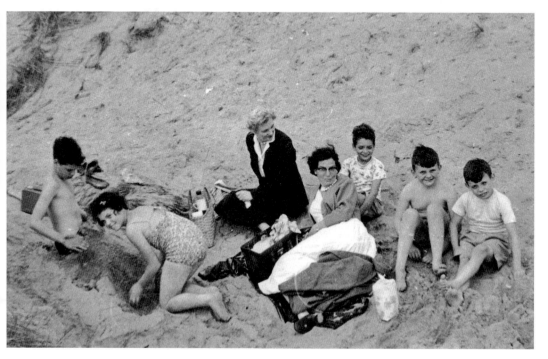

On Hoylake sands with Aunty Flo, Uncle Dick, Richard and Ken.

for the possibility of further reprimands, I decided to leave and sulk in peace. I ran off and found sanctuary in Newton Road. It was ages before Mum and Dad arrived back, but when they did I could hear their frantic voices below. It was then that I realised, with a certain amount of glee, that I must have caused them some considerable distress.

Towards the end of our stay at Hoylake, when final preparations for the return home were being made, we were told that we could have a holiday present. By this time, Dad had assessed just how much cash there was left. The present, normally to the value of two or three shillings, was, more often than not, a small toy. Jean tended to get furniture for her dolls house, Colin invariably opted for an army vehicle to add to his Dinky collection, and I went for a piece of rolling stock for my electric train set. When we travelled home, and eventually got off the bus in Western Avenue, Hoylake already seemed just a distant memory.

Much as the holiday in Hoylake had been enjoyable and exciting, it wasn't too much fun with three adults and three growing children in a small terraced corporation house. This was especially true when the summer holidays came around. In fact, Dad was the only one who could get any change of scenery. Just after eight every morning, he'd fill his pipe with St Bruno, get his bike out of the coal shed, and cycle the mile or so down to work at Dunlop's. We saw him at lunchtime for a short while, but then he didn't re-appear until he got back from work at half past five. During the day, the rest of us, that is the three of us children, Mum and Gran, were all cooped up together. We didn't get under each other's feet that much, but the situation could not, by any stretch of the imagination, be described as ideal. My grandparents in Aigburth obviously recognised the tension that this was causing at home. In order to give some relief, they suggested that one of us, me, spent a holiday with them in Blythswood Street. This was seen as being a good move all round, although I didn't know much about it.

Every year from then on, and only for one week, I'd pack a small suitcase, and make my way down to their house. Blythswood Street was very different from Lovel Way. The houses were more established, the street itself being a long row of terraced houses on either side of the road. The people who lived in the houses were also more settled than most of the people who lived in Speke, in that families in Speke tended to be young with growing children, whereas the families in Blythswood Street were people who'd lived there for many years. Basically, everything about the street was more established, as were the relationships between neighbours. Mr and Mrs Miller had lived next to Gran for over forty years, and Mr and Mrs Bains on the other side in number 54, had lived there for almost as long. When I arrived they made a great fuss of me. Mrs Bains usually passed a shilling over the back wall for me, so that I'd have something to spend during my stay. Mum and Dad also gave me extra pocket money, and with the money that came in from other

neighbours, together with money from Gran and Granddad, I was very affluent. I had money for ice creams, comics, sweets and Matchbox toys. This was very different from normal times.

The house in Blythswood Street had three bedrooms. We too had three bedrooms, but here the similarities ended. Their house was long and thin, with the bedrooms arranged one behind the other, whereas our house was more square and squat in its construction. Gran's front bedroom was the only one which was used on a regular basis. The middle bedroom, which was where I slept, was very comfortable, but apart from the bed itself and a built-in cupboard, there wasn't very much there. The cupboard was used to store home-made jam and preserved fruits in large Kilner jars. Now the back room, which was just beyond the bathroom and used as a junk room, was altogether different. It was a veritable treasure trove, with all kinds of paraphernalia strewn over the lino-covered floor. There was an old banjo with three of its strings broken, a round leather collar box with a few yellowing starched collars inside, and a cracked but lavishly painted water jug which stood in a matching bowl on the dressing table. There were also several other boxes dotted around the place, but these were all very firmly locked – I checked!

The routine was virtually the same every morning. Granddad was up first from his bed in the front room; he'd then walk past my bedroom on his way to the bathroom. Next he'd spend ten to fifteen minutes in there going through his meticulous ritual of washing and shaving – no doubt a throwback to his days in the merchant navy. Even though his toilet routine was very painstaking, he still sometimes ended up at the breakfast table with a piece of tissue on his lower lip, after having shaved too closely.

Then, almost as soon as I heard the sound of his slippers catching on the stair rods as he found his way downstairs to prepare breakfast, which was the first job he did after lighting the fire in the living room, there'd be a knock on the adjoining bedroom wall, and that was the signal for me to go into Gran's warm bed, where we waited until we were called down for breakfast. Then came the exciting bit when Gran projected finger shadow images onto the bedroom wall; these were thrown into sharp relief by the Sun's rays which came shining through the gap in the curtains covering the east-facing bay windows. Using only her hands and fingers, she could project the most realistic and complex shadow images. Two I remember in particular were the large butterfly, which she made by locking her thumbs together and then opening her hands wide – a very striking image. Another one was the fox, which she made by holding her hand out straight in front of her with her thumb sticking up – this became the fox's ears. Her index finger was then bent in half to make the forehead, her lower fingers becoming the fox's snout. Then, when she moved her little finger up and down, it looked as though the fox's mouth was opening and closing. It was a simple but effective way of entertaining an impressionable youngster. I never mastered these images in quite the same way as Gran did, but then, over the years, she'd no doubt had lots of practice with her older grandchildren.

Before too long, however, Granddad would leave his hallowed sanctum in the kitchen, having kept a watchful eye on the bain-marie for the last fifteen minutes,

and come to the bottom of the stairs, where he'd announce that breakfast was served. More often than not I was allowed to go down in just my pyjamas, which was quite a treat – I was never allowed to do that at home. As Gran and I walked down the stairs, the evocative aroma of the freshly made porridge mingled with scent coming from the in-flower privet hedges in the back yard assailed our nostrils; Granddad always insisted on keeping the back door open in summer while he was cooking, assuring us that it was good for his health. The scene that greeted us in the living room was three large plates of steaming porridge set out on the table. When we were seated, Granddad would very carefully, but with an exquisite touch, put a swirl of cream onto the top of the porridge. My job then was to give it a good stir before wolfing the whole lot down. A few minutes after finishing this, we had a cup of Typhoo which, sometimes, Gran was allowed to make. This was preferred to the Co-op tea which we always had at home. It was many years later before I discovered that the choice of Co-op tea was influenced by political doctrine rather than other considerations such as flavour!

The days that then unfolded were always different, but normally included a walk to the local shops along Aigburth Road. Granddad liked to have everything as fresh as it could possibly be, and as they didn't have the luxury of owning a refrigerator, everything had to be bought, more or less, on a daily basis – Granddad was a stickler for fresh food. After the shopping, and sometimes a bit of general housework, it was time for lunch; then after lunch we went for our afternoon walk. Gran and Granddad went walking most afternoons. Sometimes we'd walk as far as Sefton Park to look in the Palm House and then walk around the boating lake; other times we'd go along to Princes Park where there'd always be lots of fishermen sat at three foot intervals along the edge of the lake, all gazing intently at their lines. But my favourite walk was to either the Cast Iron shore or maybe a stroll along the newly opened Otterspool Promenade. Granddad was a mine of information about the local history of Liverpool in general and Aigburth in particular. He told me something of the history of Otterspool prom. It seemed that in days gone by the Mersey was a good river to fish in, with upwards of fifty different kinds of fish being caught in the river, but much of this changed when the river became more polluted from the constant water-borne traffic. He also informed me that, in the area known as Otterspool, there had been a snuff mill built in the mid-eighteenth century. I don't know where he got this information from, but it was interesting to listen to – where else would I hear about the history of snuff milling in Liverpool? He went on to tell me that in the early part of the twentieth century, the Otterspool estate was bought by the city and, in the early 1930s, Otterspool park had been opened. That was just one of our other favourite afternoon walks. It wasn't until 1950 that the promenade had been opened. Granddad said that the reason it had taken so long was that, first of all, the retaining wall had to be built, and this project had been dogged with a lot of opposition and many engineering difficulties. The big problem of back-filling was overcome by using the spoil from the Mersey Tunnel. Sounding just like a land surveyor, Granddad suggested that this was a very neat solution.

Another regular walk was to the Cast Iron shore where we'd look for crabs or watch the ships on their way to Garston docks. Once again, because of his knowledge of local history, Granddad told me how the Cast Iron shore got its name: this was because many years ago there'd been a nearby cast iron foundry, but there was certainly no evidence of this when we used to have our time there. What was there, however, was the pungent smell of churned up mud from the channel, which was constantly dredged along the Mersey to allow shipping access to Garston docks. Granddad told me that many of these ships were carrying wood, and came from such far-flung places as Canada or Russia. I didn't even know where these places were on the world map at that time, they were just names of foreign countries. Another major cargo coming into Garston at that time was bananas, carried by the legendary Fyffe's banana boats. Liverpool, so Granddad said, was the centre for the import of bananas, and more bananas came into Garston than into any other port in the whole of England.

By this time, with a 4 or 5 mile walk having been completed, we were all ready for a sit down and a good rest, but Granddad didn't sit for long. He went back into his beloved kitchen to prepare tea. What amazed me about meals at Blythswood Street was the way in which they were presented. The professional touch was certainly still evident. It was an experience to watch him preparing salads, which were one of his specialities. After selecting three large dinner plates, he'd start by placing finely chopped lettuce leaves around the outside of the plate. This acted as the base, or bed as he called it, for the necklace of sliced tomatoes, cucumber and sliced hard-boiled eggs which were then arranged on top. In the centre of the plate there was either shredded Cheshire cheese or a slice of boiled ham; the ham was invariably very thin and fatty. But, to accompany the salad we were treated to Heinz salad cream which was perhaps by way of compensation. The evening salad was a meal which I always looked forward to.

Evenings were reserved for family. Most of Gran and Granddad's family, apart from us that is, lived either in Dingle or in Aigburth. Gran's sister, Aunty Liz, lived just off Park Road, and they saw each other at least two or three times a week. Granddad's brother, Uncle George, lived in Toxteth with Aunty Bella. She was a large, jolly woman from the Caribbean. Both of them made us feel very welcome after our evening stroll there. They lived in a tenement block which nestled in the shadow of Liverpool's Anglican cathedral. It took us a long time to walk there – it was even further than Tunnel Road! Gran and Granddad went there on Tuesdays. While Granddad and his brother played cribbage, Gran and Aunty Bella sat chatting all evening. I sat and watched the enjoyment that they were deriving from a simple board game, a few glasses of Guinness and the pleasure of each other's company. When it was time to go home, Aunty Bella gave me a big hug, and thrust a sixpenny bit into my hand.

My 'Blythswood holidays' always ended with the buying of presents both for the folks at home and also for Gran and Granddad. I thanked them for having me, then went back to Speke.

As well as being an important festival in the church's year, Christmas was also important in our family calendar. Like many families, we had traditions and customs which were peculiar to us, and to us alone. The build-up to Christmas started early in November, and then, towards the end of the month, when all of the shops in town were decked-out in colourful lights and Christmas tableaux, the excitement reached fever pitch. Many shops boasted their own Christmas grottoes. We were normally taken to Lewis', as it was at the cheaper end of the spectrum. The start of December found us queuing up to visit Father Christmas. Normally, Gran and Granddad were volunteered to wait in the queue with us, while Mum and Dad went off to do other shopping. At ten o'clock on any Saturday morning before Christmas, the grotto queue outside Lewis' tailed right round the shop and into Back Raneleigh Street. Even when we'd shuffled forward into the warmth of the shop, we still had to negotiate our way up through three flights of stairs to the children's floor, where the grotto was cunningly displayed. This in itself took another hour. The present, our reward for waiting, was generally in the form of a very large cardboard box covered in plain tissue, with an extremely small gift inside. Tickets could be bought for either two and six or five shillings. Most people opted for the half crown variety.

The anticipation of Christmas always peaked during the week before. The build-up was so exciting. After spending most of the year saving in various Christmas clubs, it was now Mum's turn to cash-in. The first stop was the butcher's, where she bought the best meat. We always had a fresh turkey on Christmas Day, but the meal on Christmas Eve was even better. We had a whole leg of pork, always roasted to perfection, with crispy roast potatoes, and firm Brussels sprouts. The crackling on the pork was crunchy, and for a change, the gravy didn't have any lumps! After leaving the butcher's, the greengrocer's was the next stop. Again, on this occasion, Mum bought only the very best veg for the two main meals of our year. The Christmas spending spree was completed when Mum purchased our presents. These were always a surprise, a balance between toys and clothes, the fickle and the necessary, and always from Freeman's catalogue. We never knew anything about them until the great day arrived.

For many years the BBC transmitted a special opera for Christmas, *Amal and the Night Visitors*. I was allowed to stay up for this programme. This was another little Christmas treat for me.

Often, it was the case that *Amal* coincided with the visit of the carol singers. Our carol singers were a group of some twenty to thirty people from Mum's mission church in Dingle, The Liverpool City Mission. The church was based in Admiral Street, and every year people from the church made the pilgrimage to Speke to sing carols for us. The preparation for this magic time was almost as intense as the preparation for Christmas itself. Mum spent ages cleaning the house, and extra chairs were borrowed and brought into the parlour. Mum spent

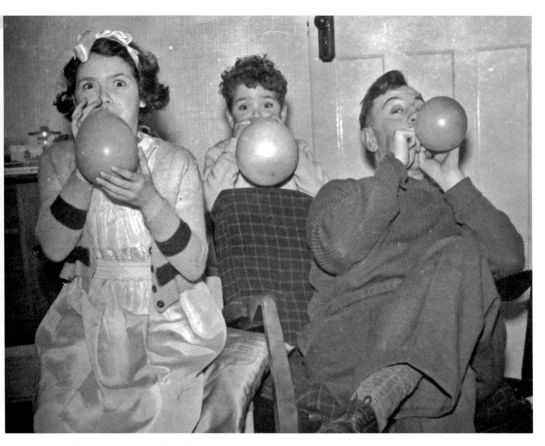

Having fun getting ready for Christmas.

most of the afternoon making mince pies, and checking that the bun loaf was in prime condition. She then secured extra cups and saucers from neighbours, and a large teapot and urn from the church hall. Everything was set. The coach from Dingle arrived sometime after 8.00 p.m. and disgorged its joyful passengers. They stood arranged in a circle at the end of Lovel Way, and sang for upwards of fifteen minutes. During this time, one of their number went around collecting for mission funds. By now, the doors of all of the houses within earshot were open, and neighbours were experiencing and enjoying the singers' Christmas witness. The singing over, they trooped into our house, and filled both the living room, and the newly cleaned parlour. Old friendships were renewed, and Mum caught up on all of the news from the mission. Dad kept a discrete distance, and busied himself by handing out cups of tea, while I followed with the sugar and mince pies. John Berrington and Tommy Boyle, both of whom worked on the docks in Liverpool, were 'leading lights' in the mission, and like so many others from that place, they were very dedicated Christians. When the singers left and the busy chatter went from the house, we helped to clear away dishes and do the washing up before we were packed off to bed. We were only allowed to wash the neighbours' cups and

our everyday cups, and left the best china for Mum to wash later on. The best china was only ever brought out at Christmas.

The days immediately before Christmas were very full, and Saturday was the most special day of all. On that day, all three of us children went to the Dunlop's Christmas party. This was something else which Dad had paid into every week throughout the year. What a party it was. Over a hundred children attended. We had games to begin with in part of the works canteen, and then, in another part, we sat down to the traditional Christmas party fare of sandwiches with meat paste filling, bread cakes with beaten hard-boiled eggs on top, crisps, fairy cakes, jelly, pop, fancy hats and Christmas crackers. No sooner had we finished the abundant feast, than we were being ushered back into the other half of the canteen, where the stage had been transformed ready for the evening's entertainment. The proceedings were started by a warm-up act, usually a children's clown. He was followed by a magician. During this act, lots of children were invited up onto the stage, and when it was realised that there were lots of free presents to be won, the well-ordered party for children of Dunlop's office workers rapidly turned into a Christmas free-for-all. Although Dunlop's could never boast anybody being sawn in half, the acts were most impressive. As the magician's spot was drawing to a close, rumour was rife. It had been circulated that the real star of the show was about to make an appearance. Father Christmas was greeted with loud shrieks, cheers and whooping. When the noise died down a little, Father Christmas told a Christmas story, and then presented every child with a Christmas gift. We were allowed to open these presents on the night, and didn't have to wait for Christmas itself. At 8.30 p.m. sharp, hordes of parents descended on the canteen to accompany their children on the homeward journey. On the way out we were given a bag full of goodies, which contained an apple and an orange, a new penny, a balloon with a Mickey Mouse transfer on one side, and a small net of foil-covered chocolate coins.

The last port of call before the walk home was a final visit to the works lavatory. For a mere lavatory, it was most impressive. In the centre of the large-tiled, rectangular room were the washbasins. These were formed to make a complete circle, each washbasin being a small segment of that circle. In plan view it was just like looking at an orange which had been sliced right across. It took quite a while to work out just how to get water into the sink, as there didn't appear to be any taps! After a detailed examination of the facility, we realised that the flow of water was controlled by means of a foot pedal strategically placed under each individual basin. During the course of the party, most of the kids visited the loos on at least four or five occasions, just to play with these jazzy washbasins.

Although Dunlop's party signalled the start of the Christmas season, the festival itself really arrived on Christmas Eve. On that day everybody was up early. More often than not, Dad went to work as usual, but us kids, having finished school, were pressed into special shopping duties. Mum had already bought most of the provisions which she needed to last over the Christmas holiday, but there was always last minute shopping. One of us was despatched to the greengrocer's queue,

another waited outside of the butcher's shop, and the third, usually Jean, waited with Mum in the cake shop queue. It was only once a year that we went for cakes to the cake shop. As Mum reckoned that Sayer's was the best cake shop in town, they received our patronage on this one occasion. We were always in their queue well before eight o'clock in the morning, as all of the cakes were sold out before lunchtime.

Christmas Day, when it eventually did come, tended to be a fairly quiet affair. After the initial excitement of opening our presents, and Mum and Dad quelling the petty sibling jealousies which inevitably manifested themselves, it was off to church for the morning service. After this it was traditional Christmas dinner, with lots of turkey, roast and boiled potatoes, pork sausage meat, carrots and sprouts. We were all made to eat at least three sprouts each, although none of us liked them. Fortunately, we were only subjected to this imposition at Christmas. Colin got the worst deal, as he didn't enjoy either sprouts or turkey. I normally helped him out with the turkey, so that he didn't get told off! After dinner, Dad and Gran slept for the rest of the afternoon. Mum busied herself in preparing tea, which was generally left untouched. Everyone was still too full from dinner. As the buses and

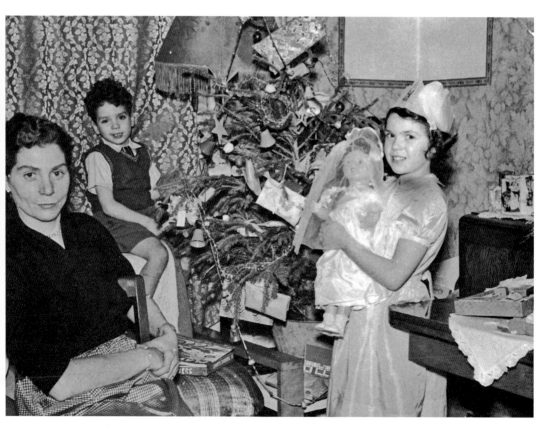

Jean opening some of her Christmas presents with Mum and Colin.

trams never ran on Christmas Day, Gran and Granddad couldn't come over from Aigburth. Public transport was always problematical, but Dad never seemed to be unduly worried at this prospect!

Parents, especially fathers, didn't play with their children as much as they do today. A few years earlier, when I was given my three-wheeler, Dad did spend some time teaching me how to ride it. He also sang a little song as I cycled around the block.

> *I ride my little bicycle,*
> *I ride it to the shop,*
> *And when I see the big red light,*
> *I know I have to stop.*

It's only a song, but the lesson is still taught today, and is called the Green Cross Code.

The only other time I can recall Dad playing with us, was when I was given a train set for Christmas. The Hornby oo came in a big blue and yellow box. Inside, it contained a transformer and controller, enough rails to make a small oval track, two coaches painted in British Railways livery, and most impressive of all, engine No. 60016, *Silver King*. It had a cast aluminium body, and was accurate in every detail, even down to the dark green matt paintwork. Although the front room was only used on special occasions, such as when the neighbours or the carol singers came in at Christmas, Dad allowed me to use it to assemble the track on the floor. In fact, he helped me to put the rails together as I was having some difficulty. He also explained how to connect the controller, then taking over the whole operation, as dads so often seem to, he carefully placed the engine, tender and coaches onto the track. We spent the rest of the afternoon just watching the train going round and round, enjoying an innocent pleasure. As our skill on the controller developed, Dad introduced another test. Taking an orange from the fruit bowl, he placed it by the side of the track. The test was then to take the train around the track as quickly as possible, and stop immediately before the orange. This proved to be far more difficult than it first appeared. Dad always won.

Boxing Days were spent with Mum's side of the family in Blythswood Street. The buses started to run again on that day, so we were able to catch the 82 down to Dingle. Gran's terraced house was full of happy Aunts, Uncles and cousins. While the grown-ups congregated in the back room with their beer, cigarettes, cigars and conversation, the youngsters were pushed into the parlour to amuse themselves. We played lots of different games.

Cousin Joe, the eldest son of Aunty May and Uncle Joe, proudly brought along some 78-speed records one year, which he was allowed to play on the gramophone. Later, when we were playing another game, he left them on top of the piano stool.

Jean playing 'blind man's bluff'.

The inevitable happened. During the course of the game, my cousin Pat pushed me backwards. This meant that I fell right onto the stool. All of the records were smashed to smithereens. The resulting row was not good to witness. We caught the bus home shortly afterwards!

4

More New Experiences

The transition to the junior school up the hill was not without its moments of drama. When we came to go there, boys and girls in our class had spent four years working and playing together. We all knew one another very well. The bonus in the junior school, which we weren't in receipt of when at the infants, was a weekly visit to the public baths. If we were quick getting changed into our trunks, then we could play in the pool before the formal swimming lesson commenced. The lesson didn't last too long, since the authorities only allowed us half an hour in the pool each week. After we'd learnt how to swim we were given a little more latitude. Even then, it never seemed very long before the teacher's whistle was being blown, and we were being ushered back to the communal changing rooms to get dressed and return to school in crocodile formation.

Joy Clarke, who was one of the better swimmers, got preferential treatment from the teachers. She was allowed to stay in the water longer than the rest of us. This caused some dissension in the class. When we were leaving the baths one day, she wanted to take a short cut and step across the corner of the pool. Somebody knocked into her, and dressed in her navy gaberdine mac, she fell, head first, into the pool – what a tragedy!

It was at this age that most of the boys were becoming more aware of most of the girls. Some of them were also beginning to figure in different ways. Ann Caldwell, who was a bouncy girl with mousy hair trailing down her back, lived with her aunt across the Mill Stile. Ann's aunt owned the sweet shop along Quarry Street. So, every morning as she walked into the playground, she was greeted and surrounded with beaming admirers queuing to chat. Also, she was allowed to choose the day's playground game. Presents of Murray mints, or on a good day, a two-bar Kit Kat, were distributed at the end of the game.

Quarry Street was good to walk down at lunchtime, as it involved crossing the Mill Stile. The Mill Stile skirted the side of Woolton Quarry. The Bear Brand stocking factory was not far from there. In their lunch break, the factory girls sat on the walls eating fish and chips. They were very generous to the kids in our school, and proffered chips, scraps from the battered fish, and bits from meat and potato pies. Following one of these trips, I was persuaded by Ernie Southall to participate

in my first cigarette. He'd bought a packet of five Woodbines from the tobacconist in Allerton Road. We went and hid behind a disused workman's shed along the Stile. Not knowing anything about smoking, I had to take lessons from Ernie. He assured me that the only way to enjoy it was to inhale the smoke as I drew on the cigarette. Upon following this simple rule, I immediately went dizzy and coughed all the way back to school, vowing never ever to smoke again. This was one of the many promises which I made at school and didn't keep! Another, which was a request from my parents, was to work hard during my time at school.

In Speke all of the houses had been built by the city council. Everybody paid rent to the rent man, who called on Thursday mornings. This being the case, the concept of private housing, where people didn't need to pay rent, was quite alien to me. That is, until I started to chat with Stella Martindale. She lived on the outskirts of Woolton, and her family owned their own home. They had a mortgage, which like our rent, they paid on a regular basis. The significant difference was that, at the end of twenty-five years, they owned their own house. My Mum and Dad would go on paying rent to the 'corpy' forever, and the house would never be theirs. Also, their house was semi-detached. She explained to me that this meant that there were only two houses joined together. This was very different from ours, which was in a row of four. I'd never met a girl with rich parents.

I became quite friendly with her during my time at school. Just before we left to go on to secondary schooling, she told me that her Mum and Dad were having an extension built onto the side of the house. They were having a new dining room and also a new bedroom. Their house would then have four bedrooms and a garage. I bathed in this reflected glory, and told all of the kids in our street that I was friends with somebody who lived in a four-bedroomed, semi-detached house with a garage. Not many of the houses in Speke had garages. There wasn't the need, as nobody owned cars.

The time in junior school was very happy, except for one little problem in the shape of David Titterington. He was the school bully. Unfortunately, there were about seven kids in the Titterington family, and received wisdom was that they were all thugs. David was the one who was in our class, and none of us, including the teachers, could cope with him. That is, not until the time when three of us decided to beat him up one playtime. We waited for our opportunity, and then, on the given word, all piled into him. It was only by ganging together in this way that we were able to overcome his sheer physical strength. The outcome was quite satisfactory. The bullying ceased.

The village of Woolton is ancient. In lunch hours, when we didn't go across the Mill Stile, we explored some of the many different local landmarks. The village duck pond was a favourite spot, as it was only down the road from school. It's an oval concrete-lined pond, but there's been no water in it for many years past. Around the edge of the pond there was a crazy paving path and, beyond that, lots of dense undergrowth. We spent many happy hours playing here, sometimes finding out just why it was that some of our friends were called girls, and others were known as boys.

When autumn came, our favourite haunt was a spot along Acrefield Road. Climbing over the sandstone wall just past the White Horse, we could gain access to the rear of the garden of the big mansion which was opposite St Peter's on Church Road. There were lots of horse chestnut trees in the garden, and we were able to take our duffle bags along, and collect as many conkers as we could gather in half an hour. Having a champion conker imbued its owner with a status not normally accorded during school playtimes. Everybody had their own secret methods of preparing conkers. The various different methods were all tried and tested. Soaking conkers overnight in vinegar was very popular, as was baking them in the oven. This method didn't usually meet with too much approbation from our mums. Dennis Cumine, who lived by the reservoir, had a very fertile mind. He developed his own unique process. He hollowed out the centre of the conker, which just left the shell in tact. Then, he filled the empty centre with putty. This was then baked, very slowly, in a low oven. He had just about the hardest conker in the school. I was threatened with death if I ever revealed his secret technique.

The 'Lions' Den' in Woolton Woods was another much favoured haunt. An apocryphal story was passed down from one school generation to the next. It claimed that many years ago, lions had roamed freely through the woods. I never doubted the truth of this story until long after I'd left the school. Every time I went into the woods, I was very careful to check that somebody went in front of me, and also that there were no lions anywhere in the vicinity.

At the far side of the woods, just where Georgina Bates lived, there was a walled garden. In the garden, there were ornamental flowerbeds. It was a cherished spot. People walking through the woods often made their way there, hoping to hear the cuckoo.

As St Peter's was a church school, we had assembly every morning. At 9.00 a.m., one of the teachers came out into the yard, blew her whistle and lined us up in our classes. She was then joined by the rest of the staff who, in a time-honoured tradition, marched us into the school hall. After prayers and a hymn, the head teacher, Miss Davies, told us stories about God's goodness. After another hymn the

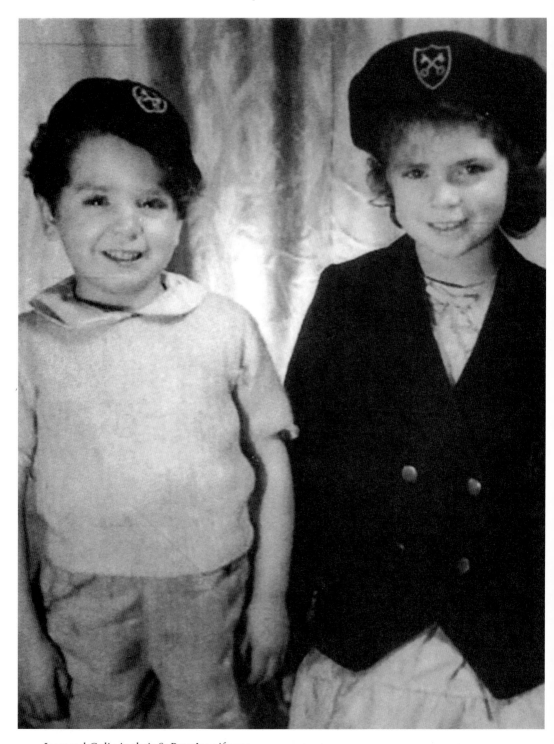

Jean and Colin in their St Peter's uniforms.

assembly came to an end, and we returned to the main school buildings across the yard to start our lessons for the day.

The school fund must have been doing particularly well, as the following year, Miss Davies invested in a wireless set. When it was delivered to school, the rector came along to bless it. The wireless, which was housed in a solid oak cabinet, almost the size of an orange box, was placed very carefully onto the stage every Friday morning. This was so that we could all listen to a special programme that was broadcast for school assemblies. It was called an Act of Worship. Everybody in the school sat transfixed in front of the set for half an hour, while we listened to the 'cut glass' voices coming over the air waves from Broadcasting House in London. The voices from afar told us about the love of God. They also wanted us to sing nice hymns, and invited us to join with them. We duly obliged.

One Friday, Miss Davies, dressed in a very fine frock with lace edgings, told us that, instead of sitting around the wireless, we were to be visited and addressed by a missionary. I wasn't too sure whether or not this was an attempt to convert us to the 'faith'. Nonetheless, I remained on my guard! I was expecting to see a stout, middle-aged, middle-class man with a military moustache, looking faintly colonial, with a Panama hat on, towering in front of us. The reality was very different from this. Instead, a frail, ageing and stooped spinster greeted us. As she talked, and unfolded different aspects of her life and work in Africa, there was absolute silence throughout the hall. Everybody was mesmerised by her devotion and dedication, as she transported our minds to the very heart of the mission hospital where she worked. Following her talk, which as they say, was full of missionary zeal, many of us wanted to offer ourselves to go forward into the field, but being an innocent aged eight, my parents gently dissuaded me from that course of action.

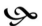

Miss Tod lived in a big house just by the golf course, and was one of the stalwarts of St Peter's. She even had her own pew in church, and had regular visits from the rector. Obviously, she was somebody very important. She also had a big garden full of apple and pear trees. Once a year, 'her man' was asked to fill a barrel with fruit from her garden. On a pre-arranged day, usually near to the end of term, the barrel was transported to school. She then sat, enthroned in splendour, with the tub by her side, and distributed its contents to the waifs and strays of the school. We were instructed to make sure that we always thanked Miss Tod for her gifts, and that a little bow or curtsy was quite in order.

Like all good benefactors, Miss Tod went to her reward with her maker in due course. His orchard is probably extremely large, and no doubt bigger than hers! Before the funeral, to which we were all 'invited', we practised singing various hymns, anthems and requiems. Also, because Miss Tod liked traditional airs, it was decided that one of us would sing a solo during the service. The solo was to be *Linden Lee*, one of my favourites. I practised for ages, and in the middle of my final practice in front of the whole school, I couldn't reach the top note. My nerve

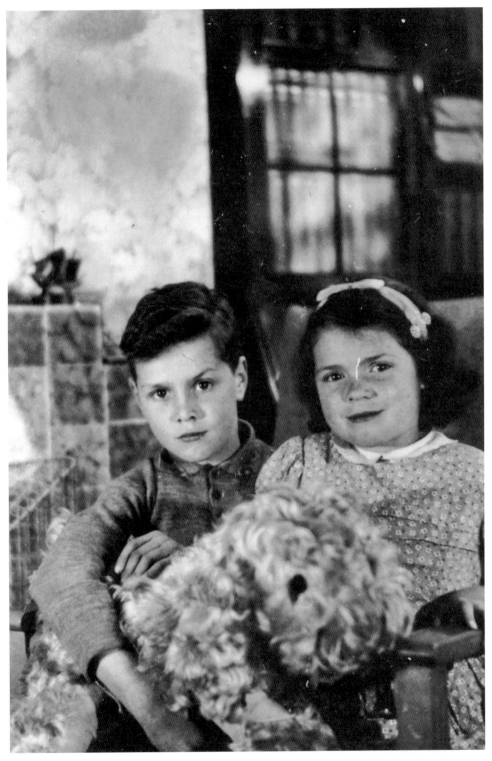

David and Jean looking after a pet dog.

had failed. I was too embarrassed to perform at the funeral itself, so Ernie Southall stood in for me.

When the day arrived, I went off to Woolton on my normal bus, as if going to school. There were masses of people walking up the hill to the church, which was full of pupils from the school, teachers, and hundreds of other people from the village community. The coffin was preceded down the church by the rector, who solemnly incanted the words of the 1662 Church of England funeral service. As Miss Tod was such an important personage, there were six men carrying the coffin. This was the first funeral that I had attended. At some stage during the proceedings, most people appeared to be crying. I ended up in the same state for some reason which I couldn't understand, because Miss Tod didn't mean that much to me. Maybe a case of mass emotions? It's fair to say that she left this world with due pomp and ceremony.

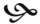

At bedtime, and we all went at the same time, Jean went into Mum and Dad's room where she slept in a single bed alongside of theirs, and Colin and I went into the box room where we shared a three-quarter bed. When we'd changed into our night clothes, Mum came up and sat at the end of Jean's bed. Then, with both bedroom doors open, we'd sing our evening prayers. Normally, there were three distinctive elements here. First of all there was a request for a safe night's sleep, so we sang:

> *Lord keep us safe this night*
> *Secure from all our fears,*
> *May angels guard us while we sleep,*
> *Till morning light appears.*

After that there was a time of extempory prayer lead by Mum, where we prayed for various members of the family including both Grans and Granddad, various aunts and uncles and one or two cousins. And then we came to people who weren't feeling too well. This was usually neighbours or some of Gran's friends, who, almost by definition, were aged and infirm. Lastly, for some reason, we prayed for the three little boys. I never knew who they were, what, if anything, was wrong with them, and how, as a result of our prayers, they fared. But, none-the-less, they were always included on the list. Tonight Mum included a special prayer for Miss Tod.

When the extended extemporaneous session had finished, we sang our final prayer which also asked for safe deliverance:

> *Matthew Mark Luke and John*
> *Bless the bed that I lay on*
> *If I die before I wake*
> *I pray the Lord my soul to take*

After giving us a goodnight kiss, Mum went downstairs again. Then, it was lights out and sleep until the next morning.

As summer approached and the nights grew lighter, thoughts turned to more pleasurable activities, like making 'steeries' – these were made from planks of wood 6 foot long, and about 9 inches wide. To one end we attached large Silver Cross-type pram wheels. Bolted onto the other end, the front, were two smaller wheels, fixed to a centrally pivoting axle. The idea of the pivoted axle was to help steer the contraption. This was not always as successful in practice as it was during the design stage! Speke was still one large building site, so it was easy to obtain wood and other bits to help make our 'steeries'. Also, because the immediate post-war baby boom was drawing to a close, rubbish tips were always full of discarded prams of one sort or another.

It needed two people to operate a steery, the braver one to sit on, and guide or steer the front axle – hence the name! The other person, who needed to be more energetic, ran behind, pushing against the back with a pole; this effort provided the motive power. The game that we developed was to get three or four steery teams and then race around the 'block'. Most of these races ended in spectacular crashes, which meant that there were bleeding bodies and spinning wheels strewn over the road. This never caused too much of a problem, as nobody in Lovel Way owned cars, and the only vehicles which ever came round were delivery vans and the odd speculative ice cream van.

'Steery' races were hotly contested, and finishing positions sometimes disputed. Billy Teare was always arguing with Colin about steeries. He was older than Colin and, because of this, won most of the arguments. One race ended particularly acrimoniously, and to show his displeasure Billy battered Colin. There was nothing for it, I had to mete out a similar punishment on Billy. Five minutes later his mum was out remonstrating, and the little initial disagreement escalated into a full-scale quarrel between our families. As the Teares lived just opposite from us in the 'half houses', an invisible divide was drawn across the street; our family didn't speak to them, and they never passed the time of day with us. It also stopped our supply of fresh eggs. The Teares kept hens at the bottom of their back garden, and one of my daily jobs was to carry all of the potato and vegetable peelings down their garden and give it to the hens. At the end of each week half a dozen eggs were sent over to us. That reciprocal practice was immediately terminated.

During the lighter summer evenings we often ventured into the woods around Speke. We played commandos, a game no doubt developed from some residual knowledge of the war in Korea. The war was just drawing to an end, and the papers and radio always had news of troops coming home. Once team selection had been sorted, the first team went off to hid,; somewhere in the Dam Woods or perhaps the Bluebell Woods being the favourite hiding places. The whole idea of the game was for the second team, who followed half an hour later, to seek

out and kill the first team. The game was only over when all of the commandos had been killed. Lemonade bottles with toggle tops were ideal for carrying water backwards and forwards to the jungle. The game of commandos was probably quite gruesome, but it kept us amused all day. We didn't make our way home until it was time to buy our Twicer from the Frederick's ice cream man. This unique offering was a combination of half ice lolly and half ice cream, but Twicers weren't in the same league as the Disney character ice lollies. The wrappers from these lollies were collected and then exchanged for small presents. Infinitely preferable!

Holiday patterns were changing, perhaps forever! We were all growing up. Colin was now nudging six, Jean was well into junior school, and I was moving into my final year. Dad's job had also moved up. He'd gone from the Precision Components

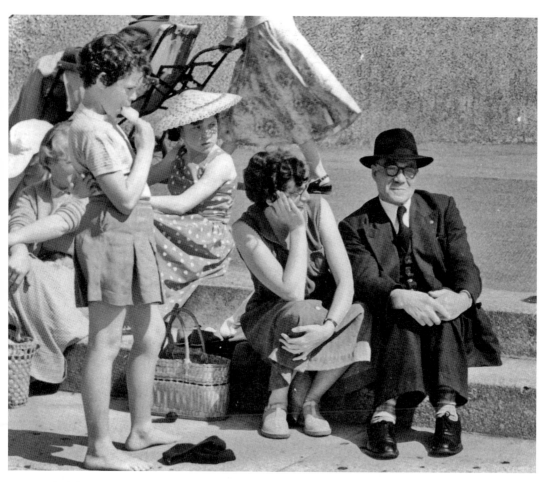

On holiday with Mum, Dad, Jean and Colin.

Department, affectionately known as PCD, into Work Study. The job was still with Dunlop's, but it was some sort of promotion. He'd spent a lot of time reading, and had attended a couple of courses down in Waltham Abbey, just outside London.

The first indication of something different being afoot was when the cobwebs were blown off the book cabinet in the parlour, and the atlas, possibly as old as the world itself, was ceremoniously removed and opened at a page showing Europe. Girdled across these unfamiliar looking shapes were the large letters, E U R O P E. The name still amuses me. I couldn't attach any importance or significance to a land called 'Your Rope'. Dad then explained that it was an expression we used for a lot of foreign countries which were near to us, but across the Channel. He said that we were going to a European country called Belgium. The three of us had never crossed the Channel, and eagerly anticipated what it might hold for us. We had no real conception at the time, although, having grown up on the banks of the Mersey, at least we could boast of having seen Atlantic liners. The cross-Channel ferries didn't quite match this grandeur.

Dad applied some of his Work Study practices to planning our first holiday abroad. In fact, it was planned in meticulous detail. Every eventuality was covered, as it no doubt needed to be. Taking three young children abroad was quite unusual in the mid-1950s. Also, Mum had never ventured further than the pleasure beach at Blackpool, but strictly speaking, this wasn't her fault. Her honeymoon had been scheduled for Paris, but Hitler decided to intervene.

Boarding the midnight train at Lime Street was the first 'leg' of our journey, and it brought its own very special excitement. This was another first for the three of us. Needless to say, none of us could sleep, so we ended up sharing Dad's piccalilli sandwiches at two o'clock in the morning. We played 'hang-man' and noughts and crosses as we passed through some of the most famous railway towns in England. Crewe, Stafford, and Nuneaton all flashed by as we sped towards the mighty Euston station.

It was a bleary-eyed group of weary travellers who arrived at platform eleven shortly after 5.00 a.m. There was no respite, however, as we were carted across London to be introduced into the world of Lyons Corner shops – the 1950s equivalent of today's McDonald's drive thru'. There wasn't much time to dally here as before long we were back on a big red bus, clutching our respective rucksacks and cases, and heading towards another of the capital's monolithic stations. At Victoria we boarded the Southern Region express which was to transport us on to Dover. By this time, the greasy offering which had been served as breakfast had taken its toll. The colour of Colin's complexion, matched the pale melamine façade on the second-class railway carriage bulkhead. He and his breakfast were soon parting company. After cleaning up the mess, Mum and Dad caught up on some much needed sleep. The three of us decided that it was time to explore the length of the corridor train. When venturing into the first class accommodation, we were met with some looks of disdain. But, apart from that, there was very little worth noting, except that the train was very long. Mum came looking for us just as the train started to slow down on its approach to the dockside station at Dover.

The cross Channel ferry offered even more opportunities for exploration than did the earlier journey from London. Our parents had also anticipated this. Their plans included regular reporting back every quarter hour. We were also given other instructions, such as not to go out onto the open deck, not to go in the lounge bars where people were both drinking and smoking, and not to talk to strangers. Although these limits did impose some constraints, we were still able to enjoy the excitement of this first crossing. Anyway, they were very sensible rules. In the middle of the Channel, when the swell became a little more marked, the five of us went strolling along the promenade deck. The smoke in the lounge had made Mum's tummy a little queasy. After six hours, a couple of Diocalm, and a few more soggy piccalilli sandwiches, we entered the markedly calmer waters of Ostend harbour. We then spent at least another hour disembarking. Fortunately, on entering the warehouse which passed as the customs hall, we were met by the courier from the travel agency. Children, it seemed, were outside of his experience. His normal tourist in those early package days tended to fall either into the stereotypic middle-aged twin-set spinster teacher category, or the retired widower battalion. Five minutes later we were introduced to several!

A Belgian tour bus with a curved windscreen then transported us to Blankenburgh. This is a small, nondescript town, a few miles along the coast from Ostend. The uneventful journey only took half an hour. We were spending the next two weeks here, at the Belgian equivalent of a down-market Butlins. To say that the accommodation was sparse would be a gross overstatement. The fare in the dining room was adequate, but very different from our standard diet in Speke. We made our acquaintance with yoghurt. After having been told exactly what it was, we devoured it at breakfast every morning.

Our mornings were filled with roaming around the open expanses in the holiday camp, playing crazy golf, making sand castles, or looking desperately for other English kids with whom to talk. This latter pursuit proved futile. The campsite boasted some large two-seater tricycles. These could be hired for a nominal sum, and when we were allowed to make the investment, we had cobs of fun just cycling around the perimeter roads of the camp.

As we were only staying half-board, we were exhorted to fill up with as much as we could at breakfast. This, for tactical reasons, became later and later. By taking this course of action, we could bridge the gap over lunchtime, and save the expense of another meal. Belgium was far more expensive than Mum and Dad had budgeted for, or anticipated. We looked forward to our evening meal, and nine times out of ten, headed the queue which formed outside of the dining room. Funny, but the people at the front of the queue invariably seemed to be English!

During our time in Belgium, we went on a couple of coach trips. For some reason, these tended to start at the crack of dawn, so we were packed off to bed very early the night before. After a breakfast which was more rushed than usual, we were again ushered onto the funny little bus with the curved two-piece windscreen. Another innovation on the bus was an electrically operated folding passenger door. This was quite novel, and different from anything we'd ever seen in England. The

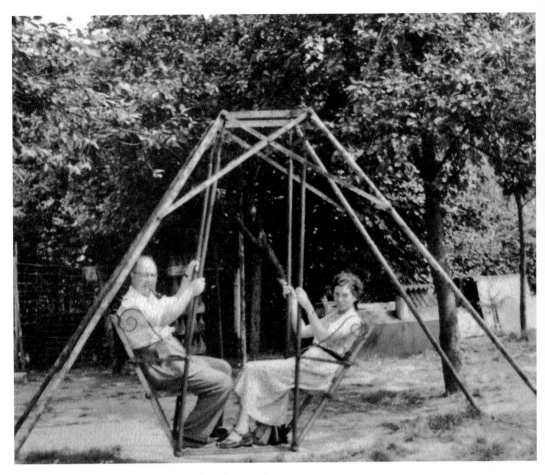

Mum and Dad relaxing on their holiday in Belgium.

coach trips proved to be very successful. They served to fill our day effectively, and we had the added bonus of a packed lunch. On most occasions, the coach was filled with English holidaymakers, and Mum and Dad were able to hold more adult conversations, rather than just chatting to us kids all day.

Queenie and Fred came onto the scene fairly early in the holiday. They were a middle-aged couple from the Home Counties; both had been married before and, judging from the constant bickering between them, it appeared that they might both be facing divorce again. They say that opposites attract, and maybe this was the case here. Queenie was brash and garish in her outward appearance, whereas Fred was more conservative and measured. During the remainder of our two weeks, Mum and Dad both spent many hours in animated, but separate conversations with them. Most of Mum's conversations with Queenie took place in the campsite coffee bar, whereas Dad and Fred preferred to retire to the bar area for their discussions. Their marriage must have held together quite well, as we received cards at Christmas and regular letters for many years afterwards.

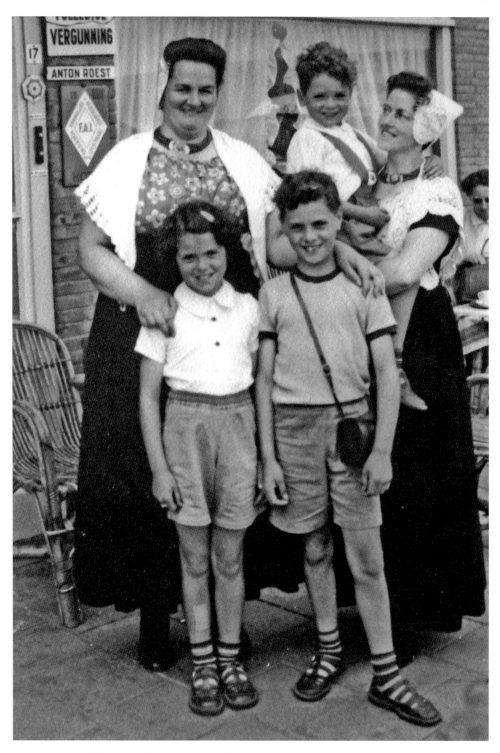

Being welcomed by two ladies in traditional dress – Holland.

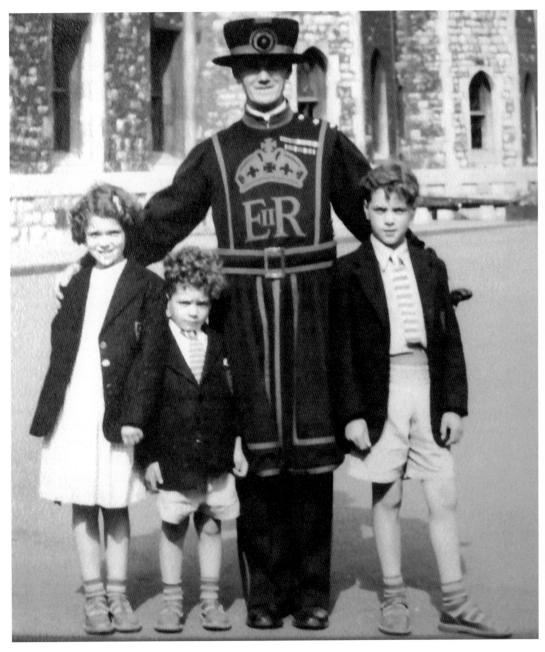

Beefeater taking charge at the Tower of London.

Other relationships were formed during that first holiday abroad. Mum and Dad became friendly with two spinster teachers from Reading, whom they'd met on the boat coming over. They seemed to be very intense in their outlook and also nervous when they spoke to the three of us. In this respect they were similar to our travel courier, in that young children on holiday were outside of their experience, especially young working-class kids from the north of England. The coach trips proved to be invaluable. They served to demonstrate that we did have some manners, and in turn, we became convinced that there was civilised life south of Watford Gap.

The other, rather sad relationship was with a frail old widower. He cultivated a hang-dog expression, which when viewed in conjunction with his long face and drooping jowl, would have been more than enough to convince any panel at Cruft's of his undoubted qualification for top awards. He was befriended early in the holiday, and obviously enjoyed spending time in the company of young people. Mum and Dad were no doubt checking him out during this time, and having passed all of the tests, he was included in most of our excursions and expeditions.

We all travelled back to England together, and said our goodbyes on the platform at Victoria. We spent another few days in London, before heading back up to Speke.

During my final year at St Peter's, I was in Miss McBurney's class. Being the top class we were given all the main roles in the school's nativity play. We practised this from the start of November. My part was to play the role of one of the shepherds. I was very pleased at this, and asked Mum if Gran and Granddad Payne could come along to the public performance on the last day of term. Mum told me that Gran was ill, and probably wouldn't be able to come along. She also asked me if I'd like to give Gran my Christmas present early, as she mightn't be too well over Christmas. I spent ages sorting out her present, as it was a difficult shape to wrap. During summer, when the travelling fair arrived in Speke, I'd won a real cut glass sugar bowl, with a silver rim around the top. I was sure that Gran would like this on her dinner table, so I'd saved it especially for her. It seemed a bit stupid filling the bowl with sugar, so I bought some of her favourite Everton Mints. She always had Everton Mints, even though she was a fervent Liverpool supporter. On 1 December, three days after I'd sent my present down for Gran, she died. My world came to an end. She was very dear to me, and I was her favourite grandson. I wasn't allowed to go to her funeral. The following week when I went into school, Miss McBurney knew that there was something wrong. She called me out, and I stood at her desk sobbing my heart out, and telling her all about the wonderful lady who had been my Gran, and what she had meant to me.

All of the teachers at St Peter's were very caring. The wellbeing of the children in their charge was paramount in their minds and actions.

❧

It was always the same at Christmas, lots of presents to buy, and very little money with which to buy them. Just a few days before the final deadline, I found an old Roman coin on the bedroom floor near to Dad's wardrobe. The wardrobe was kept in here because there wasn't any space in his bedroom. I wondered what to do with the coin, although I knew in my heart of hearts that it was from Dad's collection. I suddenly remembered George Riding. He owned one of the local sweet shops in Woolton, and had a keen interest in foreign coins. The next day during lunch hour I asked him how much he would give me for it. Without a second thought, he offered me half a crown. Delighted, I jumped at this opportunity. Two and six for an old coin really was hitting the big time! I couldn't believe it! I immediately bought a large bottle of Robinson's Lemon Barley Water, which we all shared at playtime that afternoon. The one and six that was left was spent on sweets and crisps before we got the bus home. I didn't dare take any money home, because too many questions would be asked. Clearly, I wouldn't have any answers. Although the half-crown had provided lots of goodies at school, it hadn't eased the problem of buying presents for the family.

As we didn't get very much pocket money, the only way to go about buying presents for Mum, Dad, Jean and Colin was to join one of the various 'Christmas clubs'. Most shops ran clubs of this kind throughout the year. I joined the club which the toyshop ran, and paid a penny into this fund on most weeks. It didn't mount up very quickly. The idea was to buy Colin a few toys at Christmas. He collected models from the range of army vehicles that Dinky made. There must have been at least twelve different vehicles, all accurate in every detail and painted in khaki. I was hoping to buy the tank transporter, which was a Mighty Antar, and a tank to go on top. When I came to make my purchases, the tank transporter itself cost fourteen and six, and if I'd wanted the tank as well, I would have had to pay over a pound for the two. In the event, I bought him the field ambulance which cost three and six.

The post office in Woolton was very small, and certainly not big enough to cope with the Christmas rush. A few weeks before our Christmas holidays started, the school hall was hired by the GPO and converted into a temporary sorting office. It also meant that our playground became the parking area for all of the bright red GPO vans, and also the other vans they'd had to hire. These vans just had little stickers in the windscreen saying Royal Mail. Playtimes were spent propped up against the school walls, watching the comings and goings of the scores of lorries with their seemingly countless sackfuls of mail. We thought of people from all over the world who would soon be receiving Christmas presents that had started their journey from our school.

When winter came, school became very cold. The heating system was powered by an ancient coal-fired boiler next to the caretaker's house across the far side of the playground. The boiler circulated lukewarm water around 6 inch diameter

cast-iron pipes that hugged the walls in all of the classrooms. On more than one occasion, usually after the weekend when the system wasn't fired up, the pipes burst, and we became even colder. We were allowed to wear overcoats and balaclavas at these times to keep ourselves warm. When the sky grew grey and snow came drifting down, we armed ourselves with snowballs and ran down the path which led to the Roman Catholic school. The 'catties', as the kids from St Mary's were known, were never ready for us. But after we'd mounted a spirited attack, they retaliated and invaded our playground *en masse*. It was great fun dodging in and out of the vans which acted as vantage points and shields, but the drivers didn't seem to share this view. The rest of the day was then spent shivering in damp, icy clothing.

Even in winter, we still walked across the Mill Stile. Since I had been introduced to the pleasures of smoking, it was fast becoming a favourite lunchtime stroll. Lots of boys and girls from the school had dads who worked at the quarry, so, after our cigarette, we went there and watched the sandstone-cutting machine. This was housed in its own shed, and was a massive steel saw, about a foot in depth, and at least 9 feet wide. It cut very slowly, and throughout its operation had jets of water being played on it to keep the blade cool. The water also got rid of the sandstone sawdust. All of the quarry's output went to the building of Liverpool's Anglican cathedral. When the building work was completed, the quarry was closed down, and the entire workforce made redundant. So much for God's work never being done.

Christmas that year wasn't too happy. Granddad came and stayed with us, but he was in a complete daze. I'd never seen him like that before, it was as though his grief at the loss Gran had detached him from his real self. He tried to be bright and jolly, but as his life's partner had died only a few weeks before, his efforts were none too successful. He was almost like a ghost figure, just going through the motions and observing everyday conventions.

The time came to sit for the eleven-plus as it was called. It was the results of this examination that would determine what secondary school I would attend. Mum and Dad's preferred option for me was the Collegiate, but this was one of the better schools in Liverpool, and even I didn't think that I had very much chance of getting there. Our teachers primed us about the tests and told us how they would be structured, but it was so different from everyday lessons at St Peter's, that it was just too much for me to comprehend.

It had been snowing earlier in the week, and it was also snowing on the day that I caught the 82 down to town with Dad. He knew where the school was, but it was just somewhere else in Liverpool as far as I was concerned. It was very slippery underfoot as we got off the bus and made our way to Shaw Street. As Dad was leaving, he offered me his 'Parker 51' – this was a very special honour, as he was very careful with his prized pen.

As the aspirant scholars assembled in the school's playground, our names were called out and we were told which room we would be in for our three exams. The room which I was to sit my exams in was on the first floor. The treads of the sweeping oak staircase with its sandstone banister were wet from the hundreds of damp feet that were now passing over on their way to the first test – English. The lancet windows, which were to the side of the staircase, were frost-clad and beginning to drip with condensation, thus adding to the cleaners' immediate task, which was to mop the stairs dry before the exodus for playtime. The first exam over, we all ran down the stairs, relieved to be free for fifteen minutes. Running alongside one of the far walls in the playground was the biggest slide that I've ever seen, and there was an even bigger queue of boys waiting for a turn. I queued up for most of the playtime, freezing, and then, just before hearing the whistle which called us back for the arithmetic exam, it was my turn. I ran up as fast as I could and hurled myself down the slide, but with perhaps a little too much vigour, as I found myself sliding along on my backside for most of the slide's length. My jacket and trousers were sodden, and I was just about to go into an hour's arithmetic test. Fortunately, when I checked, Dad's pen was still intact.

The results were received a few weeks later: I hadn't passed for the Collegiate, but I had been given a place at St Margaret's. Mum and Dad appeared to be both relieved and ecstatic at one and the same time, but this was a school of which I'd never heard. Mum, in her usual placatory way, said that it was a very good school.

There was some immediate benefit from having passed the eleven-plus. The first being that Dad took me to the cinema one evening to see *The Dam Busters*. The only other time that this had happened was when we'd visited the cinema on holiday. *The Dam Busters* was an exciting film, but the real treat was to come. On the following Sunday afternoon we all walked down to the bike shop in Eastern Avenue. They sold Dawes racing bikes there; hanging right in the centre of the window was a Dawes Double Blue. This was the top bike in their range, having a triple clanger and a total of fifteen gears. It also carried a price tag of thirty-six pounds, which Dad was quick to point out. I didn't get a Dawes Double Blue, but a few weeks later when we went down to Jim Chambers bike shop in Tuebrook, I was rewarded with a Dawes Clansman. This was a far more modest machine, retailing for the princely sum of seventeen pounds and ten shillings, and was more suited to Mum and Dad's pocket.

John Manner's was a very special shop, directly opposite to Lewis' in Raneleigh Street. The shop was on two floors, and it was one of the main school outfitters in Liverpool. It had to be a very special occasion to be taken into Manner's. On walking into the shop there was a definite and distinctive aroma of polished oak,

mingled with the smell of newly cut material. The school uniform department was located on the first floor. It was like entering into a grand mansion, with numerous uniformed assistants, sedately and intently gliding on what appeared to be pre-ordained paths. This, coupled with the reverential and hushed silence in the shop, made it a very special kind of shop. As soon as we headed towards the staircase, an assistant followed us, very discretely, and upon reaching the top, inquired how he could be of help. Meanwhile, I was surreptitiously eyeing up the rocking horse, hoping that I would be allowed a ride, even though it had to be acknowledged that I was reaching the age when it would be a little childish to be seen riding on a rocking horse. Being less encumbered by protocol and decorum, Colin wasted very little time in hustling off the current rider, and mounting the steed while we were otherwise engaged.

My first school uniform was bought in Manner's, but, because it cost 'an arm and a leg', as Dad was heard to remark, subsequent uniforms were purchased from Owen Owen's.

We went abroad again at summer. Mum and Dad skimped and saved all year so that we could have another exciting holiday experience. Similar to last year, we were scheduled to travel down to Dover by train and cross the Channel to Calais. But instead of just catching a bus up the coast, this year we'd be going on a long train journey straight from Calais docks. The journey was to take us right through France, Switzerland, and on to Austria. We'd be on the train for a day and a half! There was intense excitement at the prospect of this journey.

As had been the case last year, the weeks immediately before our holiday were filled with lots of preparation and activity. All the washing and ironing for our holiday had to be sorted, as did the actual travel arrangements. Just as important as this was sorting out exactly where Gran would be going for the two weeks of our holiday. This year Aunty Rosie won the lottery. So, a few days before we were due to depart, Gran was despatched from Exchange station on the morning express up to Barrow-in-Furness.

When Dad came home from work on Friday evening, we were all issued with our final check lists, which included exactly what clothes we would be taking, what toys and books we would be responsible for, and most importantly, just how much pocket money we would be allowed. We were also made responsible for checking that everything on the list was actually inside of our rucksacks and cases. Mum or Dad did a double check just to make sure anyway. The discipline of Work Study was winning converts every day.

The 82d deposited us outside Lime Street station which stood towering over us, enveloping us in its voluptuous beauty, like an old well-endowed, kindly and caring aunt, who'd watched over every passenger's arrival or departure for more than a hundred years. Our little party must have looked to her like wartime evacuees. There were some differences though. Our clothes were perhaps a little neater – I

was proudly sporting my black blazer with the distinctive badge of St Margaret's school sewn on to the breast pocket, Jean wore a new St Peter's uniform, and Colin was dressed in an old, but recently cleaned, one.

The musty fourteen-coach train trundled its way through the night, meandering through what must have been every siding between Lime Street and Euston. After the countless intermittent stops along the way, we emerged into a cold, damp London morning (some six hours later). During the journey, Colin was the only one to sleep for any length of time. He must have been in a very heavy sleep because, just beyond Rugby, when his rucksack came falling on top of him from the luggage rack, he didn't even bat an eyelid!

We travelled across London and then spent some time in Victoria Station before boarding the train for Dover. Victoria was quite different from Euston. Its layout was completely different, and as the morning opened, we were able to witness the hustle and bustle of the first flush of commuters. It appeared that their only aim during this frenetic activity was an endless quest to arrive in work in a totally dishevelled state. Then, after a respectable gap of maybe an hour or so, a more sedate and genteel set of daily travellers began to arrive – many of whom were no doubt drawn from the far-flung regions of the Empire, places such as Brighton, Hastings and Worthing. These later arrivals didn't look like the office workers who'd been arriving earlier, they appeared to be drawn from the higher echelons of the capital's workforce. They even had different rules of engagement – part of the ritual being to greet the ticket collector with a clipped 'Good morning'. But Mum and Dad were far too busy to spend much time observing this particular phenomenon. Their first priority was to get cups of hot tea organised. This was somewhat easier said than done, as half of the travellers passing through were now in the queue for this life-giving elixir.

Having achieved that first objective, Mum and Dad's next aim was to make sure that we'd all been to the toilet. Jean and Mum went off in one direction, and we dutifully trailed behind Dad in the other. The dingy white-tiled public convenience was the biggest I'd ever seen, with enough spaces for at least fifty standing guests and twenty of the sitting variety. After locating an empty bay, I experienced some considerable difficulty in finding my little friend below, being enmeshed somewhere within those new underpants and rough grey flannels. With one hand keeping tight hold of my rucksack, having to contend with five fly buttons wasn't the easiest single-handed operation in the world.

We were soon making our way back to the rendezvous, ready to start the next phase of our journey, but before we could board the train, we had to meet with the representative from Tyrolean Travel. He rolled up twenty minutes late, looking like a cross between an advertisement for Colgate toothpaste and a well-groomed Saint Bernard with those sad, languid eyes. We were to find later that his incongruent facial features were in total accord with his incongruent character. After introductions had been made and tickets distributed, we were on our way down to Dover. We knew all about the formalities of the customs, so it wasn't too long before we found ourselves walking up the gangway onto the ferry. Rumour

was rife as to whether we'd actually get across the Channel that day. Different members of the crew were suggesting that weather conditions in the Channel were continuing to deteriorate. The indomitable British spirit was still alive, however, and it was going to take more than a few white crested waves to deter us intrepid travellers. Sailing from the dock to the harbour wall wasn't too bad, but after that, the sea state changed quite considerably. I decided to go below, arguing that, if I couldn't see what was going on, there wasn't much chance of me being sick. This was not good logic! In the next few hours new relationships were developed, as passengers held on to one another in the biting wind, leaning over the rails in an unspoken, but common aim. Collective self-dignity was now sinking to an all time low.

Amid all of this apparent chaos, Dad went on smoking his pipe, Jean kept on munching her Smarties, the ship kept on bobbing up and down, and the captain kept on announcing over the tannoy that stabilisers were fitted – just whom he was trying to convince was a matter of some conjecture. After what seemed to be an interminable length of time, we arrived in the embracing shelter of the harbour wall at Calais. Jean was promptly sick. Following much cleaning of her blue gaberdine mac, we disembarked with some considerable relief. Mum's prayers had been answered!

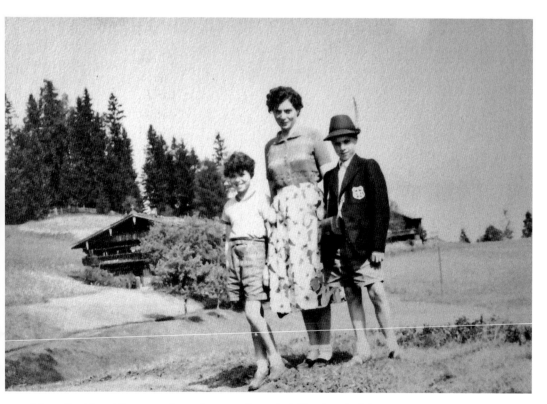

Mum, David and Jean pose for a photograph on their Tyrolean holiday.

Customs officers were very different on the other side of the Channel – somehow they seemed to be more official and officious than their counterparts in England. The surprised expression on their faces indicated that it wasn't too often that they saw three young children and their parents passing through the port. With rucksacks and suitcases duly scrutinised, we left the customs hall and walked out onto French soil. Just a few yards, or more correctly, metres away, we saw the stark outline of the dark green SNCF train. Even the steady drizzle which was now falling didn't detract from its majesty and look of sheer, naked power. Mum told us to get on at the nearest coach to avoid the rain. We escaped the drizzle but had to negotiate our way through five long corridor coaches until we reached our reserved compartment. Two sedate middle-aged women had already occupied the window seats. Judging by their reaction to us, they were a little surprised, and maybe none-too-pleased to learn that we would be sharing their compartment for the next thirty-six hours.

Pencils and paper were rescued before rucksacks were stashed away with the rest of the luggage. After her cross-Channel ordeal, Mum was still feeling a little woozy and asked for a pot of tea. This was Dad's cue to find the buffet car, another first for our family. If Mum had have been well, he wouldn't have entertained such an extravagant request. The cost of the small pot of tea was the equivalent of 'half a sheet'. By the time Dad got back from the buffet car, the train had departed Calais, and was making its way through the marshalling yards on the outskirts of town. During the remainder of that afternoon and evening we eased our way around Paris, and continued to head down towards the Swiss border. Progress was slow, as the train stopped at every other small station along the way. When we did come to a large town, the train stopped for even longer and we were left staring out onto abandoned platforms for upwards of half an hour. Observing this particular pattern, Dad took the opportunity of departing the train at these stations in a quest to buy food, as the snacks available on the train were prohibitively expensive. His forays onto the platforms were a little nerve-racking, as it was touch and go as to whether he'd get back on the train in time. Fortunately, he always did!

After the first few hours of absolute and stony silence, our reluctant travelling companions ventured to make some polite conversation, but this was only to ascertain the sleeping arrangements. As night was beginning to fall, the pleated cotton curtains were drawn across the window, the overnight case was opened, and a new nightie and two new pairs of pyjamas were brought out. All three of us made our way along the corridor to the end of the coach. This was in order to clean our teeth in the wash room before getting ready for bed. Once attired in our nightwear, we sang our prayers as usual before being shown to our respective couchettes. This interlude signalled a complete, but welcome change in attitudes towards us from our fellow passengers. We'd been accepted!

The gentle motion of the train ensured that we drifted into slumber very easily. Dad woke us up a few hours later as we were crossing the Swiss border. Here, customs officials came along checking passports and other travel documents. We were soon getting back to sleep again, and the train continued on its journey

through the night. When we woke up next morning, we were travelling through Austria towards Innsbruck. We then transferred to a local train which took us to the regional capital, Vorgl. Our journey from Speke was now nearing its end. After our luggage had been loaded onto the roof rack of the local post bus we boarded, and experienced a tortuous journey along winding mountain roads leading to the tiny hamlet of Oberau, our holiday centre for the next two weeks.

It was easy settling into the small family-run hotel. Everyone was very friendly, and the son of the hotel's owner was the same age as Colin. We played with him quite a lot during our stay. He was able to show us all the nooks and crannies in the bowels of the ageing building, and also introduced us to other children in the village.

Our bedrooms in the hotel were particularly large, and spotlessly clean. Days started early, not long after the sunrise, as we were awakened by the smell of the freshly baked bread rolls assailing our nostrils. The bakery was only a few blocks down the road, and by five o'clock in the morning the baker was in full production. It wasn't long before we were running down to the dining room to feast ourselves on fresh fruit juices, yoghurt and the newly baked confectionery. Days were long and happy. After breakfast we played in either the hotel or its grounds before venturing out along one of the many footpaths around the hamlet. Returning before midday, we had a light lunch on the hotel veranda, before getting changed into our swimming costumes and heading off to the open air pool on the outskirts of the village. Most afternoons were spent there. Apart from the almost stagnant water and the large horseflies which always congregated around the pool, the only other feature to be remembered was the slimy, semi-submerged log which floated in the water – this acted as a focal point for pool games.

The highlight of the week occurred on Wednesday evenings when the local Oompah band came along to the hotel. Accompanying them was a group of Tyrolean dancers, dressed in their traditional national dress: the women in white embroidered blouses and long flowing black skirts, and the men in funny short leather trousers with matching braces. As the band played and the dancers went through their intricate steps, more and more hotel guests joined in, until the whole of the hotel's veranda was filled with people enjoying each other's company. Time in Oberau passed very quickly.

Our two weeks soon came to an end. As we were packing our bags there was a knock on the bedroom door. The hotel manager, dressed in a long frock coat and looking particularly grand, was standing outside with his son. They came in and presented each of us with Edelweiss, a gift to treasure and remember. We were soon boarding the post bus again and heading down the mountain road to Vorgl. We arrived at Innsbruck as night was falling, and then had to wait until our train departed. Everything was pitch black outside, that is, until the start of the most spectacular electrical storm. From 10.00 p.m. until just before midnight, when the train left for Calais, the sky lit up, and it was as clear as day. All around we could see, in stark relief, the peaks of the mountains that surround Innsbruck. A memorable goodbye.

David riding on the chair lift – Austria.

Hotel in Oberau.

16th Allerton Band on parade in Speke.

On the way home we talked about many things: the visit to the glass factory at Rattenburg where we'd bought cut-glass vases; Colin running uncontrollably down the mountain path behind the hotel; the Golden Roof at Innsbruck; our trip to northern Italy; the funeral when everyone from the village attended; and Dad's handmade boots which were specially made for him by the local shoemaker. Oberau was very different from Speke!

5

Teenage Years

My arrival at St Margaret's was not heralded with much enthusiasm. For the staff, many of whom were standing around with resigned looks on their faces, the event was no doubt as magical as the pleasure that an ageing pit bull terrier gets when cocking its leg for another tiresome, yet painless, pee.

Douggie Swift who lived just up the road from us, and who was going into the third year, was asked to show me 'the ropes' in the first few weeks. Before going to the school, I was invited to meet him and his parents. Mum and Dad also came along to that first meeting. I'm sure that during this very brief, yet formal, introduction, they took the opportunity of checking exactly what was needed in order to meet with minimum compliance regulations for the school uniform. One thing was for certain: my standard uniform would be somewhat different from the uniform which the school recommended. Their standard set of kit included five grey shirts, three white vests, much sports equipment and two pairs of short grey flannel trousers – at that time, boys didn't start to wear 'longies' until their early teens. Some of the uniform had already been bought at Manner's, but there were still one or two outstanding bits.

On the first day, we were welcomed to the school by the headmaster, W. S. Grimshaw BSc. He mumbled a few words about what a well-established school we were joining, with good educational standards and solid traditions. He also detailed the behaviour that would be acceptable, and also the activities that wouldn't be tolerated by the school authorities. I can't remember what behaviour it was suggested wouldn't be tolerated, suffice it to say that I mustn't have transgressed too far, since I emerged five years later still intact, but having few qualifications to show for my sentence. I left relatively unscathed – a model pupil perhaps! The only memory at the end of that first day was of asking the question 'What does BSc mean?', then – having received the answer – resolving to be able to boast those letters after my name.

Everything was exciting in this new, and infinitely bigger school. It certainly was very much bigger than the little village school I'd just left behind. Also, there were lots of new subjects to study, such as French, woodwork and geography. I was told that the school was 'three form entry'. By this they meant that about

ninety new pupils started at the school every year, with about thirty kids in each class. Pupils were graded by teachers' initial, and unseen, assessment of ability and possible potential. I went into class 1y, the middle class. The top class was 1x, and the bottom was 1z. It was pointed out that there was scope for movement between classes, but you had to be very good to go up, or, conversely, very bad to go down. For the time being, 1y suited me.

We had French on the first day and our teacher tried to explain the different use of languages in other countries. His opening words were *la porte* and *la fenêtre*, the door and the window respectively. We repeated this – my very first words in French! I still couldn't understand, however, why people had to use a language that wasn't necessary. After all, what was wrong with English, if everybody spoke it?

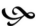

Although exciting at first, I was now finding that school was becoming a bit of a chore; I preferred my weekends, especially when I was allowed to work with Dad. He'd developed an interest in photography and I was keen to follow in his footsteps. In the late 1950s and early 1960s, amateur photography became the vogue in working men's circles. Kodak, Ilford and other specialist companies had produced lots of innovative products. Film was more widely available now that the deprivations of the war were receding, and national economies were beginning to move away from a wartime footing. Now, newly formed night school classes were beginning to run and educate people in the art of developing negatives and printing. Also, a few people had been introduced to the concept and mixed blessings of the package holiday. This meant lots of holiday shots. Some were now in full colour, although this was the exception rather than the rule. Keen photographers were also beginning to take slides. Dad hadn't graduated as far as slides, but he was certainly becoming very interested in standard black and white photography. The discussion group, which he attended on a regular basis, changed its unwritten constitution to reform itself into the Speke Amateur Photography Group.

In between discussing matters of photographic interest and concern, they no doubt had time to discuss other issues which they considered to be of interest, such as the state of local party politics. The group was almost exclusively working class, being based in Speke, and most of its members worked at the Dunlop Rubber Company. When it became more widely known that the group was in existence, and more particularly that, occasionally, they had live models, the membership grew quite considerably. Oblique references were sometimes made to exposures, although I didn't quite make the connection at the time. Some quite good nude photographs were discarded and left for the bin-man to collect – these had obviously been over-exposed!

As the club developed, and members became more ambitious and inquisitive, the club secretary, for the club was now on a far more established and formal footing, organised a number of Saturday morning trips to local places of interest. Here, members who weren't working on Saturday morning could get their f11, f16, and 1/100ths of a second sorted out, and snap away to their heart's content.

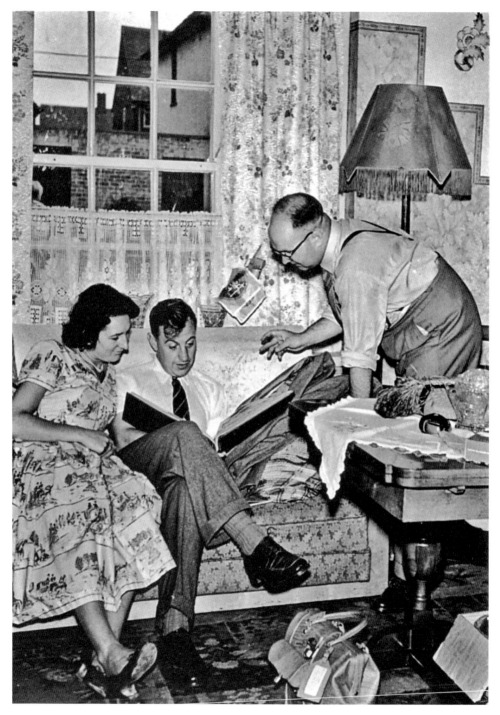

Dad explaining some of the finer points of his photographic techniques to Doreen and Bleddyn.

With all three of us at home during the weekend, Saturday was sometimes a day filled with sibling rivalry and friction. Because of this, and to get me out from underneath everyone's feet, I was dragged along on some of the outings – the old approach of divide and rule! Popular visits included the Anglican Cathedral, the Liver Buildings and Lime Street Station, all of which were in the city centre. The group met at Western Avenue bus terminus, near to Dunlop's factory, and caught the 82 down town. The cathedral was in its final stages of completion. It was a magnificent sandstone edifice. When we got there, my first thoughts were of the quarrymen who'd hewn the stone from Woolton quarry. We were conducted around by one of the canons of the cathedral. He obviously knew the building inside out, and explained its construction and development in the minutest detail. We also received a blow-by-blow account of all the major services held there during the last ten years. The climax of the visit was when we were led, with great ceremony, up the stairs to the bell tower. Some ten minutes and about two hundred and sixty steps later, we emerged at the top of the cathedral's central tower. The lancet arches that formed the balustrade around the periphery were only about 4 feet in height, and on a windy Saturday morning, thoughts of being splattered on the cathedral steps a couple of hundred feet below were never very far away. When attention could be diverted to focus on the view from the top of the tower, it was, as they say, breathtaking! Although the wind was swirling around the top, the day was still very clear, and we could see right across the Mersey to the Wirral, and even as far as the hills of North Wales. Looking in the other direction, we could see the elbow of the Mersey, etched out like one of Popeye's distorted arms. Somewhere down there the Mersey flowed past smelly old Widnes. I never dreamt for one minute that it was flowing in the other direction, and coming towards Liverpool; I'd always assumed that the Mersey started at Liverpool! I didn't venture too close to the balustrade, but stayed near to Dad, feeling immense relief when the canon said that we needed to be making our way down to see the Chapter House. We were treated to tea and biscuits when we arrived at ground level, and somebody made an impromptu speech thanking the cleric for his time and also for sharing with us his knowledge of the cathedral.

The next trip, which was a few weeks later, was to the Liver Buildings – the iconic building that dominates the waterfront at Liverpool and is a metaphor for the city itself. Like the cathedral, its central tower is very high, but that's where the similarities end. The Liver Buildings weren't built in praise of Almighty God, but in praise of the Royal Liver Insurance Company and its associates; that meant that the building had to be very tall indeed. From the top of the building we could see right along the length of the busy Mersey waterfront, with all of the different coloured funnels of the many ships that plied to and from the busy port of Liverpool. Also, and again like the cathedral, we could see over the blue heartland of Toryism on the Wirral, and further afield, the nationalist stronghold of North Wales.

The third and most vivid visit was a trip to Lime Street Station. This was in the days of steam trains, and now, with those wonderfully coloured rose-tinted glasses, which are issued to people when they reach forty, the scene was reminiscent of

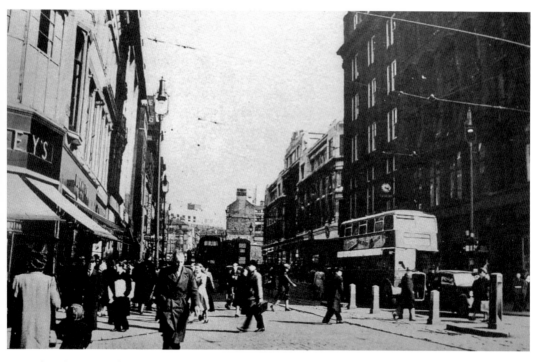

Church Street before it was pedestrianised.

many of Monet's paintings of Gare Saint-Lazare with steam hissing out of engines from many different orifices. Everything became blurred with a fog of smoke and steam. It was here on platform seven that we walked right the way up the length of the London train to watch the Lime Street engine turntable in operation. Later a huge navy-class loco was shunted onto the waiting carriages. The engine's fireman showed us his party trick. Opening the door to the furnace, which was a mass of red and blue glowing coals and fierce flames, he cleaned his shovel, held it in there for a minute, withdrew it, and then, to our amazement and astonishment, cracked an egg on the shovel face. The shovel was fed back into the furnace and then, thirty seconds later it was pulled out – the egg was fried to perfection! We didn't actually watch him eat it, but the performance was on a par with anything to be seen at the Liverpool Playhouse, and that's in no way to demean the talents of their actors.

Back at school, everything was slotting into a regular, if boring routine. The first lesson on Monday was a double period of woodwork with 'dirty Sid'. This was a good way to start the week because we could catch up on all of the weekend's happenings. Woodwork lessons weren't too bad. I shared a bench with Aggie and as his dad was the local painter and decorator; teachers who lived locally treated him with a degree of deference, not to say caution. Working at the bench was

quite good when we got some wood, but the problem was the teacher. 'Dirty Sid' was a bit of a boy for the bum, so you had to watch yourself while within striking distance. Other than that, the sum-total of my two years effort in woodwork was a table lamp base, an egg rack, and a rickety book holder.

During the course of that first year at St Margaret's, many friendships were both formed and broken. One of my closest friends in that first year was a boy from the north of Liverpool, Stuart Granger. I got to know him quite well and enjoyed chatting with him about everyday things – football, family life, girls, cars, etc. His mother was Dutch, a fact that quite fascinated me. I was invited down to their house in Waterloo one Saturday morning. As Waterloo was in the very north of Liverpool, and Speke was at the very south end of the city, it took almost two hours to get there. Granger met me at the Ribble bus stop. I was amazed when we arrived at their house – it was three storeys high, had six bedrooms and several lounges downstairs. I couldn't believe it. In the garden, they had an aviary with lots of exotic birds. This was just something else which was way outside of my experience. It transpired that Granger's father was Chief Engineer on one of *Empress Boats*, a very prestigious job. The style, environment and standard of living in their house was very different from my home. In our home, Dad made his way to work on a clapped-out US Army surplus bike, whereas his dad went to work in a chauffeur-driven car. They had soufflé for lunch – we had jam butties. Our small three-bedroomed house had six people living in it, whereas there were only four people living in their large six-bedroomed house. I felt quite ashamed. Later that summer Dad picked up on this and asked me why, after having made several visits to Granger's house, no return visit had been made by him. We then had a very long talk about this, and Dad explained that home wasn't just about big houses and grand meals. He said that it was about being united, sharing in love and happiness, and having a worthwhile set of standards and values. It was only then that I began to realise one of the first and most fundamental facts of life, and from that time on I was never again ashamed of my family or background.

One of the subjects that I really liked was billed as music, although in reality it was a singing lesson. During this time we learnt patriotic songs and one or two traditional airs. One day, Jim Brophy and 'Mac', the teachers in charge of music, introduced us to the *Earl King*. This was a mournful piece about a father riding through the night with his dying child. Knowing this, the father cradles the child in his arms and tries to ride even faster in a desperate attempt to seek help. The son, sensing he is dying, sees death all around embodied in the *Earl King*. Although the father desperately implores his son to hold on to life, the son can see the *Earl King* coming closer and closer. Eventually, in a very dramatic climax, the struggle is over, the *Earl King* wins, and the son dies in the arms of his distraught father. At this, most of the boys in the school hall erupted into pleats of laughter. I sat sobbing with my head down.

After the trips with the photographic club, I began to take a more active interest in photography, but it was quite an expensive hobby, and was perhaps a little more expensive than Dad could afford. So, every now and again he'd suggest that we went through to St Helens to buy some out-of-date film. There was a shop there that sold film for about one third of the retail price – obviously a particularly good buy. Dad preferred Ilford when he could get it, as he said that this produced a much better quality of photograph – it was something to do with sharpness and

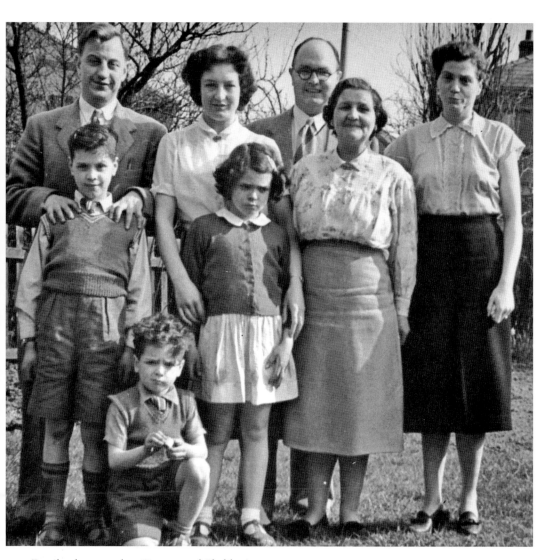

Family photograph at Doreen and Bleddyn's.

depth of field I think, but I just accepted his word anyway. Whenever he went there he'd take me along for the ride.

St Helens corporation buses, and it was St Helens who operated the 89 route between Speke and St Helens, had smart red and cream livery. Like many of the Liverpool buses, they were Leyland diesels, but they must have been based on a different chassis, as they always seemed to be shorter and a little narrower, but perhaps that was just my imagination. Whenever we did go on the 89, we boarded at the terminus, which was only one stop along from our usual stop in Central Avenue. Also, we went upstairs – this was so that Dad could smoke his pipe as we went on the hour-long journey. The seats on the St Helens buses were quite luxurious, being covered with a sort of patterned valour material, which was very different from the harsh leatherette seats provided on Liverpool buses. When the bus drivers were behind time, or when they were feeling particularly lazy, they took the short cut along Woodend Avenue towards Hunts Cross, but then they followed the normal route to Woolton with which I was very familiar. After that we went out along Acrefield Road, down Gatacre Brow and then through areas that I didn't know on our way to St Helens. It was always a real trip of discovery.

The bus terminus at St Helens was to the side of some large and very imposing Victorian buildings, which I assumed must have been the town hall, but I never knew that as a matter of fact. Upon leaving the bus, we walked into the old town centre and then out towards the farther side of town where the photographic shop was located. On our route we passed a large billboard that proclaimed 'Beecham's pills for working people'. Dad gave a wry smile, but the significance went completely over my head as I didn't know the significance of the statement, or even what a laxative was!

The photographic shop sold second-hand cameras as well as new ones, and Dad normally spent a few minutes examining these before making his way over to the fixture, which was a large hardboard hopper-type container, full of boxes of assorted film: 120, 126 and 127, as well as the 35 millimetre, which he now preferred to use. The next ten minutes were spent in finding the rolls of film that had the most recent expiry dates. So as to make the trip worthwhile, he bought at least twelve rolls of film, but I think that he might have sold a few of these to other members of the club, so that he could defray some of his travel expenses.

I certainly enjoyed those trips, and I certainly enjoyed being invited into Dad's darkroom, which was very special to him. It was perhaps the 1950s equivalent of the garden shed, having restricted entry, but, in its normal guise, it was the family bathroom. Dad used to escape there on two or three nights a week. On those nights he commandeered the room for the evening, that is, after we'd all had our evening wash before going to bed. What he did then was to transform it into his own darkroom, as it was mysteriously called in photographic circles. In order to effect this transformation, he first placed a sheet of hardboard over the bath, which was suitably reinforced around the edges with lengths of one-by-one wood to give it some rigidity. The bath cover had suitable holes cut into it in order to accommodate the taps that protruded at the end of the bath. It then took

Dad was never seen without his faithful pipe.

some time to set up the equipment and apparatus on top of the improvised work bench. The surface was divided into two distinct sections by using a hardboard screen. On one side of the screen, Dad placed his enlarger, and then connected it to a three-pin plug on the landing – the law wouldn't allow any electrical devices to be connected in the bathroom. On the other side of the screen, he placed three 10 by 8 trays, similar to the seed trays used in the garden. He then took out from the cupboard under the bathroom sink two large brown screw-top glass jars, one filled with the developer, and the other with fixer. Developer, to a depth of 1 inch, was carefully poured into the tray nearest to the enlarger. The second tray was filled with water from the bathroom sink tap, and into the third tray he emptied the fixer. Both of the clearly marked brown glass jars then had their tops screwed on and returned to the cupboard. Dad then replaced the 60-watt pearl bulb for a special light. It was a small red filament bulb which emitted a subdued red glow, enabling just the outline of the enlarger and the various dishes to be seen. The last operation before printing started was to cover the bathroom window with a piece of very heavy black curtaining material, thus rending the bathroom completely dark – ideal conditions for printing. With everything set up and the door closed, we took our places at the two small wooden stools that were placed on either side of the screen. The enlarger, which was Dad's pride and joy, changed the size and focus of the image being projected onto the virginal photographic paper by means of a wheel-operated bellows mechanism. Using a small toggle switch on the electrical flex connecting the enlarger with the mains electricity, the paper was exposed to the light for a set number of seconds – Dad always knew the exact time, although the resulting images were sometimes very dark.

The now impregnated paper was then carefully lifted into the bath of developer where it was completely submerged and, again, left for a specific length of time. All of a sudden, as if by magic, a faint image began to appear on the paper. The image gradually became more well-defined and darker. At a given signal from Dad, I lifted the photograph out of the developer with plastic tweezers and submerged it into the waiting dish of water. When Dad deemed that the water had done its job and washed the developer off the paper, it was then dipped into the fixer. Once the photograph went in here it wouldn't develop any further, but would be fixed at that tone and definition. Everything had to be timed right down to the very last second, so Dad had a stop watch for this part of the operation.

Throughout the whole of the printing process there was an acrid smell of chemicals in the dark room which got down my throat; this got progressively worse as the evening wore on and became almost intolerable when Dad lit his pipe, which he could never seem to do without.

After leaving the Cubs, Mum and Dad invested in a new scout uniform, and I was welcomed into the 16th Allerton Scout Troop. I didn't stay here too long, as some of the practices which occurred in the toilets were unsavoury in the extreme! Also

we never did any badge-work. Lots of kids in our school who were in different troops had been entered for the cyclists badge, the First Aid badge, the swimming badge and many more besides. We didn't do anything like this. But worse was to come. Every year we were exhorted to do 'Bob-a-Job', when we offered to do little jobs for people, usually family and friends, in return for a contribution towards scout funds. Wanting to go one better, I started hawking my services around the streets of Speke. I came across one unsuspecting old lady in Sutton Wood Road who said that she had a few bits that I could be doing in the back garden. I went home for my spade, but when I came back I was asked to dig over the whole of the garden – I was there all day!

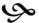

By now the year settled into a steady routine, and for fairly obvious reasons, weekends were infinitely more appealing than weekdays. But one weekend in that first year at St Margaret's stands out more than most. When I arrived home from school on the 81d, Dad was already sitting in the living room. This in itself was most unusual, because Dad was never home before 5.30 p.m., and before he'd purchased his US Army surplus bike it was normally 6.00 p.m. before he got home. But today, not only was he home and sitting on the settee, he was smartly dressed in his good suit – the one that he always wore on the rare occasions we went over to see Aunty Gladys and Uncle Sid in Bromborough.

Before I'd even had time to put down my satchel, he told me to go upstairs and have a good strip wash. This was also unusual, and almost as bad as a bath – a ritual reserved for Saturday evenings. As I was finishing my all-over wash in the bathroom, Mum came up and said that she'd put out some clean clothes for me in the bedroom, but she wouldn't tell me what all the fuss was about. It was only when I went downstairs some twenty-five minutes later that Dad shared his little secret. Well, he didn't tell me the entire secret, he just informed me that we, me and him, were going up to Barrow-in-Furness for the weekend.

I was given the task of carrying Gran's small attaché case – the only serviceable case that was available and suitable at the time. I'm not too sure what was in it, but I'd watched Mum making some corned beef sandwiches earlier on, so I knew that they'd be included. Mum walked down with us to the bus stop in Western Avenue, on what was turning out to be a cold, dank evening. The Crosville 120 sped along towards town as most passengers, at that time in the evening, were on their way out of town rather than going into Liverpool. Because Dad always insisted on smoking his pipe we went upstairs on the bus, so he was able to puff away all the way to the Pier Head. Leaving the bus, we then had the walk along Water Street and then Dale Street and on to Exchange Station, where another treat awaited me. First of all we queued for what seemed an interminable length of time for our second-class tickets up to Barrow, and as soon as Dad had secured them safely in his inside pocket, having first checked every single detail, we walked over to the W. H. Smith stall where Dad invested in an *Amateur Photographer* and I was given a choice of either

an Eagle comic or the *Children's Newspaper*: *Dan Dare* and the *Eagle* won hands down! We sat alone in the cold waiting room for upwards of half an hour, quietly reading and thinking about the weekend ahead. There was a fire in the grate along one of the walls, but nobody had bothered to put any coal on, and the greying embers were just about dying. The room became progressively colder, and my school blazer and gaberdine mackintosh didn't offer too much protection against the chill wind that was now embracing the room. Sometime after 7.00 p.m., Dad suggested that the train would now be waiting, so we made our way to platform five where we found the six-coach train. I insisted on walking up the platform to look at the engine before we boarded the train, although train spotting and engine numbers had never featured on my list of hobbies – it was just one of the many childhood pursuits that didn't hold any interest for me.

As soon as we sat down in the dimly lit second-class compartment, Dad pulled down the faded linen blinds and drew the window curtains, assuming that these actions would preserve the privacy of the compartment, and enable us to enjoy an uninterrupted journey. Delving once again into his inside pocket, Dad took out his wallet. I naturally assumed that he was just checking the tickets once again, but a minute later he handed over to me a wad of crisp, new five-pound notes – I'd never seen so much money before. Quietly, and with a wry smile on his face, Dad asked me to count the money. Very slowly and with infinite care, I counted a total of twelve notes – sixty pounds in all. I then made a second count, just to ensure that there was no mistake. I looked across to Dad, and could tell from the expression on his face that, by simple deductive logic, he'd already anticipated my next question: 'What's all this money for?' His answer was simple, 'All being well, we're going up to Barrow to buy a new family car.' And on that happy note, I heard the station master's piercing whistle and felt the first lurch of the train, which signalled the start of our northwards journey.

We stopped at a few stations on the way up, and as is so often the way on Friday evenings, the compartment we'd wanted to reserve for ourselves was soon filled with another four passengers, all, in their various ways, no doubt looking forward to an exciting weekend. Two of the travellers appeared to be middle-aged, middle-class spinsters, and judging from the way in which they tucked themselves as tightly as they could into the corner of the compartment, and then promptly pulled out copies of the latest Mills & Boon novels, it was abundantly clear that they didn't want to join in any conversation. They did, however, give us an old-fashioned look which prompted Dad to pull at the leather window strap so that the window dropped a little, just enough to clear the fug that he'd created during the last half hour since he'd been smoking his pipe. Another traveller was a youngish man whom Dad thought must be a student travelling home for the weekend, and our fourth companion was an itinerant plumber, currently working in Preston, but on his way home for a few days. We discovered that he was a plumber because he immediately engaged Dad in conversation, and was just about to regale him with some of his more fanciful and interesting extra-occupational exploits when I caught Dad nodding in my direction, indicating non-verbally that perhaps his

stories weren't quite suitable for younger ears. It was a pity in some respects, as for the next six months maybe I considered getting an apprenticeship in plumbing when I left school! Our plumber friend vacated the now smoke-free compartment as the train was pulling into Lancaster. We waited here for another twenty minutes or so, looking out onto the – by now – deserted platforms. The only sign of life was a man pushing a trolley and selling hot drinks and snacks, and just one or two other people waiting to catch the late train to Scotland, so Dad informed me. We moved off to Carnforth, the last station stop before Barrow-in-Furness. After leaving there, Dad pulled back the window curtains and put up the blind. Crossing over the bridge and skirting around the curve of Morecambe Bay, we were greeted by reflections coming from the twinkling lights shining through the windows of the Westmorland Grand Hotel shimmering on the icy waters. The hotel stood out like a glittering crown set into the hillside.

We slowed down going through Grange-over-Sands, but as it was only a small town the express from Liverpool didn't bother stopping there. Not many minutes later, sensing the change and anticipation in Dad's manner, I knew that we must be getting near to Barrow-in-Furness; also, he'd knocked out his pipe, checked if I needed to go along to the toilet, and then, just as the train was beginning to slow down, asked our two spinster ladies if they wanted their cases taking down. Dad reached up to the string-bottomed luggage rack above the bench seats and retrieved the single small case that the two ladies were sharing. The holiday advertisements, fixed above the seats on either side of the compartment, portrayed in innocent detail the delights of Southport on one side and St Anne's on the other. They looked to be drawings of the respective towns printed in primary colours onto cardboard; they weren't very effective, and Barrow didn't even get a look-in!

So, a few hours after leaving Exchange Station, we'd reached our weekend destination. There were very few people waiting on the main platform as our train eased into the station, apart, that is, from the lone figure of Uncle Bob who we could see sheltering under the overhanging canopy of the waiting room, eyes straining to see his relative from Liverpool. It was drizzling very heavily as we emerged from our coach, but not even that could dampen our spirits. As we were among the last of the passengers to leave the train, Uncle Bob immediately spotted us and came bounding over to greet us. He was obviously pleased to see his brother-in-law, and perhaps a little surprised to see me. He shook hands with Dad and then patted me on the shoulder. As our corned beef sandwiches had been eaten well before arriving at Preston, Uncle Bob's suggestion of taking in fish and chips was very welcome. Fortunately, the chip shop was right at the very bottom of their street, James Street, and as the pubs hadn't emptied out as yet, there was only a small queue. Very soon we were walking triumphantly up the brew of James Street, ready to consume our supper.

Aunty Rose, resplendent in hairnet and floral pinnie, was obviously pleased to see us and stood by the table in one of her typical postures. Back arched, she bent over and clutched a loaf of bread into her bosom. Then, holding the knife in her left hand, she deftly swept the blade though the bread with a much practised action. I'm not

sure why or how she developed this unique cutting technique, as she had a perfectly acceptable, but redundant breadboard in the kitchen. The 'doorsteps' thus produced were of all shapes and sizes. They were then smothered in Summer County margarine. The plate was piled high and looked like some gruesome yellow and white totem pole which was just about to topple over. It was then ceremoniously placed in the centre of the table, standing proudly next to the ever-present bottle of HP sauce.

Our meal consumed, Dad and Uncle Bob dropped into deep conversation, with Dad drawing heavily on his pipe, and Uncle Bob enjoying yet another 'ciggie'. But, all good things come to an end as they say, so it was off to bed and dreams as to what events would fill our day tomorrow.

The day duly dawned and, following another fulsome meal, Dad and I set off for Ulverston. The small town comes to life every Thursday when the cattle market is held, and because of a by-law passed some eight centuries ago, the pubs are allowed to stay open all day – much to the delight of traders and farmers alike. But today was Saturday! The distinctive blue and white Barrow Corporation bus, with its proud coat of arms emblazoned along the side, dropped us off in the centre of Ulverston some 8 miles inland from Barrow. We then had a long walk out to the Glaxo chemical plant which was on the outskirts of town, near to open countryside. The man whose car we were hoping to buy was working an extra shift. Dead on the dot of twelve, the factory hooter sounded and workers came streaming out – some walking, some riding bikes, and others in cars, but all reprieved until Monday morning. Towards the end of the exodus, we spotted a black Austin 12 coming, very sedately, through the factory gates; for some reason I immediately thought of the Queen Mother. The car pulled up next to us, and Dad introduced himself to the owner before we climbed in and set off on our half-hour test drive around the streets of Ulverston. Everything was perfect. Dad kept nodding and smiling as he alternated between chatting with the owner and checking the dials on the dashboard. Meanwhile, I was enjoying the drive in the back, being sat on the fine-grained leather seats that smelt of beeswax polish. Even the floor was covered in carpeting that was better than we had at home.

As our demonstration drive drew to an end, the car was stopped at the top of a gentle hill quite near to the factory. A few whispered words were exchanged out of my earshot, and then Dad produced his wallet. He gave the sixty pounds in exchange for the car's logbook and keys. The transaction was completed with due ceremony, and after shaking hands, the former owner went on his way. RN4524, of 1935 vintage, was ours. We had a car, and what a wonderful car!

Dad had driven during the war, but that was a long time ago as we were about to find out! With funereal correctness, he opened the door and ushered me into the front passenger seat. He then walked around the back of the car, opened the driver's door, and sat behind the wheel of his newly acquired treasure, exuding total satisfaction and a certain degree of pride. Moments later his brow became furrowed, as he looked bemused at the array of dials and controls in front of him. He disengaged the handbrake and, almost imperceptibly, we started to roll forwards down the hill. Although the engine hadn't been coaxed into life, we were

Workers finishing their shift at English Electric.

gaining speed, and Dad's agitation was growing in direct proportion to the increase in momentum. Fortunately, he managed to bring the car to a halt before reaching the junction at the bottom of the hill. It took him another fifteen minutes to pluck up enough courage to have a second attempt. This time, by using the starting handle, he did manage to get the engine going. We drove into Ulverston, but it was obvious that Dad needed to be on much quieter roads. We made our way out of town to the coast road. It was then a very easy drive back into Barrow. On the way, we stopped at a refuse tip to pick up some house bricks; these were to wedge under the car when we arrived at James Street. When Dad's new toy was firmly secured outside of number 38, he walked round and gave a resounding knock on the front door. Rosie and Bob both came out and made suitably appreciative noises about this wonder of pre-war engineering excellence. For the rest of the day, the four of us visited just about every relative we could think of in and around Barrow.

The next morning we were up very, very early. In fact, we were up before sunrise, as Dad was concerned about the long drive home on uncharted roads. Aunty Rose came down, bleary eyed, with her dressing gown draped around her. Even at this time of the morning she had a cigarette dangling from the corner of her mouth. After bacon, eggs and fried bread, we were given the customary and obligatory ham sandwiches wrapped in greaseproof paper. There was no heater in the car, so I snuggled into an old army surplus sleeping bag, and was suitably positioned in the front passenger seat. We were on our way well before five in the morning. There were no motorways then, so it was along the A590 to Levens Bridge and

A sulking teenager stood by the *Chariot*.

then all the way down the A59 and A6. We watched the sunrise as we approached High Newton. After the trials of yesterday, Dad was now far more confident in his driving abilities, even though he still hadn't obtained a license to drive! All the way down to Liverpool he chatted about his ideas for the family, now that we had our own car. We stopped a few times in lay-bys to drink coffee from a flask, and also to eat the sandwiches that Rosie had prepared with such loving care.

We didn't get back to Speke until early afternoon, by which time we were both feeling quite exhausted. Mum allowed me to miss Sunday school that day. As most of my friends had already made their way to the Baptist hall, I wasn't able to boast about our new car until later that evening! Also, because it wasn't the done thing to be seen to be working on Sunday, Dad couldn't clean his new car which was now very grimy after our long journey. He was up and cleaning it very early next morning before driving to work. Dunlop's car park was five minutes away!

The *Chariot*, as our car was soon to be christened, was a great source of enjoyment for all of us, and Dad's pride and joy for many years.

With summer fast approaching, apples became bigger and the scrumping season was with us once again. Posh areas were our preferred targets, as they tended to have apple trees in their back gardens. Also, there was the 'Robin Hood' aspect of

the operation to be taken into consideration. Setting off with Yankee, we'd both equip ourselves with duffle bags. These were used to hold the anticipated haul. We tried to avoid gardens with free-range dogs, as their roaming often impeded our progress. My dual role was lookout and packer, while Yankee's brief in the mission was to climb into the trees and throw down the harvest. We tended to aim for eating apples, but being good sons, we made sure that baking apples were not forgotten. Progress was fine until, inadvertently, we went into a friend's garden and stripped their one and only tree. When I went to sing in the church choir on the following Sunday, there was only one topic of discussion in the vestry. This related to the investigations which the police were conducting into the theft of apples, and the alleged vandalism to the garden at the house down the road. This news had a salutary effect. It was just as well I'd heard it before the service, as the next hour was spent in fervent pray asking my maker for both forgiveness and, more critically, deliverance. Fortunately, the local constabulary had far more pressing crimes to investigate, so the case was dropped. The message was clear, 'seek pastures new'!

Lots and lots of apples were now being taken home on a regular basis. Mum was very grateful. She did ask where they were all coming from, but was placated when I informed her that, because Yankee's mum had lots of apple trees, she was sending them as a little present. She didn't know it, but there weren't that many gardens full of apple trees in Rycot Road, with its rows of neat prefabs, and pocket handkerchief gardens. However, the gifts were readily accepted, and Mum carried on making more and more pies. In fact, we had apple pie every day throughout that particular summer. Is it any wonder that I can't even look at an apple pie now!

The school year dragged on. It was enjoyable, except for the exams at the end. One consolation for the teachers was that they didn't have too much marking to do. As a result of the examinations, it was decided that I should be relegated to form 2z on my return to the second year. Even for a young boy of twelve, the sense of rejection, ignominy and failure was quite overwhelming. The only bright spot was that I had a two-week holiday in France to look forward to, and the rest of the summer to accommodate the notion of being an 'also-ran'.

Earlier in the year, 'Mac', the deputy head, had announced that he would be leading a group of pupils on a school trip to France during the school holidays. After pleading with Mum and Dad, they said that I could go. Preparations were even more lengthy and detailed than when we'd been abroad before. First of all, the school had to make sure that everybody had paid for the trip. Every Monday morning after assembly, we all queued up to pay our weekly instalment of ten bob. The total cost of the holiday was in excess of twenty pounds! 'Mac' said that we could also take a maximum of £5 per week for spending money. The school holiday bank was quite separate from the holiday fund itself, and 'Mac's' number two on the trip, Mr Moss, handled all the arrangements. He was a bright fresh-faced teacher of English, who also doubled as a teacher of PE. Very much the

conformist, in that, just like the rest of the younger teachers, he wore grey flannels and a Harris Tweed sports jacket. Everybody knew that PE was his first love, and teaching English was an insurance policy for the time, later in his career, when teaching PE might become too demanding.

Forty-three of us went to France that summer. The starting point for the holiday was the cavernous Lime Street Station. We were going on the midnight train to London. When we arrived just after half eleven, the scene that we witnessed was straight from the club catalogue. My contemporaries, who were normally dressed in short trousers with matching regulation tie and blazer, had been transformed, as if by some benign fairy from the John Moores catalogue, into something approaching respectable young adolescents. The 'in-thing' at the time was suede jackets, and a goodly number of mums were smugly viewing their little protégés. They were also checking at the same time just how many other kids were wearing similar regalia. As we got out of the *Chariot* I was all for turning round and going straight home. I'd asked for a suede jacket, but Mum couldn't afford it. Secretly, she'd ordered a suedette jacket to surprise me. It must have cost her a fortune at the time, but it was nothing like real suede, and I was covered with embarrassment as I mixed with my mates, all of whom were dressed in their real suede jackets. My 'cardboard cut-out' had a zip down the front, and chromium-plated hooks appended at various strategic positions. The feeling was one of absolute and complete inferiority. This thought was easily communicated to my parents. The message was reinforced yet again, that as long as I was clean, tidy and respectable, then I could hold my head high.

The scene at Lime Street was one of intense activity, with mums and dads checking that their sons had every possible material need, and 'Mac' wandering around collecting his little flock together before getting ready to embark on our great adventure. Just before the train pulled out, Mum asked me to bring back some Chanel No 5. To a twelve-year-old boy from Speke, this was too much to comprehend. I asked for the correct spelling and then wrote the request down on the back of a ten bob note. This effort proved fruitless as, less than half an hour later, I exchanged the note for sweets and 'ciggies'. As with most schoolboys going on holiday, we didn't sleep all night, everything was too exciting.

Our arrival in France was a complete non-event. The only incident of note was 'Mac' venturing out to a market stall which was just around the corner from the dockside station, and bringing back a huge tray of large, juicy peaches. Much of the juice came oozing out over twenty-five new suede jackets. I'd never had a peach before, so it was quite an experience. Looking around, most of my fellow-pupils were guzzling their peaches as if they ate them every day – I'm sure that this wasn't the case. The only other memorable thing about that first quayside experience in France was the sight of 'Mac' dodging in and out of the early morning stream of whirling and whining mopeds, with the morning drizzle being picked out by their vivid orange headlights.

The first week of the holiday was spent in Fécamp, a small fishing port on the Normandy coast. During this time we lazed about on the beach, watched the fishing

boats' regular journeys to and from the rich fishing grounds, and had a conducted tour around the Benedictine distillery. We were all under eighteen, so the visit was of academic interest to us. The main beneficiaries of the tour were 'Mac' and the other teachers in the party. On their departure from the distillery, it was clear from their glazed expressions that they'd thoroughly enjoyed learning about the history and distilling of the famous liqueur. At the beginning of the second week we moved through to Paris for a few days of culture and sightseeing. All the usual touristy bits were covered, including the Eiffel Tower, Sacré Coeur and the Louvre. When we went there we saw the Mona Lisa and the Venus de Milo, but I was left wondering what all the fuss was about, because one of her arms was missing!

This first school holiday was very memorable. I fell in love with France then, and it's been an ongoing love story ever since.

It was always special when we went to Barrow, but when we went to my cousin's wedding, it was even more of an occasion. As there was only one train in the evening up to Barrow, we were allowed to leave school early that day. It was unusual to come home in the middle of the afternoon to have a hot bath. Mum had been busy all day making preparations for the long journey north. Even the journey to the station was more fraught than usual because Gran was coming with us this time. We eventually got to the station, only to find that the train for Barrow-in-Furness was right down at the very far end of the platform. After we'd carted everything down the dimly lit platform, we found an empty compartment for the six of us. The journey was uneventful, and after departing from the market town of Ulverston, the shipbuilding cranes of Barrow-in-Furness could be seen on the horizon.

Much as Rosie and Bob were pleased to see us, their little house wasn't really the ideal place for a family reunion. We were all squashed into the living room, which was even smaller than ours in Speke. There was the six of us, Aunty Rose and Uncle Bob, our cousins George and Arthur, and finally Dorothy – she was the cousin who was getting married. As our cousins were much older than us, their respective girlfriends were also present, as were some other, more distant members of the family. Quite a gathering! It was a relief when Dad and I were dispatched to the 'chippy' at the bottom of the street. As we were waiting for our several portions of pie and peas, a favourite in many northern towns, we warmed ourselves against the stainless steel fittings in the shop. On our return, the party was in full swing, with lots of lemonade being given to the kids, and countless bottles of Mackeson and India Pale Ale being shared among everyone else. On this unique occasion, nothing was too much trouble. Dad took full advantage, although he knew that Mum was lurking in the background checking that he didn't empty too many bottles on his own. The adage 'Sit a beggar on a horse, and he'll ride it to death.' still resonates.

As the evening wore on, I grew more tired. Jean and Colin had already gone to bed when Mum asked me to leave and retire to the mausoleum-like parlour which

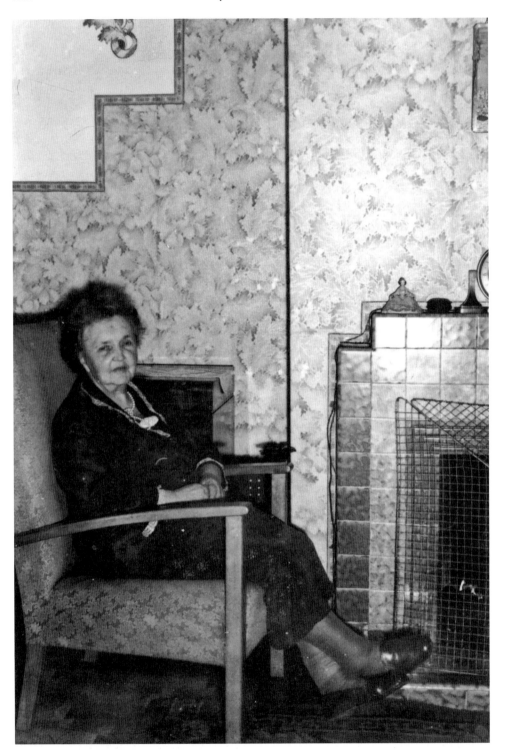

Gran Paul in contemplative mood in the parlour at Speke.

was to be my bedroom for the next few nights. The noise from the living room was both loud and sustained, with most of the adults vying for space in the increasingly smoky atmosphere, and the parrot simply vying to be! It all served to ensure that neither the dog in the kitchen, nor me in the parlour got to sleep very quickly. After all too short a night, I was being woken up again to help with preparations for the great day.

Breakfast took ages, with grown-ups coming down at various times, all in differentiated states of awareness and readiness. Aunty Rosie spent her time bobbing backwards and forwards between the kitchen and living room, with plates of bacon and eggs precariously balanced along her short forearms. On more than one occasion, she only just managed to avoid falling over the dog when coming from the kitchen. I felt sorry for 'Patch', who seemed quite bemused and disturbed with this radical departure from routine.

After breakfast, the three of us were taken into town to have our hair cut. It was then back home for the ritual of 'rolling the pennies'. Traditionally in Barrow, as a bride was ready to leave for church, children would gather outside of the house to wish her well. Armed with bags full of pennies, the bride's father then rolled or threw them from the doorstep to the assembled children. Today, there were about fifteen of them, running frantically after the coins, and jostling with each other while trying to collect as many as possible.

The wedding service itself was boring and nondescript, and although the church was full to overflowing, when Wesley's *Love Divine, all Loves Excelling* was announced, there were very few people who could be heard singing. There was lots of muttering after the service. Although St George's was a typical middle of the road Church of England establishment, things seemed a bit odd. Maybe this was because Dorothy wanted the service to be held in another church, but as she wasn't a regular communicant there, the vicar of that church refused point blank to conduct the wedding.

When the ceremony was over, a few photographs were taken before everyone retired to the Vickers' Social Club. Everything was laid out ready for the wedding breakfast, but things certainly were strange in Barrow – whoever had breakfast in the middle of the afternoon? One or two toasts were made after the meal to wish the newly married couple well in their new life together, but they then beat a hasty and undignified retreat. I really couldn't understand why they were in so much of a hurry to get off. Nothing much happened during the next few hours, it was just a group of relatives talking about old times and drinking up the beer which had been left over from the wedding breakfast. That's another thing, Dad never ever had beer at breakfast! Throughout the proceedings, Uncle Bob had picked his way through all of the different family groups, dispensing smaller drinks from a flask which he had concealed in his inside pocket. Dad seemed to be enjoying much of the contents from this flask, and towards the end of the afternoon, he was in a very jolly mood indeed. I was told that he'd been drinking a special kind of cold tea. Mum was also very partial to a cup of tea, but she never seemed to smile quite like that after a brew!

But all good things come to an end. Uncle Bob made an impromptu speech, thanking everybody for coming, and also expressed the wish that they'd have a safe journey home. Friends and relatives were soon donning their overcoats, bidding farewell and drifting away from the smoky atmosphere of the club, out into the cooler and cleaner hinterland of Barrow.

With many of the adults feeling quite mellow now, not to say melancholic, the stage was set for an evening of nostalgia at James Street.

After much jollity, and when everything was beginning to settle down, Mum remembered that the last episode of the TV thriller *Five Names for Johnny* was being screened that night. We'd watched this for the last five weeks and couldn't miss the climax. The TV was switched on, and I was allowed to stay up to watch the programme. Although, I wouldn't admit to it, the start absolutely terrified me. It showed two medics dressed in full theatre garb, standing on the running boards of a clapped out old banger. The doctors were being driven around the fog-bound streets of London, searching for a badly injured patient who had discharged himself from their hospital. Scouring the streets, they shouted through the fog, 'Johnny, Johnny'. The programme itself, which only lasted half an hour, wasn't too scary, it was just the horrible beginning. I was given my marching orders as soon as it ended, but the thought of lying on the small two-seater settee all night just gazing out of the window into the moonlit street didn't thrill me! When I plucked up the courage to curl up on the couch, the aspidistra, which stood in the middle of the bay window, seemed to be waving ominously and menacingly at me, and was now the central figure of a conspiracy into which I was becoming inexorably enmeshed. All kinds of terrifying thoughts were making their way into and through my mind, and after an eternity, which perhaps lasted for five minutes, I was in a state of high anxiety. Events then took a bizarre turn. I could see the brass knob on the wooden panelled door being turned very quietly. The door was then gently opened. Somebody was entering the room, and whispering my name 'David, David'. I jumped up and hurled the blankets at my would-be assailant, and started to scream as loudly as I could. It was another ten minutes before I realised that the person entering was Dad. He'd come down to see how I was, and not wanting to disturb the rest of the family, had kept his movements as quiet as possible. After calming down a little, I spent the rest of the night sleeping, fitfully, at the bottom of Mum and Dad's bed. I was still a bag of nerves on Sunday morning.

We got the train home later that day, but because of lots of line repairs being carried out, instead of taking the normal three hours to reach Liverpool, today's journey took almost twice as long. The weekend, to say the very least, had been eventful.

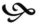

Returning to school and my new-found status in 2z, the teachers organised a parents evening. This was to give everyone the opportunity to talk about what we'd done in France, to swap some stories, and to look at our photographs. The

school had also organised a modest photography competition, with entry open to all pupils who had been on the visit to France. I was encouraged to enter. Dad suggested that I could select up to ten of my favourite compositions, then enlarge and mount them ready for entry. This was just the kind of diversion from school that I relished. I spent a great deal of time in Dad's darkroom that week preparing my photographs, and was very pleased and proud when they were adorning the walls in the main hall at school, and being admired by many parents.

Sandyman, the art teacher, was doing the judging with the aid of a little clipboard. He looked very serious as he peered into the photographs, examining them for that indefinable quality that marks a winner. During the course of the evening, while the parents were wandering around the hall and no doubt making their own choices, I noticed that much attention was being focused in the area of my display. As the tension and anticipation mounted before the results were due to be announced, I really thought that this was to be my big moment. In the event, I was awarded one of the five consolation prizes – a cheap imitation of a Parker biro. Mum and Dad asked why I hadn't been more successful, only to be told, 'Well, Dad's a professional photographer, and he's obviously done this work. We're looking for work which the boys' themselves have done. As you know, it's supposed to be their exhibition.' This view, as expressed by Sandyman, really reinforced rejection. I cried all the way home to Speke.

Art was becoming quite a fun subject, especially with our fun teacher, Mr Sandyman, or 'Sandy' as he was affectionately known. 'Sandy' was square jawed, wide eyed and innocent. He was always very helpful during lessons, but since the episode of the photography competition, 'Sandy' now had a few marks against his name. By way of childish revenge, I encouraged other classmates to flick powder paint onto the back of his jacket as he wandered up and down the rows of desks. He was quite oblivious of this practice, and on many occasions left the class with his suit jacket looking more like Joseph's Technicolor Dreamcoat, daubed as it was with an array of different coloured paints easing their way into the fabric.

Lunch and playtimes were without doubt the highlights of the school day, that is apart from going home at 4.00 p.m. What really helped playtime go with a swing was a good fight in the schoolyard. Georgie Shaw's favourite pastime was playing the pugilist, which he did to great effect. One day while watching him following his chosen pursuit, a firm hand suddenly took me by the scruff of my neck. Without further ado, 'Fitz', the teacher on playground duty, told me to proceed to the head's office. Naturally I protested my innocence, being an observer rather than a participant. Mr Fitzpatrick knew better, as was a teacher's prerogative. According to him, he'd clearly seen me fighting, and didn't want any cheek. He also informed

me that if I remonstrated any further, he'd recommend that I got twelve strokes of the cane. Prudence suggested that I should settle for a draw, and accept the six strokes which I was now due. Punishment was swift. Every one of the six strokes hurt, but the real hurt was the fact that I was totally innocent of any wrongdoing on this particular occasion. Along with 'Sandy', 'Fitz' now went into my little book. I was beginning to build a little dossier on the injustices of the system – and in the process, while not appreciating it at the time, beginning to critically examine 'authority figures'.

Now that the myth of Father Christmas was firmly out of the way, Christmas presents and requests took on a different meaning. I decided that it was time to improve my woefully poor writing skills. The two-fold solution was simple. First obtain a Parker 51 like Dad's, and then copy his style. What could be more simple? I'd always admired his handwriting, and with mistaken logic, thought that if I had a pen like his, then I would be able to emulate his distinctive style. I put the request in, but as a Parker 51 cost four guineas, I was told that it was out of the question. Irrespective of cost, which in itself was prohibitive, the pen was really too much of a luxury for me to handle. I wasn't prepared to settle for this. I suggested that if I couldn't have this particular pen, then they might as well save themselves the money and hassle, and not bother to buy me anything. A game, very similar to poker, developed. Both of us, that is Dad and me, trying to push the other to the edge. The trick was not to reveal your hand. Christmas Day that year fell on a Sunday, and as late as Thursday we were still at impasse. Then the breakthrough came. Dad said that I could have the pen, and that we'd buy it on Saturday morning. Going into Henstock's, the best pen shop in Liverpool, just off Bold Street, was like stepping back into a Dickensian age. At any moment, I expected to be accosted by a wizened old man in a dirty waistcoat, with one of those dark green shades over his eyes. This didn't quite happen, but the old woman who did serve us must have joined the company when the foundation stone was being laid. It was difficult to fault her knowledge of pens. She explained all of the different styles, starting with the solid gold variety, and slowly worked right down to the lustalloy-topped pen, retailing at the princely sum of four pounds and four shillings. We already knew the price, and I also knew that that was the only option on offer. If the truth be told, I'm sure that she too knew this, but professional pride, not to say her innate sense and psychology, dictated that she told us about the full product range. After she'd made her sale, she explained about the eight different types of nibs which were available, from the broad italic, for highly stylised writing, right through to the very fine nib. I was aware that Dad had a very fine nib in his pen, so there wasn't much contest as to which one I would be opting for! With a final flourish, just before taking the cash, she demonstrated the unique filling action of the pen. The deal was completed. My writing didn't significantly improve, but I still use the pen every day in the vain hope that it will!

We spent a very quiet Christmas that year. Granddad had come to our house, as he had done every year since Gran died. Christmas Day came and went, but the following day Colin had been invited to Nicholas Peters' birthday party. Nicholas was Colin's best friend at school, and had been christened Nicholas because of his arrival on Boxing Day. He came from a very large family in Woolton, and on that day, all of his many elder brothers and sisters returned home in order to be together. But, as Nicholas's father had died earlier in the year, there was some question as to whether the party would actually go ahead.

Dad did take Colin through to Woolton, and then went to collect him a couple of hours later. When he arrived home, Colin looked to be in a complete state of shock. He'd managed to tell Dad the whole story as they drove home. Apparently, halfway through the celebration tea, Nicholas had felt the need to go upstairs to the toilet.

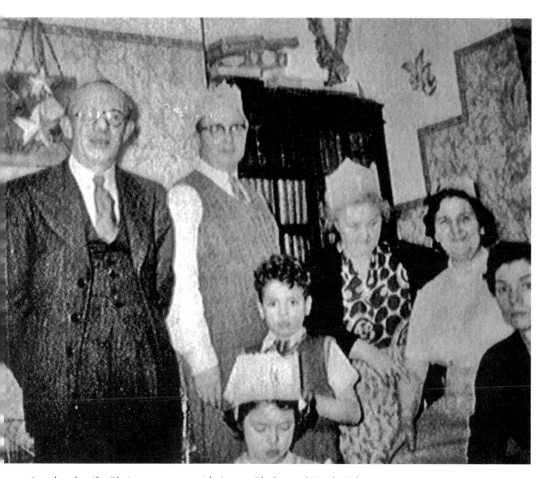

Another family Christmas party, with Aunty Gladys and Uncle Sid.

He'd excused himself from the table and went out to the hall to climb the stairs. In less than a minute he was back in the lounge once again, face ashen and trembling all over. His mother had come over to comfort him, but there was an uncontrollable sobbing which couldn't be staunched for some time. When he was eventually able to divulge what had happened, it appeared that as he was beginning to walk up the stairs, he'd felt the urge to look up, whereupon he'd seen his father standing at the top of the stairs on the landing with his arms open, as if in a attitude of welcome and greeting. Nicholas was pleased, shocked, even terrified at what he'd seen and had returned to the comfort and warmth of the body of his family in the living room. Obviously, I only saw Colin when he returned home, some two or three hours after the events themselves, but that was enough for me to confirm the veracity of the events.

Now there was just the long gap to fill before the inevitable return to school in the New Year. For some reason Dad was either off work or maybe it was a weekend, but when he saw me looking quite disconsolate and dejected in the living room, he suggested that I might like to find the man who was, apparently, wandering around Speke with as many noses on his face as there were days in the year. For some reason this sparked my imagination. I immediately donned my blue gaberdine mac, together with the new balaclava that Mum had knitted me for Christmas, and went striding out into Lovel Road. I walked the length and breadth of the road, kicking the odd stone or empty cigarette packet, no doubt part of the Christmas detritus, and when I couldn't find this illusive character, I decided to look in Stapleton Avenue. I walked right past Linner Road as far as Western Avenue, and then turned around and came up the other side. There was a building site near to St Christopher's so I stopped there, but I couldn't see any workmen. I knew that the cocky watchman there was a funny old geezer, so I thought that it might just be him, but it wasn't! Undeterred, I walked right past the junction with Harefield Road, and almost down as far as Oldbridge, but by this time I was freezing cold. I decided, reluctantly, to make my way back to Lovel Way. As I hadn't bothered to find my gloves before leaving home, my fingers were dropping off when I went down the back entry and opened the door into the kitchen. Mum was standing at the cooker making the evening meal of rissoles and baked beans, and judging from the quizzical expression on her face, seemed to be at some considerable loss as to where I'd been for the last couple of hours. After five minutes of interrogation, she burst out into peals of laughter, and said 'That was just one of Dad's little jokes. What is the date today?' I duly replied that it was 31 December. 'So, how many days are there left in the year?' As soon as she said this, I realised the significance of the joke. Once the laughter had died down, her next instruction was to go and have a good wash, as we were going out later in the evening to see Aunty Flo, Uncle Dick and the boys. I went upstairs; Colin was already in our bedroom and getting into his new Christmas clothes. Mum had put out my uniform trousers, together with one of the grey school shirts that Gran Paul had bought, and the smart blue

and white stripped ties that Colin and I had been given from Aunty Margaret. The only thing that perturbed me was that they looked like Evertonian ties. This didn't please me as I was a staunch Liverpudlian. I put the tie on anyway.

Later that evening we piled into the *Chariot* and sedately made our way to 1 Sefton Square. As was always the way, I went straight into the parlour to listen to some Duane Eddy and Chet Atkins records with my cousin Richard, while Colin went up to Ken's bedroom to play Bayko builder. Dad walked across Admiral Street for a quiet pint with Uncle Dick, and Jean was left to sit twiddling her thumbs, while Mum and Aunty Flo caught up on all of the gossip.

Aunty Flo and Uncle Dick lived in a very different way from us. They always had chocolate biscuits in their house, and there was always supper before we left – for all of us, not just Mum and Dad. When Uncle Dick and Dad returned from the pub we went back into the living room and enjoyed sliced ham sandwiches and tea. We had milk in our tea, but Aunty Flo always had thick 'Conny-ony' as she called it – condensed milk to other people. I only tried it once and thought that it was revolting stuff.

But as it was New Year's Eve, tonight was a little bit different. As soon as supper was over, Richard asked if we could go out along Park Road. Surprisingly, this request was granted, so off we went at 11.00 p.m.! The streets were absolutely full of people – all laughing and joking, smiling and even greeting complete strangers. It was nearing midnight when we walked into one of the numerous chip shops that were open, and still doing a roaring trade. The scene in there was just like outside, in that people were laughing, joking and chatting with one another, happy that another year was dawning, and we were now moving on as the war was becoming more of a distant memory. At the countdown to midnight, we heard the tugs and other ships on the river sounding their horns. We could also hear the bells ringing from many churches. It was a joyous welcome to the New Year.

One of the lads was selling white mice for sixpence each. As he only lived just up Lovel Road, I decided that an investigation might be warranted. I went along that evening after school, and was fascinated with the little white creatures and the obvious potential that there was to sell them to some of the other kids in Speke. I bought a pair and kept them in the coal shed at the back of the house. This was a precaution, as I wasn't too sure about Mum and Dad's reaction if they found them inside the house. A few weeks later, the coal shed housed ten mice instead of the original two. It took me quite a while to work out why this had occurred. When realisation dawned, the marketing strategy for a mice farm became a reality, and I immediately swung into action. I was so excited that I took the box of them in to show Granddad who happened to be visiting that day. The inevitable happened. The mice got loose and ran throughout the house. We spent an absolute age trying to find them. They were under beds, in the pantry, we even found one in Jean's dolls' house, which didn't please her too much. Dad got rid of them that night, and I wasn't allowed to keep mice in the house again, ever!

Fashions were changing, we were growing up, and clothes were becoming more expensive. Mum had the brilliant idea of investing in a knitting machine. This was a revolutionary new product, to which every progressive family was beginning to turn. It was the 1950s equivalent of today's home PC. When it arrived, all boxed up in its strong cardboard packaging, we had a great unveiling ceremony. After this, Dad, in his usual meticulous manner, spent most of the rest of the evening reading the instruction booklet. The translation from German was difficult to understand, as neither Mum nor Dad were fluent in that particular language. By our bedtime they'd managed to work out enough for us to begin to thread the wool onto the needles. This in itself took quite some time, but once we'd mastered the process, it was very easy to pull the knitting carriage across, and just watch the garment grow. A ball of wool was devoured in less than twenty minutes, and a cardigan side could be made in one short session. A few days later we were parading up and down the road in new pullovers and knitted waistcoats. As a treat, we were also allowed to make ourselves a scarf for winter in whatever colours we wanted. I chose black and white, the school colours, Colin had blue and white, the colours of Everton Football Club, and Jean decided that she didn't want a scarf. Even Gran had a new shawl knitted for her, and when Christmas came, all of our relatives and family friends were given a knitted garment of some description.

The knitting machine fad lasted for quite some time, but there's a limit as to how many new sweaters, cardigans, balaclavas and scarves can be accommodated. Also, because the machine needed to sit on top of the table in the living room, it was a fag to get it out every night. Its use was quietly phased out, and the table was once again able to double as the family's table tennis table.

Mum and Dad's relationship with us was beginning to change. Obviously, they needed their own space, and a degree of independence from both us and Gran, but we were too young to appreciate the finer nuances of that situation. Another fact that we didn't appreciate was Gran's quiet but determined efforts to cause tension between Mum and Dad. She was quite manipulative in her own way, using a very particular form of approach. Mum and Dad seemed to be able to combat this, and all of the other problems of communication. One day when I came home from school, I found my parents conversing in what, at first, appeared to be a foreign language. I wasn't too sure whether it was French, German or Spanish, but there were odd bits which sounded vaguely like English. All I knew was that I couldn't understand what they were saying. It was obvious, however, that they could understand each other. This language was used more and more throughout our teenage years, and remained very private between Mum and Dad. We found out later that the language was called 'Backslang', and was in fact jumbled-up English. We never cracked the code, and never understood any of our parents more intimate conversations.

There was a nursery across the other side of playground, and girls from a local secondary school often helped out there on a sort of work placement scheme. I became very friendly with one of them. Every Tuesday evening after school, we walked along together before I caught the bus home to Speke. On one occasion, I spent rather more time with Rita than was usual. In fact, we walked all the way from Leamington Road, right through Broadway as far as West Derby church, only stopping now and again to become a little better acquainted. We ended up at East Prescot Road, which is a few miles from the school. I'd completely forgotten about time. It's not that the earth was moving just yet, but it certainly was getting ready for some sort of seismic shift. When I came to catch the bus home, the conductor informed me that my contract wasn't valid after 7.00 p.m. Not having any money with me, a workman on the bus kindly paid my fare, just as I was about to be turned off. Meanwhile, and quite unbeknown to me, my parents were becoming quite demented at home. Added to that, my liver and bacon had long gone past its best. When I did arrive, Dad quizzed me critically as to what exactly I'd been doing. My excuse was that 'Mac' had asked for volunteers to help erect the school's boxing ring. Being a willing sort of chap, I'd offered my services and stayed behind. I don't think that Dad accepted this story, and for a long time, as I was to find out much later, he'd thought that 'Mac', a bachelor, was one of those *funny* teachers. Although his concerns proved to be unfounded, they were, nonetheless, very real at the time.

My romance with Rita didn't last very much longer. On Saturdays she was a shop girl in Woolworth's and met lots and lots of boys. I just didn't figure.

At the end of the school year, I was again allowed to go to France. Everything was just about the same as last year, but this time we spent our first week in Granville. This year's holiday was by way of a reward, since I'd managed to climb back into the 'Y' stream. I couldn't account for how this elevation had been achieved, but the bonus was another foreign holiday. Being an old hand at school trips, I was able to advise some of the first years and other new travellers as to some of the necessary steps they should take to ensure a good holiday. The first rule was to save enough English money in order to buy 200 cigarettes on the ferry. The second rule was to make sure that the teachers didn't find out. There were other, unwritten, standard rules and procedures to be conformed to if the holiday was to be a success. There was also an élite club for those already in the know. The prerequisite and entry qualification to this club was to get hold of a really good 'nude book'. I didn't have the guts to buy one at Victoria Station, but I managed to 'borrow' a copy of *Nature* from under the pillow of my next-door neighbour. When he found his prized copy missing, he was livid. But in reality, there was

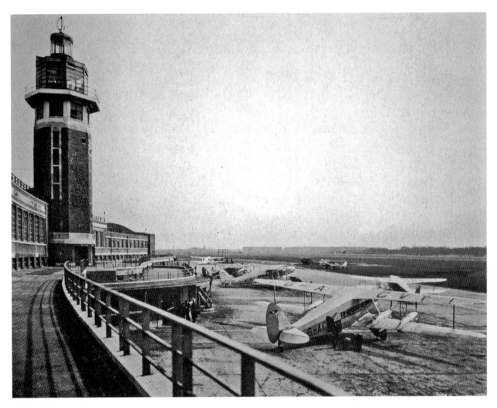

Liverpool Airport, Speke.

very little he could do to rectify the situation! He stayed out of the club, but I was welcomed in!

It wasn't much fun being caught smoking in the centre of town and having all our cigarettes confiscated, but then the compensation of the week was being able to observe the comings and goings in the girls' dormitory just across the other side of the garden. From the vantage point of our dormitory window, we were able to watch them as they undressed. Early in the week, while we were all jockeying for good positions at the window, 'Mossy' crept into our dormitory. Sensing his presence, most boys quietly crept back to their beds. I ended up standing there on my own, continuing to look out of the window, as 'Mossy' asked me if I was enjoying myself. I felt honour-bound to answer in the affirmative, but then promptly turned beetroot red, and went back to my bed in disgrace.

6

Moving On

There was an extra holiday bonus this year. Yankee's mum and dad always hired a caravan in Talacre. It was one of those caravans that are now called 'holiday homes', but in those days, caravans weren't quite so refined. In fact, it was just a very large and relatively old caravan with no facilities like loos and bedrooms, just open spaces of emptiness. As Yankee's younger brother was being allowed to take a friend on holiday, he was given the same opportunity. I was invited to the caravan for three days. We journeyed to Chester first, courtesy of Crosville, and from there went along a very circuitous route to the little Welsh holiday resort. At that time, Talacre was the poor relation of Rhyl, its close neighbour and rival. In fact, most people didn't often mention Talacre, always referring to Rhyl instead. When we were dropped off the bus some two hours later, we had a long walk down a sandy track to the caravan site and heavy cases didn't make the walk any easier. Also, the fact that it was teeming with rain didn't bode too well for our short break. To make matters worse, we found that the caravan hadn't been used for some considerable time. It was dark and the built-in settees, which were dotted around the walls of the caravan, were very damp and smelt of old age, mould and dirt. After sorting out the lights, we managed to get the gas fire going. Even though the fire was on high for most of our stay, we still couldn't get rid of the dampness or its smell.

The next morning things did brighten up a bit. We found out that Yankee's mum helped out in the local general stores. After what was a substantial breakfast by any standards, she took herself off to the little supermarket. Just before she left, we were given a long list of shopping, which included some very exotic items. We arrived at the shop with empty bags, and left a few minutes later with our bags packed and bulging to overflowing. I was surprised to find that the bill for the whole lot was only a fraction of what I'd anticipated. We decided to give the shop our patronage for the remainder of the holiday! Naturally, we smoked a lot more Senior Service than we would otherwise have done, but at such give-away prices, the little white and blue packets were difficult to resist.

It rained throughout the holiday. This meant that we spent long hours inside the caravan. Yankee's air rifle came in handy. After propping open the end window,

we could pick off unsuspecting starlings at leisure. We hit the jackpot whenever pigeons came into our sights. The local butcher offered to buy as many as we could shoot – pigeon pie being a local delicacy.

On the second day of the holiday, some unexpected visitors turned up. As the caravan wasn't that big, it meant that Yankee and I would have to sleep in a tent. We decided to pitch it on the beach, and save ourselves a long walk every morning. It wasn't much fun erecting a canvas tent in torrential rain. Night came, and we felt more and more isolated, as the few people who were on the beach were now making their way back to the campsite. There were no lights to be seen anywhere. Although we wouldn't admit it to each other, we were both scared out of our wits that night. The final indignity came when the tide lapped up to the tent just before 3.00 a.m. There was nothing for it, but to beat a hasty retreat back to Speke.

As Yankee's parents wouldn't be home until the weekend, we decided to take full advantage of the empty house. Normally a single storey prefab in Rycot Road with leaky cast-iron window frames wouldn't have been that attractive, but with no adults to get in the way, lots of exciting opportunities sprang to mind. First of all, we could smoke in comfort. This was a much better proposition than walking along cold, deserted streets, as was our norm. Secondly, we could invite a few girls in for an evening. And thirdly, we could sample the contents of some of the bottles which were kept in the sideboard cupboard. After finding that all the girls we'd invited were otherwise engaged, we decided to opt for the pleasures contained in the square dark green bottle, which was always hidden out of harms way. Being the host, Yankee poured two ample measures of gin into the best china cups. After some considerable effort, we managed to drain them, but didn't enjoy the experience for one minute. It seemed a particularly long walk home that night. After getting Dad out of bed to let me in, the only thing I can vaguely remember, is nestling on the cold linoleum floor of the loo, arms lovingly draped around the lavatory bowl, vowing never to drink again!

'Flossy', the nickname we'd given to our maths master because of his long curly blond locks, was a young Scottish graduate fresh out of a redbrick university. The kids in the class soon realised that he was totally lacking in confidence, and terrified of teaching the 'scallies' who populated 3y and other classes notorious for their indiscipline. He was probably a good communicator, and even a reasonable teacher, but he didn't have a clue with regards to class control. Unlike 'Sandy' the year before, who'd had paint flicked all over his jacket, this time we flicked chalk at 'Flossy'. Paper pellets which had been dipped into the inkwells were also a popular form of missile. These were then fired at his back. If 'Sandy's' jacket had resembled Joseph's Technicolor Dreamcoat, then 'Flossie's' coat, which was Harris Tweed, looked just like one of the Tate's more avant-garde works. Needless to say, 'Flossy' didn't last very long. After two terms he had a mild nervous breakdown, which prompted his rehabilitation into the safer haven of industry. He obviously considered this to be infinitely preferable to the turbulent waters of secondary education in Liverpool.

The fact that I was now back on course in 3y pleased Mum and Dad. The thought of their son being branded as a failure at such an early age was somewhat repugnant to them. It's not that they had aspirations for me which were beyond my reach, they just wanted me to achieve what little potential they thought I possessed.

Moving into 3y was to inhabit a very different world from the one I'd left in 2z, but even in that class there were only two subjects that I really enjoyed, engineering and technical drawing and history, which was taken by my favourite teacher, Jim Brophy. He was a middle-aged slightly rotund figure of medium height. Like so many other teachers, he always wore a grey, Harris Tweed-type jacket and grey flannels. He sported a salt and pepper 'tache, and his hairline was slightly receding to be generous to him. But what made the difference with Jim Brophy was the way in which he brought his subject alive – the lessons really were very pleasurable. The history syllabus that 3y followed was what they called social and economic history, which was all about industrial events and included inventors such as James Watt, Thomas Newcomen and James Hargreaves with his Spinning Jenny. We were also told about the Luddites and were introduced to Wat Tyler and his followers among many more illustrious and infamous characters of a bygone age. Lots of the facts seemed to be about people of the immediate region in the north of England. Jim Brophy made it sound as though if we went off to the various locations that he talked about, we'd still see the men and women working away at their looms in the Lancashire cotton mills, or unloading schooners at the nearby Liverpool docks. We spent time talking about the slave trade, in which Liverpool and its merchants had a significant influence. We were also introduced to William Wilberforce and his associates who brought a bill before parliament to abolish the slave trade. Jim Brophy was our history teacher throughout my time at Belmont Road, and it was only later, when I reached my fifth and final year at school that I became totally disenchanted and disillusioned with one of his decisions, but never his teaching. We came to sit the mock GCE exams, which determined whether or not we sat the GCE later that year. When the results were announced, I'd managed to attain 39 per cent in the mock history exam, which I thought was very credible – the mark required for an outright pass being 40 per cent. Unfortunately, Jim Brophy and the other teacher involved in the selection process thought differently, and entered me for the lesser examination that summer, which was known as the ULCI exam, that is the Union of Cheshire and Lancashire Institutes exam. This qualification carried no currency, whereas the GCE was the nationally recognised qualification. I gained a distinction in the ULCI exam, and no doubt, certainly in my mind, I would have passed the GCE exam.

In addition to enjoying history lessons, I was also developing a modest skill in engineering and technical drawing. My marks here went some way to placate and encourage my parents about my future well-being. Engineering drawing was held

in the lower school annex at Leamington Road where I'd spent my first two years. It was about 3 miles from the main school in Belmont Road, and as the lesson lasted for the whole of the afternoon, the lunch break was used to make the journey from the main school. This also presented a good opportunity for a quiet smoke. After selling the bus tickets which were allocated, we then clubbed together to buy a packet of five Senior Service. Two of these were duly smoked as we wandered down to the annex. The inevitable happened. One Tuesday, while walking along Townsend Lane, 'Uncle Mac', as he was now becoming affectionately known, stopped his car about five yards ahead of us. I immediately dropped my cigarette, and with alacrity covered it with my left foot.

'Where's that cigarette, Paul?' I was asked.

'Cigarette Sir? Which cigarette, Sir?'

'I think the one that's under your foot'.

Without any further discussion, I was told to report to the Head's office after assembly the following morning. 'Mac' had made a mistake: I had time to prepare! The next morning came, and I took the precaution of putting swimming trunks under my trousers. They were woollen and very thick; the cane held no fears for me! After morning assembly, the two miscreants were named. We were ordered to leave assembly and make our way to the Head's study. I'd never been in there before and lots of thoughts and emotions were spinning around my head. I was concerned about 'Mac' detecting the swimming trunks under my trousers and what the consequences would be if he did. But it was the miscellany of books on the two shelves above the fire grate which took my attention. I was amazed to observe that very few were about education. They were mainly novels by Walter Scott and a few science textbooks, no doubt from his days as an undergraduate.

The caning was preceded with a homily about the follies of smoking, although 'Mac' himself was a heavy smoker – another example of the 'do as I say, and not as I do' philosophy which was rife in the school at the time. It didn't end there. 'Mac' took the opportunity of suggesting that I was wasting my time at school. While I couldn't fully endorse what he was saying, he did have a point. Smiling broadly, the formalities having now been dispensed, Mac flexed the supple cane and duly invited me to bend over one of the frayed leather arm chairs which were placed on either side of the black wrought-iron fireplace while he administered 'six of the best'. He stopped after the first stroke and made an enquiry as to what I was wearing for underpants. Somehow I felt obliged to tell him, which in turn prompted another homily, this time it was about being deceitful. He was gracious enough to add that my precautions also showed a certain degree of initiative, and decided not to proceed any further. That was the closest I came to being suspended.

During the course of the year, every pupil was required to enter the school's annual road race. For those of us who weren't into sport this was a real pain, as it entailed having to run a complete circuit around the perimeter road of Newsham Park. To

make the event even more of a challenge, we ran in our house colours. St Margaret's had four houses, Royden, Sheepshanks, Preston and Langton. I think that they'd been named after some of the founding luminaries of the school, but most people seemed to think that they sounded more like the names of combat craft from the Second World War.

Before the race started, each house captain gathered his team together and exhorted everyone to do their best. I was in Royden, and ran in my green shirt, white shorts and Dunlop Green Flash pumps. Being slow, lazy, and by this time a heavy smoker, I found myself in the company of other tail-enders well before the first half mile had been completed. This had hidden benefits, as we all agreed to stop for a quick drag. Realising that we were some way behind, inspiration came to our rescue. Our motley group ran straight across the park in an attempt to catch the main body of runners before they reached the finishing tape. Unfortunately, we were too successful, arriving some five minutes before the front runners. The staff and prefects had obviously anticipated this kind of move. Perhaps it had even been done before! We were disqualified, given three detentions each, and roundly condemned as being a disgrace to the school, and in my case, to Royden in particular.

Not everything was as bad as the road race, so when the 'egging' season came round again, we'd wander all over the place to get the most remarkable birds eggs for our collections. We also collected extra eggs to use as swaps. It was easy climbing lampposts to get the small light blue starlings' eggs, and hedgerows could always be relied upon for blackbirds' eggs, but for more exotic eggs, we had to go further afield. Out by the Horses Rest at the far end of Halewood, there was a farmer's field called the Rose Field – an apt name, since the field was absolutely full of brightly coloured roses in the season. Right at the very centre of the field was a pond which had bramble bushes all the way around it, and around the bushes there was a barbed wire fence. Perhaps this was meant to deter would be trespassers, but Yankee had been reliably informed that there was a moorhen's nest in the centre. Early one evening we made the long journey on our bikes, past the pits in Bluebell wood, over the railway bridge and on to the Horses Rest. We then pushed our bikes down Baileys Lane on an evening which was becoming colder by the minute. Maybe it was fear and anticipation that induced this state, rather than the air temperature around us. The bikes were left by the edge of the field, and we went running across to get to the pond. It was difficult getting through the barbed wire and bushes as we could only find one break in the hedge around the pond. The reward was there for the taking! Right in the centre of the pond, nestling among the reeds was a delicately constructed moorhen's nest. As there were some nettles to negotiate before getting to the edge of the pond, it was a toss-up as to who would be delegated to wade out into the pond. It was Frank Whitfield, Yankee or me. As Frank was not one of our inner circle, somehow he drew the short straw!

Once the nettles had been negotiated, he carefully took off his shoes and socks and waded out into the centre, where he reported that there were eight eggs in the nest. He made two journeys, so that we could clear the lot. Yankee, who was a fund of knowledge about nesting and nature in general, said that the bird would lay another clutch of eggs in the next few days, so it didn't really matter. Anything which Yankee said about nature was automatically believed.

As we eased our way back through the gap in the hedge, we realised that the farmer was waiting for us. There was no escape; he lashed out at us with his horsewhip as we came through. Not very pleasant. Frank still hadn't got his shoes and socks on, and had to run across the field in his bare feet. We didn't go to that farm again, and decided that Frodsham Marshes were much better anyway.

The following Saturday, loaded with bottles of Full Swing lemonade, we waited for the 120 to take us to Widnes town centre. From there we walked across the railway bridge, and then caught a bus out to Frodsham. We'd never been into Frodsham before. It was a new and exciting experience as the single-decker bus weaved its way along the narrow lanes of Cheshire. There was a good view of the surrounding countryside, as we could see over the hedgerows from the bus. It took an age to get to the picturesque village of Frodsham, with its wide main street, and small long-established shops. It seemed as though just about every other one had a painted sign outside, proclaiming the fact that the business had been started 1856, or in one case, 1763, at the time almost two hundred years ago. Although Frodsham was less than 20 miles away from Speke, they were worlds apart in all other respects. Even the sweetshop was very different from Jack Allen's at the bottom of Western Avenue.

Walking out of the village we followed the signs for Frodsham Marshes. Down the lanes and over the marshes, Canada geese could be seen, as could herons, lapwings, mallard ducks, and quite a few other birds which we didn't recognise. The prospects were good for a full day's 'egging'. In one of the hedgerows on the way to the marshes, we picked up a few blackbirds' eggs, and later managed to collect two more thrushes' eggs. These were for swaps. On the marshes themselves, we saw more herons and a number of swans, and began to hope for a swan's egg to add to our collection. Nobody we knew had a swan's egg, and it would be quite a prize. The egg proved too elusive, but the day's tally was good and included three coots' eggs, some moorhens' eggs, and the blackbirds' and thrushes' eggs we'd found earlier.

Lunch was eaten on the banks of the River Weaver. The lemonade was taken out of the rucksack, but the bottle was covered with egg yolk. So much for the coots' eggs! As well as Full Swing lemonade and cream soda, there were lemon cheese butties, a Wagon Wheel each and some apples garnered from an earlier sortie. As it was such a warm day, we decided to go for a swim in the river after lunch. Stripping off to our undies, we were soon in the cool waters of the Weaver, enjoying a swim that seemed to last for hours. The river was only a matter of 30 feet wide, and it was good fun just racing from side to side. That is until, pushing myself off from the mud bank, I pushed my foot straight into a broken beer bottle.

This, very effectively, ended the day's enjoyment. We hadn't got a clue where to find the nearest hospital, and as my foot was now bleeding quite profusely, we thought it best to get the bus straight to Garston hospital. Yankee took charge as I was now feeling somewhat faint. It took three different bus journeys before we managed to find our way to the cottage hospital. Because of where the injury was, on the sole of my foot, they couldn't administer any painkilling injections. They just stitched the wound up, holding me down as I screamed in pain. After being bandaged up, the job was ended with a tetanus jab. I was told to report back to outpatients in a week's time for the stitches to be taken out.

Mum and Dad got quite a shock when I came hobbling in at 7.00 p.m. The day's egging hadn't gone exactly to plan!

I'd taken to early morning cycling expeditions with Yankee. Trips to the North Wales coast were favourite, but occasionally we strayed further afield. One bright summer's morning we decided to head off towards the market town of Ormskirk in Lancashire. Being well prepared we had a spare inner tube, a puncture repair outfit and plenty of butties. We hadn't gone much further than Waterloo when Yankee had a puncture. Rather than repair it there and then, we decided to use the spare inner tube. This was fine until, less than twenty minutes later, a nail went straight through the same tyre. This was unusual, and although we were able to fix a puncture, he was none-too happy. I think that he'd had enough messing around when we'd changed the tyre earlier. He decided to make for home. As the day was beginning to brighten up, I thought that I'd carry on as far as Ormskirk. In fact, I reached there well before 7.00 a.m. Preston was the next town up the road, so I headed off up there. When arriving there, the shops still weren't open, although I'm not sure what material difference this made to the ride! It had to be Lancaster. It was late morning when the ancient market town came into view. The day was quite sunny now, but there was a gentle breeze blowing. Cycling along the minor roads parallel to the A6 was very pleasurable. From knowledge of previous trips to Barrow in the 'Chariot', I realised that the next stop after Lancaster was in fact Barrow. At this stage I started to consider the possibilities of cycling there. After half an hour's break in Lancaster, and still full of energy, I decided that it really wasn't worth stopping. There was one major flaw in this argument, however, and that was although Barrow is in fact the next major town after Lancaster, it's still a hell of a long way to go, especially when you've already cycled over 60 miles. The leisure activity, as it had been until then, turned into somewhat of a chore. Barrow was reached in the late afternoon, by which time I was knackered and very saddle sore. Arriving in James Street, I very gingerly eased myself off the bike and, like a cowboy who's been in the saddle for too long, took three faltering steps towards the house. When Aunty Rose answered the door, her face was a picture. Filled with complete surprise, she shouted at the top of her voice, 'Bob, here's David from Liverpool.' Her next actions were to check whether I'd run away from home, and

how I'd arrived there anyway. She found it difficult to believe that I'd cycled the 103 miles from Speke in a single day. After the initial excitement had died down, and I'd eased myself into a comfortable armchair, Aunty Rosie set to and made me some butties, while Uncle Bob walked down to the phone box to tell Mum and Dad just where I'd landed. Meanwhile, I was busy relaxing, being utterly exhausted. The single bed in their back bedroom was beckoning, so well before ten o'clock I was tucked up and sleeping the sleep of the dead. I stayed in Barrow for a couple of days to recuperate, before facing the long journey back to Speke. Although the distance going back was exactly the same as it had been going, it seemed that the journey was more than twice as long.

Over the next few years I made a few more visits to Barrow on my own, but never again by bike!

Bude was one of the few holidays that just seemed to happen by accident. In truth, I think that Dad had been talking to one of his mates in work. It somehow emerged from this conversation that we were going to be spending our annual holiday that year in the West Country of England. Jean had just passed the eleven-plus, and would be attending St David's school after summer. This was the only Jewish secondary school in Liverpool, and understandably, school uniforms were very expensive. That, coupled with one or two other items of expenditure during the year, made the cost of another foray into Europe prohibitive. Bude it was!

There was no such thing as the Exeter by-pass, and motorways wouldn't be a feature on the landscape for many years to come. Because of this, Dad had been advised to travel to Cornwall overnight. It was suggested that there wasn't too much traffic about at that time. We must have picked a bad night! With the boot flap of the *Chariot* open to accommodate luggage; three kids on the back seat in pyjamas to accommodate sleep; Mum in the front passenger seat wrapped in a blanket with a torch in her hand to accommodate map reading; and Dad at the wheel, we set off. The three of us in the back went to sleep very quickly. This left Mum and Dad free to chat away through the long hours of the night. During the drive, we stopped a few times for necessary breaks. Early next morning we hit very heavy traffic as we were negotiating our way through Exeter. By this time, all three of us were wide awake, and eager to help Dad cope with the traffic. Even with our help, we did eventually find the way into Bude.

The boarding house, which had been recommended, was large semi-detached, and very imposing. A far cry from Newton Road. The house stood on a steep brew, which wasn't too good for the *Chariot*. As soon as we got there, we lodged bricks under the wheels and, once parked, the *Chariot* didn't move too much during the next two weeks. Dad still had to face the journey home!

The boarding house was just about empty during our stay. So much so, that all three of us were given separate rooms. My room was at the back of the house, and was very small, damp, dark and foreboding. We were the only family present at

breakfast and sat at an oval table in the bay of the front window. The room was stark and very cold. The only redeeming feature was that it looked out over the hill towards the town itself. The breakfast dishes were cold to touch, and the butter, which was arranged in small pieces on a little plate in the centre of the table, never spread very easily on the cold toast. Dinners weren't much better, starting with a bowl of lukewarm soup which had obviously found its way from a cheap packet earlier in the day. This offering was followed by a main course of meat and two veg. Although nothing was ever said, I'm sure that all of us were thinking about the splendid meals at Mrs Shipman's, with plenty of meat and gravy, and lots of fresh vegetables from the allotment.

Mornings were spent on the beach, a walk of about 2 miles. On arrival, we were allowed some discretion as to how we spent our pocket money. This was normally a choice between either a ride on a donkey, or taking out a rowing boat for half an hour. After a week of hiring boats, I became an expert oarsman. Skill prompted me to invite Mum and Dad for a row up the river, and twenty minutes later, pride prevented me from asking Dad to row back. He eventually came to my rescue, but not before he and Mum had derived some gentle pleasure from my plight. I was well and truly knackered!

Apart from days on the beach, we did go for other walks. We also drove out to some of the towns and villages near to Bude: villages with magical and mysterious names such as Week St Mary, Canworthy Water, and Halwill Junction. We also visited Bideford and Stratton. And, with Mum's avid interest in history and romance, no visit to the West Country could ever be complete without a pilgrimage to Tintagel.

After a day out and an evening meal, there was nothing much to look forward to until breakfast the next morning, and even the joy associated with that prospect was questionable. Everybody at school told me that the only thing worth doing in the West Country was to drink the Scrumpy. I didn't manage this, but I did sneak a large bottle of Strongbow into my room one night. The next morning, it was even more difficult than usual to face breakfast.

Holiday presents were very grand that year. We stopped in Camelford on the way home. This was a little out of our way, but we'd seen a particularly good toyshop earlier in the week. Dad's tolerance threshold in shops was limited to a maximum of twenty minutes, but as we were travelling home, the limit changed to ten minutes. It wasn't too long, therefore, before we were making our final selections. My choice was a battery-driven scale model of an Austin Healey 100/6.

The journey back to Speke was long and tiresome. After our holidays on the continent, Bude came a very poor second!

It was back into the *Chariot* again the following summer. This year we were off to Anglesey. We children had never heard of this place, but we were told that it was part of Wales, indeed, an island separate from the mainland. The journey there took forever. The crowded roads to North Wales were particularly bad at the height of

summer. After almost five hours, Dad had had enough. During the journey Mum had been desperately trying to keep him calm, as well as checking directions and endeavouring to hold the attention of three excited youngsters. Bangor came in the nick of time. We stayed there for lunch. Mum bought a loaf of bread from a local baker and sliced it while it was precariously balanced on her knee. The bread was spread with Summer County margarine, and then topped with boiled ham. After drinking some pop to wash everything down, we set off again, cheering as we crossed the Menai Bridge over to Anglesey. The traffic had eased quite a lot by now, and the landscape was becoming more rural as we drove towards Amlwch. We stayed in a little cottage in Rhosybol, a village just a couple of miles inland from the town. Mum and Dad could only afford a week's stay here, and even then we were sharing the cottage with the owners. We had two bedrooms and part use of a sitting room that had a television.

The owners were very welcoming, in marked contrast to the people in Bude, and helped us to settle in before announcing that dinner would be at half past six. We were all starving, so the large plates full of chicken with all of the trimmings were a very welcome sight. Later that evening we walked around the village, which took all of twenty minutes. The next morning, Sunday morning, and Mum just had to find a church. While she was there, we sat reading books and playing games. Sunday here was even quieter than at home, and they were very quiet! Wales, it appeared, or certainly this part of it, missed Sunday out completely.

On the Monday we drove back into Amlwch, where we wandered around the shops and came across the local cinema. Mum decided that a trip to this palace of entertainment would be a great holiday treat tomorrow evening. The cinema itself was very similar to the Woolton, a small well-kept building, predominantly frequented by local residents, but peppered with one or two more colourfully dressed holidaymakers. We went to see *A Summer Place*, starring Sandra Dee. It might have had one or two other people in, but I can't recall seeing them. I returned to the cinema on several occasions to watch this magnificent film. The other benefit of going to the cinema was that I could smoke in peace and quiet, without any fear of being caught. But the problem with going to the cinema was trying to get a lift into town. Dad really didn't want to drive me there night after night. One evening as I started to walk along the main road into town, a chap on a 650cc Velocette motorcycle kindly stopped to give me a lift. By the time that we'd reached the cinema, I was somewhat shaken to say the least and, unfortunately, I didn't have a spare pair of undies with me! We'd covered the hilly, winding road between Rhosybol and Amlwch in less than ten minutes. I'm sure that my motorcycling friend had taken great delight in this trip, knowing that I was terrified.

By now I'd driven the *Chariot* on several occasions, and the deserted roads around Anglesey presented the ideal opportunity for a little more practice. Fortunately, Dad shared this view. Everything was going fine until, driving down a steep hill, I thought that I was at the wheel of a Ferrari rather than a 1935 Austin. The car wasn't crashed but I didn't drive again for some considerable time after that little episode. Although the holiday on Anglesey was enjoyable, we didn't return.

Back at school, physics was another one of the many subjects that I couldn't get a handle on. Fortunately the situation was helped when, surprisingly, the Church came racing to my rescue. They say that 'God moves in mysterious ways', and this was certainly the case here. After the usual service of Mattins one Wednesday morning, we were told that confirmation classes would be starting in the near future. The rector announced that anyone wishing to be confirmed would be excused from classroom lessons. My little, yet fertile mind went into overdrive. Attending confirmation classes meant that I would be excused physics. At that time on my own road to Damascus, I decided that the most desirous thing in my life was to be confirmed by the bishop. I duly presented myself for the confirmation classes.

At fourteen, I wasn't too familiar with the differentiations between high and low church. It was, however, soon forcibly implanted in my mind that the Reverend Leverick was aware of those differences, and further, that he was of Anglo-Catholic persuasion. I gained this knowledge after asking of him the innocent, childlike question, 'If I haven't seen the Light, should I be getting confirmed?' The rebuttal came rapidly and most unequivocally. 'We don't believe in "Seeing the Light".' Body language also said, 'Don't ask such stupid questions again.'

Confirmation lessons were a complete waste of time. During each session, the catechism, creed and general confession were drummed into us. Nearer the time of confirmation itself, we were also given instructions about how we were to conduct ourselves. Unfortunately, we weren't given the opportunity to ask any questions about the meaning of confirmation and life as a committed Christian. Strangely enough, I'd gained the impression that learning and lessons were all about asking and finding out. It just goes to show how wrong you can be!

The Bishop of Liverpool was scheduled to preside at the confirmation. I made some excuse at home that I needed to go out on my own, being too embarrassed to tell the folks about the business of confirmation. Somehow they found out, and halfway through the proceedings, I realised that they were sitting towards the back of the church. There was nothing I could do about the situation. It did mean that I'd get a lift home, and Bishop Martin didn't seem to be too aware of my acute embarrassment. A trip home in the *Chariot* was preferable to waiting in the cold for the 81.

Having been duly confirmed, there was nothing left but to go back to my physics lessons on Wednesdays. On balance, it might have been the lesser of two evils, but only God and time would tell. After my enforced absence of some six or seven weeks, I can't say that Bobby Dawkins, our physics teacher, was overly pleased to see me as he walked into our new science lab. His diminutive figure, together with his little clipped moustache gave him the appearance of a Hitler lookalike; in fact, he now looked even more emaciated with the collar of his white check shirt flapping around his slender neck, and his grey flannel trousers

being held up with the aid of a sturdy green leather belt, fastened such that the end almost went halfway round his body again. But the lessons did start to go a little better after confirmation, that is until Jimmy Slea was introduced to the class. He was the new physics teacher the school had brought in to replace Bobby Dorkins who was about to retire after hundreds of years of sterling service to the school and its pupils. Jimmy Slea was very different from Bobby Dawkins and wore a white lab coat with biro stains on the breast pocket. His approach to physics was also very different from Bobby Dawkins, as became evident when he tried to demonstrate making a bulb thermometer. While juggling with a Bunsen burner in one hand, and a phial of molten glass in the other, he accidentally burnt his fingers. There was uproar, which obviously didn't please him too much. His response was swift. Like an athlete in the 100-yards dash, he sprinted around to the back of the benches and kicked our stools from under us. I didn't particularly admire this action, plus, it hurt! Physics was another of the many subjects that I failed in the GCE.

In our next physics lesson, Jimmy Slea, who by that time had calmed down quite a bit, continued with his theme of heat, and mentioned Catherine wheels and their history, which he thought was appropriate since it was approaching 5 November. The story seemed a bit far fetched to me and most of the other kids in the class, but at least it allowed him to use his lesson to demonstrate how heat could be used for several different purposes.

A few days later, when Bonfire Night arrived, Doreen and Bleddyn came over from Runcorn bringing with them a small box of Payne's fireworks, and Aunty Flo, Uncle Dick, Richard and Ken came through from Dingle. Uncle Dick slipped Dad a sly wink as he passed over a significantly larger box of Standard fireworks, but by this time, Bleddyn had signalled his intent to be in charge of the pyrotechnics, which probably suited Dad and Uncle Dick down to the ground, as they could relax in the kitchen and break open a few bottles of Mackeson as it was such a special occasion. I suppose that, given slightly different circumstances, they would have preferred to have walked down to the Fox, but with so many kids around, Mum was no doubt able to dissuade him from this particular course of action. They seemed to accept the situation quite happily, and stood in the kitchen keeping a watchful eye on activities. A couple more kids from the street came in, and the Brews watched from their adjoining garden. Peter and Ronnie Tyson came down, but that was all that we could fit into the back garden. Mum issued everyone with sparklers, and we had fun swirling them around in the darkening night sky, amid a haze of smoke and pungent smells of burning aluminium, iron filings, barium nitrate and other noxious chemicals. Bleddyn told us all of the chemicals involved in the manufacturing process, and then Dad told me that he had a first-class honours degree in chemistry, but that didn't mean very much to me.

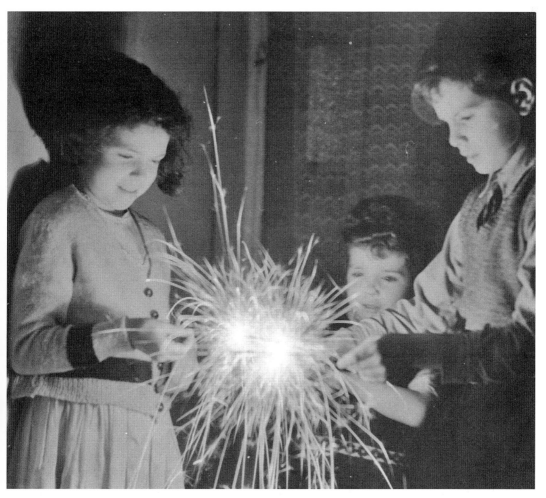

Sparklers were always fun on Bonfire Night.

Bleddyn continued his allotted task of sliding rockets into milk bottles, and fixing Roman candles onto an upturned beer crate that served as an impromptu display platform. We were all given beakers of Full Swing lemonade or cream soda, one of my favourites, and as soon as the sparklers were expended and suitably disposed of by Doreen, the firework display proper started. Gran, Mrs Larch and Mrs Youlton had grandstand seats in the living room, and seemed highly amused at all of the intense activity going on outside. It was obviously much better than going to a bingo session at the pensioners' club, which had been scheduled for that night. There was also the additional bonus of a glass or two of South African sherry, which certainly wasn't on offer at her club.

As the display became more and more frenetic, with Bleddyn setting off fireworks in rapid succession, he appeared to get a little over-enthusiastic with the activities, and all of a sudden, gave an almighty yell and ran into the kitchen past

a startled Dad and Uncle Dick. He plunged his hand under the cold water tap and doused it in running water. Doreen was obviously very concerned about the burn, as indeed were all of the other adults, but the accident passed largely unnoticed by us children, as by now we were far too engrossed in playing in the dark further up the garden.

Fortunately, Bleddyn's burn wasn't as bad as was first feared, and the display finished some twenty minutes or so later. After that, Uncle Dick, Aunty Flo and the boys drove home to Sefton Square in their 1952 Morris Oxford; Mrs Larch and Mrs Youlton said their good-byes and traipsed off, and finally, after clearing up lots of the remaining debris, Doreen and Bleddyn departed. We were told to have our night-time wash and then went to bed a little later than usual, but we still had to sing our evening prayers!

Nothing very special happened before the start of school: a quick pee in the outside bog and a scuffle in the yard was the norm. All the outside 'traps' were full of boys either finding out more about themselves, or having a last drag on the dreaded weed. The bell went at 9.00 a.m., or whenever the 'duty dog' arrived in the playground. For our morning assembly we went into St Margaret's church, which was adjacent to the school. This kicked off with a rousing hymn – Jim Brophy giving it full spleen on the church's Mighty Wurlitzer. We were then plunged into near silence, as a collective endeavour was made to recite the school prayer. The decibels were soon restored, however, when Grimshaw announced the day's notices, good causes and other items of totally useless information. His monosyllabic monologue was never completed without the naming of unfortunates who had been caught committing some minor misdemeanour. They would have to pay the penalty of leaving assembly early, standing outside his office, and awaiting his imminent return. Assembly ended with a rendition of the school hymn, *Guide Me Oh Thou Great Redeemer*, during which Grimshaw lead the way out, closely followed by 'Mac'.

As we were leaving one day, Aggie who was into TV, informed me that there was to be a dirty programme screened later that night. Apparently it was due to start after the News, and was billed as a documentary. Our faultless logic determined that, because it was a documentary, it must have some sexual connotations. We didn't speculate further than that, but Aggie told us that there might even be interviews with 'pros'. At playtime, news broke that the programme would be explaining all about how 'it' was done, and some of the wags even thought that the programme might actually show 'it' being done.

After break we were due to have our weekly religious education lesson with 'Biddy'. He shuffled in with his wispy hair awry, his specs covered in chalk dust, and promptly asserted that the Bible could answer any of Life's questions. This amused me, as it can't have answered too many for a failed Methodist minister working in a Church of England high school. During the lesson, poor old 'Biddy' was greeted with a barrage of questions all relating to the Sex Act.

With homework finished and Panorama just ending, Gran sidled off to bed somewhat earlier than usual. That too was normally the time when I had to retire, but tonight the situation was very different. After the news, Mum also decided that she too would go to bed early. She made some feeble excuse about having had a few late nights recently. That left just Dad and me. We sat there in front of our ageing black and white telly. Feeling a little uncomfortable, to say the very least, I suggested that it was long past my bedtime, and that perhaps I should be heading up the stairs. Dad had other ideas, and told me, very firmly, to sit down and concentrate on the programme which was about to be screened. We sat there in total silence and splendid isolation while the presenter introduced the programme. After about five minutes, when the mutual embarrassment was becoming unbearable, I informed Dad that we had lessons on this subject in school. He appeared quite relieved to hear this, and after a few scant and largely irrelevant questions, decided that bedtime had indeed arrived. I'm sure that when Mum quizzed him later, as she undoubtedly would have done, he probably gave a different account of his perception of events. Be that as it may, this was my first and only formal introduction to the Facts of Life.

After Christmas the rot really set in. I took to 'sagging' school, a pastime that I considered to be far more preferable than attending. The routine was fairly standard. So as not to arouse any suspicions, I set off in the morning at the normal school time. Sauntering along to the bus stop in Western Avenue, I got the twenty-five past eight 81 as usual, but then, at Hunts Cross, I'd change buses and head off into the centre of Liverpool. 'Sagging' was not a lone occupation, Yankee and Russell always accompanied me. Our arrival in town was normally at a very awkward time, when the shops hadn't really opened, so there wasn't that much to do. One of our favourite pastimes was wandering round the naughty bookstalls and nonchalantly checking the centre page spread. When we'd tired of this, round about lunchtime, the scene moved to the food halls which could be found in all of the main departmental stores. This was an important element in the day, as the money which we'd been given for dinner had now been spent on 'ciggies'. The drill here was to go around the counters offering free samples as often as the assistants would allow. Generally speaking, by the time we'd been warned off, we'd had enough to eat anyway. It was time to go home after lunch, but because our bus contracts didn't become valid until later in the afternoon, we were faced with a 10-mile trek to Speke. The question was never asked as to whether a lengthy walk home was worth a day off school.

The 'sagging' routine was fine until one day, while walking through Dingle, I happened to bump into Granddad. He'd often go for a stroll, and think nothing of walking 5 or 6 miles, but he did find it strange seeing me at 3.00 p.m. when he knew that I should have been attending school. The only thing that I could think of was to tell him that we'd all been to the Philharmonic

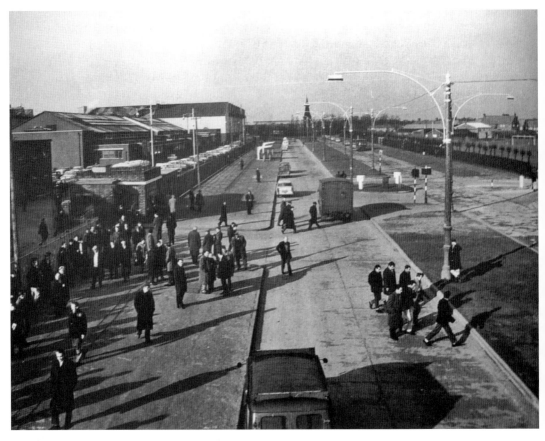

The end of another shift at Dunlop's.

Hall for a school concert. As it had ended early, we'd decided that, rather than wait in the centre of Liverpool until bus contracts became valid, we'd enjoy an afternoon walk. He obviously admired this action, as without further thought, he delved into his pocket and gave us the bus fare home – what a bonus!

One fateful foggy night, Vic McKay came to our house, ostensibly, so that we could revise for the upcoming GCE examinations. We spent some time working diligently, but then the conversation turned to our commission work. By way of offering a service to our fellow pupils, we obtained, at a fraction of the retail price, exam revision papers. This little business venture was proving to be very lucrative and we were certainly meeting a need, although our activities wouldn't have helped W. H. Smith's profits. We reasoned that the school also benefitted from our activities, in that if more of the school's pupils got good exam results, then its wider reputation would be enhanced.

As the evening wore on, the fog was becoming really thick outside, and we hadn't heard any buses passing for some time. Mum decided to phone Vic's mum and suggest that he stayed overnight. After another half-hour of revision, things got a bit more relaxed. We decided to plot the next campaign for obtaining revision papers. Also, I put a new needle in the record player, so we were able to listen to some jazz. Mum and my uncles on her side of the family had a deep love of traditional jazz, so, quite naturally, I'd been gently drawn towards its rhythms. In fact, I'd become a zealot, and attempted to convert anybody who'd give me five minutes to play something by Jelly Roll Morton and his Red Hot Peppers.

Our attention was diverted from the music, when, looking through the curtains, we could see a rosy glow through the fog. Being young and alert, I ventured out to make further investigations. To my horror, I discovered that the plastic sheeting that covered our prized *Chariot* was going up in flames. It might have been possible to deal with the fire, but at the time, the thought predominant in my mind was to ensure that the fire was put out as quickly and as effectively as possible. This meant just one thing. With alacrity I leapt to the phone and dialled 999. After seizing that opportunity, and being informed that the fire engine was on its way, I went in to report to Mum and Dad. Their reaction was very different from the one which I'd expected. Instead of praise for my quick thinking and actions, I was greeted with a tirade of abuse from my father. For some reason, he couldn't understand why I hadn't told him first. Mum, as usual, tried to look at the positive side of the situation. By this time, Dad had run outside with a bucket of water, and was frantically trying to extinguish the blaze. He'd just about managed to do this, when four burly firemen came walking onto the scene in front of their slowly moving fog-bound fire engine. Being hardy professionals, they weren't going to settle for the word of a lay person who insisted that the fire was out. Also, they had to demonstrate their superior skills and hose handling techniques. They immediately proceeded to open a fire hydrant in the road, and drenched the car with a few hundred gallons of water. Needless to say, Dad was beside himself and near to tears throughout the whole of this operation. I didn't sleep too well that night, as by this time I'd realised just how much damage I'd caused by my precipitous actions. The next morning, a recovery vehicle towed the *Chariot* away. It was a very sad day. We were told later on, that nothing could be done for our little car. The *Chariot* had made its last journey.

Out-of-school activities weren't confined to commission work alone. We had quite a range of other enterprises. Brian Russell was becoming quite a dab hand at lifting sweet jars from just about any counter around the centre of Liverpool. There was one shop in particular, not far from Williamson Square, which had one of the best assortments of sweets we'd ever seen. We took the same approach every time. Before going into the shop, lookouts were posted, then thirty seconds later Brian would come running out with a large jar full of Mint Imperials, or something

similar, tucked under his arm. Unfortunately, one day the owner of the shop came out too in hot pursuit. We 'legged it' down a few streets, dodging in and out of shoppers, and managed to jump on a bus, thus evading capture. We were very lucky that day! As we sat on top of the bus heading towards Dingle, the spoils were divided. I was the most popular kid in the street that night – my pockets being full of sweets had nothing to do with it of course. Two pounds of Mint Imperials takes quite a bit of eating. I wrapped up a few and gave them to Mum, which she accepted without too many questions. Dad just gave me one of those funny looks when I passed over his share. I think that he liked Mint Imperials anyway!

Although the GCEs had only just started to come to a close, I was already at a loose end as I wasn't taking that many. I'd finished my exams somewhat earlier than most of my classmates, and Russell found himself in a similar position. As we made our way to Belmont Road, the breeze coming off the river was cold and biting, quite uncharacteristic for the time of the year. It certainly wasn't the sort of day to be wasting our time at school, after all, there wasn't that much there to keep us gainfully employed. Russell suggested that we wag off and go for a day about town. I was always receptive to this sort of suggestion, especially now that my poor performance in the GCE examinations was beginning to fade, and I was becoming more resigned to accepting the inevitable outcome when the results were announced. Almost as a reaction, and certainly a method of releasing pent-up tension, we'd taken to roaming the streets of Liverpool, and causing considerable disruption.

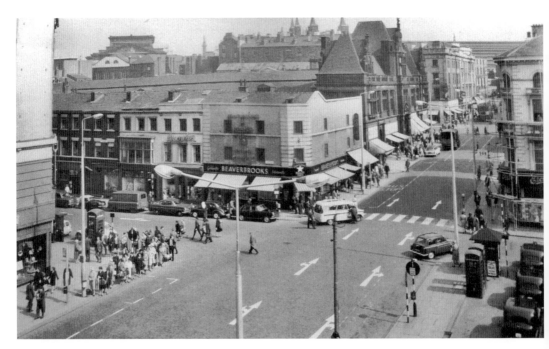

Clayton Square, Liverpool.

We visited many places on our days out, some of our favourite haunts being the public parks. Newsham Park, just across the road from school, was a pleasant place to spend the odd hour or two, but today it was to be Calderstones Park, which had a particularly good cafeteria. When we got there, we saw armies of gardeners, most being dressed in bold check shirts with heavy corduroy trousers held up by braces, and all wearing strong council-issued wellington boots. They were tending the ornamental gardens and the area around the cafeteria, which was where we were heading. Russell, as always, had a few bob in his pockets, so we were able to buy a Coke between us, before surreptitiously lighting up. When we were hard-up, we shared ciggies, taking alternate drags – this was far more economical than splitting them into two.

A couple of minutes after purchasing the Coke, Russell made a second trip to the counter, this time to enquire the price of some obscure item sitting on one of the upper shelves. There was nobody else in the cafeteria so, as soon as the lady's back was turned, he took the opportunity of removing the charity box from the counter – the box was just waiting to be lifted! We ran out, past the gardeners who all looked up in surprise, through the park gates, down the jiggers, along Elm Hall Avenue, and on in the general direction of Penny Lane. When we thought that we were at a safe distance from the park, we found a convenient place to sit, break open the RNIB box and share the cash. There were only pennies and the odd three-penny bit in it, but at

Liverpool Playhouse.

Church Street was a busy thoroughfare, especially at weekends.

least it was better than nothing. Russell got the lion's share of the takings as it was his idea in the first place, but I certainly didn't mind, as I now had another few bob to spend on ice cream, sweets and 'ciggies'. It wasn't one of our more laudable acts.

Dave's fruit shop really was something else! I'd taken a trip to the newly built Shopping Parade at Speke, which is where I first met Dave who owned the fruit shop, in partnership with his glamorous wife, Sonia. They were waiting to find a new 'dogsbody' to cart the spuds around, and anything else that needed lugging in the shop. Being short of the 'readies', I volunteered my services. It was only a Saturday job, but the days started early, at 7.30 a.m., and ended late.

The morning started with lorries arriving from the wholesale market. While the drivers unloaded their cargo of fruit and veg, Dave was busy checking the quantity and, to a lesser extent, the quality, while Sonia was busy painting her nails and looking attractive to the drivers. During this time I was working flat out, trying to keep up with carting the produce into the shop as it was being unloaded. Potatoes were easy to move as they came in large hessian sacks. It was the other fruit and veg which proved more difficult, as this was packed in all manner of wooden crates, cardboard trays, and string nets. After unloading, the next job of the day was to store the different types of potatoes into the various hoppers behind the shop's main counter. This took a long time, especially when there were new potatoes to be loaded. Dave prided himself on his new season Cyprus and Egyptian potatoes and, as he said, it was a first for Speke. The prices he charged were also a first,

More market activity in Liverpool.

The fruit market was always a very busy place in the morning.

but he obviously knew what he was doing as, by the end of the day, the whole lot had usually been sold! The only thing that he did insist upon before the new potatoes went on display was that all of the 'crap' was removed. I'd never heard this expletive before, but when I was sorting out the 'crap' potatoes from the good ones, I soon realised exactly what he meant. The next job was to clean the bananas up, and put them out on the shelves. The reason why bananas came after potatoes was obscure, but they invariably did, and were always followed by the preparation of cauliflowers. Twenty minutes was spent hacking off all the outer green leaves from the cauliflowers to expose the ivory white centres. Even in Speke, shoppers demanded that cauliflower centres were clean, white and crisp – fresh enough to eat raw, as I often did at the back of the shop.

 We opened at 8.30 a.m. and as the punters came streaming through the doors, Sonia was there to greet them, resplendent in her pre-designer top, skirt, real leather belt, dangling earrings and newly painted nails. It didn't take too much persuasion for them to part with their hard-earned cash. Dave, with his ample girth and bullet-shaped head, merely ensured that the shelves were full and that everybody was being served as quickly as possible. The activity before lunch was frenetic. People, for some reason, always wanted to shop on Saturday morning rather than Saturday afternoon. After lunch, the difference in the shop was quite remarkable. The morning saw people queuing outside, almost fighting to get in, whereas in the afternoon, it was only the

St John's market, Liverpool.

occasional customer who popped in, and very often they were coming in for fresh flowers or fish, both of which we sold, but not in any great quantities. At lunch, when the break did come, the shop's blinds were pulled down, the doors closed, and some semblance of order and quiet was restored for a short while. After working there for five weeks, Dave said that I might as well have some fruit to eat during my lunch hour. He was soon to rescind this offer, perhaps just as well, as on the first Saturday when the offer was made, I stuffed myself with six bananas, two Granny Smith's and a large Outspan orange. My work wasn't too productive that afternoon, and when I arrived home in the early evening, I was sick all over the kitchen floor. I was sacked two weeks later for not working hard enough, and eating too much of the profits.

After the rigours and traumas of school, I looked forward to a relaxing weekend, but working at Dave's had changed that for a short time. After that little episode came to an abysmal end, Saturdays reverted to a more normal pattern and routine. During the morning I went to the shops for Mum's weekend groceries, but after that I was free to do whatever I wanted for the rest of the day. Sundays were different, as they were given wholly to attending church. Sunday morning was Holy Communion, Sunday afternoon was Sunday school, and on Sunday evening it was Evensong. A little bit on the heavy side, even though I was now earning reasonable money in my role as choir leader.

There were three main options to choose from on Saturday afternoons – all of which were dependent upon the weather, my financial status, whether or not Liverpool FC were at home, and what films were on at local cinemas. The choice wasn't too difficult, since on most Saturdays I couldn't afford either the entrance fee to the 'Kop' or the price of a cinema ticket. So, more often than not, the third option won out, and that was a trip into Liverpool city centre. Alan Brew, who was a few years older than me, had a seemingly infinite knowledge of Liverpool. He knew all about its shops, its architecture, its history, its culture, and its people. When we went to town, he always wanted to travel on Crosville rather than the 'corpy' bus.

Liverpool was busier on Saturdays than during the week, especially by the Pier Head. Here, buses and trams converged from all over the city, and also from other more distant districts such as Manchester, Prescot, Warrington and Chester. We made our way past James Street underground station and the Victoria Monument. It was then down into Lord Street, past Boodle & Dunthorne the jewellers, where we looked at the expensive hand-tooled pieces, before heading on to the Kardoma for coffee. A visit here was terribly sophisticated for two urchins from Speke. Kardoma coffee shops were dotted all around the city centre, but our favourite spot was the shop in Church Street. The most enjoyable and very colourful part of the afternoon came next, when we walked around Saint John's retail market. This had, literally, hundreds of different stalls, selling everything from fresh fruit and veg, to pet animals, to patent medicines, to artificial flower arrangements, to exotic herbs and spices. Our favourite stall was the Nut Centre, which as its name implies, sold every conceivable kind of nut.

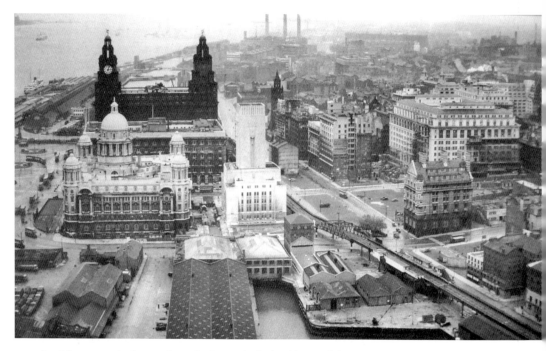

Looking towards the northern docks, with the buildings of the Pier Head in the foreground.

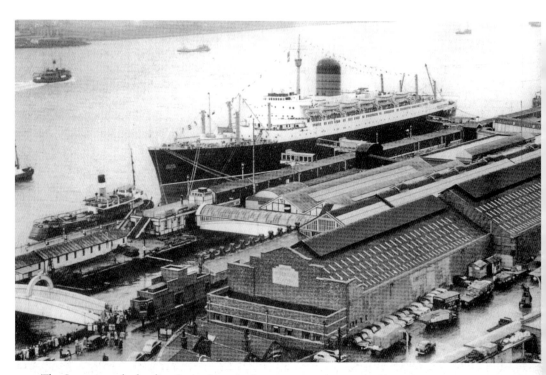

The *Saxonia* at the landing Stage, Liverpool.

It even sold nuts of which we'd never heard! A purchase from here was obligatory. The wizened old man who was in charge of the stall had wrinkles all the way down his face, just like the tiger nuts which were prominently displayed on the counter. Tiger nuts were Alan's favourite, but I preferred the fresh redskin peanuts. Passing on, we went through the section that sold fresh flowers. I'd never dreamt that there were so many different varieties, they certainly never saw the light of day in our back garden! We'd never grown orchids or chrysanthemums or irises. The flowers in our garden were Sweet William, lupins, Michaelmas daisies, and Magnolias, which were the colour of the matt paint in the hall. Finally, it was on to the fish and poultry section, where we wondered at Monk fish, shark fins, halibut, conger eel, turbot, red mullet and all kinds of other rare and expensive fish. They were all packed in large lumps of electric ice. The poultry stalls were also very interesting, with guinea fowl, pheasants, partridges and pigeons, all hanging from stainless steel rails that ran around the stalls.

As we left the market hall at the end of the day, the stallholders were making special offers to everyone who passed. They had to sell everything by the end of trade on Saturday as the market wouldn't be open again until Monday morning. In those pre-refrigerated days, unless everything was sold, it would perish. The strange thing was that even the patent medicine stalls gave special deals late on Saturday afternoon!

The saddest day came a few years later when, following a decision of the city fathers, bulldozers moved in and pulled everything down. With it they ripped out the very heart of Liverpool. The new market hall was hailed as a triumph of

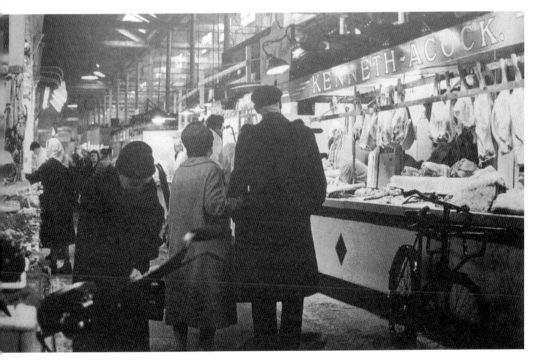

Inside the old St John's market before it was demolished.

modern architectural design, and even won one or two awards, but the atmosphere and community of the old market had gone forever.

If there was a good match on, and funds allowed, I went to watch the football at Anfield. This was a pleasure that I never shared with Colin, as he was a staunch Evertonian. Like many other northern cities where there was more than one major football team, loyalties were often divided right down the middle, causing intense family divisions. In our family, Mum supported Liverpool, but Dad was an Evertonian – it was known as a 'mixed marriage' in the city. Matchdays were, and still are, very ritualistic. Anticipation before the game was electric, as we talked about last week's performance, which players needed to be dropped, and who Shankly was grooming for stardom. When we got to the 'Kop' there was singing and chanting as we waited for the game to start. Bill Shankly had just been appointed as manager of Liverpool, and things really were beginning to buzz. He was building a great team. We tried to do our bit, and players from opposing teams often said that the 'Kop' was worth an extra goal to Liverpool.

The other Saturday afternoon favourite was a trip to the 'flicks', but we only ever went to three cinemas: the Mayfair at Aigburth, the Gaumont at Allerton and the Odeon in town. Friday evenings were spent poring over the *Echo* and discussing the merits of the films that were on offer. If we wanted to see something that was a recent release, we tended to go to the Odeon. The only problem here was that, being in the centre of town, there were always queues outside, and admission was expensive. The Mayfair and Gaumont were, more or less, on a par, but there was a dairy which sold superb ice cream and lolly ices near to the Mayfair, and that gave it a slight edge over the Gaumont. Also, the Mayfair had an organ which came up from under the stage, directly in front of the screen. The organist played requests for half an hour before the afternoon's programme started. But if an 80 came first rather than an 82, we'd go to the Gaumont. This meant that we were able to pay a visit to Aunt Lollipop's on Rose Lane. This, surely, was the best sweet shop in the world. Behind the counter there was a massive display of hundreds of large rectangular sweet jars, with shelf upon shelf filled full of mouth-watering goodies: Callard and Bowser's toffees, Maynard's wine gums, Lion's liquorice tablets, floral gums and the ever-popular and very expensive Cherry Lips. A decision to buy them called for fine judgement – would two ounces of Cherry Lips last longer than four ounces of anything else?

After we'd queued and paid our shilling entrance fee to the cinema, we ventured forward to the darkened foyer which had a tiled floor and a very large marble-faced square fishpond in the centre. The pond, which was filled with gold fish, was used as a wishing well. Everyone stopped here and threw in pennies and halfpennies. We always aimed for the fish, but never managed to hit them.

On Saturday afternoons when I couldn't get to the 'Kop' or to the 'flicks', I'd go with Dad and watch the football on Dunlop's sports field. The ground, just opposite to the factory, was kept in first class condition throughout the year. In their

season, both football and cricket were played. During the football season, there were always at least five different games in progress on any Saturday afternoon. Dunlop's, who sponsored several teams, played in distinctive gold-coloured shirts with black shorts. It was a very impressive strip. It's just a pity that their teams, most of whom played in the lower divisions of the local leagues, couldn't match the quality of their kit. As Dad didn't fully understand the rules of cricket, we never ventured to Dunlop's during summer.

During the winter, Dunlop's also organised table tennis tournaments, and some amateur boxing. These events were held in the factory canteen, the same place as where the children's Christmas parties were held. I never enjoyed watching boxing, but Dad seemed to know a lot about it, and as there was no way that Mum would go with him, I was dragged along. Table tennis tournaments were fun to watch at Dunlop's, and Dad took me to quite a few events, especially now that I was developing skills in that particular sport.

In his early life Dad had been a champion swimmer, and very much into sport, but now, because of his somewhat portly stature, the only exercise that he regularly took was riding his bike to work every morning. Apart from that, it was strictly spectator sports!

Just before leaving school, we'd been given a talk by somebody who explained about possible job opportunities. The word career was never mentioned, as it was assumed that the dummies in 5y would never aspire to such dizzy heights. We sat there attentively, while various options were explained. The only aspect of the discussion that I remember was having to make up my mind as to whether I wanted to work with people. It was suggested that I'd make a good apprentice, as I was neat and tidy! Another prospect on offer was to become a policeman, but that wasn't quite my scene. One avenue that certainly wouldn't receive any further consideration was an option that my parents had suggested, and that was to repeat my year in the fifth form with a view to obtaining a few more GCEs – I couldn't settle for this.

Towards the end of our jobs discussion, we were prompted to reveal what occupation we might follow when we left school. I hadn't got a clue, so I followed the lead taken by Brian Russell. He'd informed the careers teacher that he wanted to become a Marine Engineer. I found it very easy to make the same response, although I didn't know what being a marine engineer entailed, it just sounded like a good answer. When I thought about it a bit more that night, I realised that many of my cousins and uncles had been to sea, and they didn't seem to have done too badly out of it. Marine engineering it was. Early in September I joined the Pacific Steam Navigation Company as a Cadet Engineer.